CW00850682

Writing
from
Experience

Brian Taylor spent his working career in university admin-
istration, first in the University of London and later with
the Committee of Vice-Chancellors and Principals of the
Universities of the United Kingdom of which he became
Secretary General. During his retirement he has had more
time to enjoy browsing in bookshops and the London
Library. He is married and lives in Walton-on-Thames in
Surrey.

Writing
from
Experience

From Louisa M. Alcott
to Virginia Woolf

Brian H. Taylor

ROBERT HALE · LONDON

ISBN 0 7090 6604 X

Robert Hale Limited
Clerkenwell House
Clerkenwell Green
London EC1R 0HT

2 4 6 8 10 9 7 5 3 1

For
Katherine, Emma
and
Jonah

Typeset by
Derek Doyle & Associates, Liverpool.
Printed and bound by
Gutenberg Press Limited, Malta

Contents

Acknowledgements

I would like to thank my wife, Audrey, and my daughter-in-law, Elspeth, for their help and encouragement. The London Library must have my thanks as well.

For permission to use extracts from copyright material, I acknowledge the following:

HarperCollins Publishers Ltd for *The King's English* by Kingsley Amis (1997); *C.S. Lewis, Letters* (1966); and *J.R.R. Tolkien, Letters* ed. Humphrey Carpenter (1981).

Laurence Pollinger Ltd and the Estate of H.E. Bates for *The Blossoming Word* by H.E. Bates (1971); and the Estate of Frieda Lawrence Ravagli for *D.H. Lawrence, Letters* (1970).

A.P. Watt Ltd on behalf of Madame V.M. Eldin for *The Truth About an Author* by Arnold Bennett (1903); on behalf of the literary executors of the Estate of H.G. Wells for *Experiment in Autobiography* (1934); on behalf of the Lord Tweedsmuir and Jean, Lady Tweedsmuir for *Memory: Hold the Door* by John Buchan (1940); on behalf of the National Trust for Places of Historic Interest or Natural Beauty for *Something of Myself* by Rudyard Kipling (1951); on behalf of the Trustees of the Wodehouse Estate for *Performing Flea: A Self Portrait in Letters* by P.G. Wodehouse (1954).

Curtis Brown Group Ltd for *Why Do I Write?* by Elizabeth Bowen © The Estate of Elizabeth Bowen (1948); *Journal of a Novel* by John Steinbeck © 1970 the Executors of the Estate of John Steinbeck; and on behalf of Angus Wilson for *The Wild Garden* by Angus Wilson (1963).

Methuen & Co. Ltd for *Writing a Novel* by John Braine (1974).

Artellus Ltd for *You've Had Your Time* by Anthony Burgess (1990) © The Estate of Anthony Burgess.

Agatha Christie Ltd for *An Autobiography* by Agatha Christie (1977).

Cambridge University Press for *Joseph Conrad, Letters* (1986).

Writing from Experience

Victor Gollancz for *Growing Pains* by Daphne du Maurier (1977).

Faber & Faber Ltd for *T.S. Eliot, Letters,* vol. 1 (1988); and *A.A. Milne* by Ann Thwaite (1990).

Chatto & Windus Ltd for *Essays, Speeches and Public Letters* by William Faulkner (1967), and *Midnight Oil* by V.S. Pritchett (1971).

The Provost and Scholars of King's College, Cambridge, and the Society of Authors for *The Commonplace Book* (1985); and *E.M. Forster, Selected Letters* (1985).

The Society of Authors for *Katherine Mansfield: Selected Letters* (1989); *The Common Reader,* vol. 2, by Virginia Woolf (1986); and *Shaw: An Autobiography Selected from His Writings,* vol. 2, by Stanley Weintraub (1971).

William Heinemann for *John Galsworthy: Life and Letters* (1935); *The Summing Up* by W. Somerset Maugham (1938); *Outcries and Asides* (1974), *The Moments and Other Pieces* (1966) and *Instead of the Trees* by J.B. Priestley (1977); and *Slide Rule: The Autobiography of an Engineer* by Nevil Shute (1954).

Reinhardt Books Ltd for *A World of My Own* by Graham Greene (1992).

Jonathan Cape Ltd for *Graham Greene, Life,* vol. 2, by Norman Sherry (1994); and *Patrick White: Letters* (1994).

The English Association for *The Novelist's Responsibility in Essays and Studies* by L.P. Hartley (1962).

Hemingway Foreign Rights Trust for *A Moveable Feast* by Ernest Hemingway (1964).

Peters, Fraser & Dunlop Ltd on behalf of the Estate of Rose Macaulay for *A Casual Commentary* by Rose Macaulay (1926).

A.M. Heath & Co. Ltd on behalf of the literary executor of the Estate of the late Sonia Brownell Orwell and Secker & Warburg for 'Why I Write' by George Orwell in the *Complete Works* (1953).

Weidenfeld & Nicholson Ltd for *Evelyn Waugh, Letters* (1981).

The Hogarth Press for *Virginia Woolf, Diaries* (1982).

Whilst every effort has been made to approach the copyright holders, apologies are offered for any omissions.

Introduction

'A man may write at any time, if he will set himself doggedly to do it.' Samuel Johnson may have been correct in this, one of his superb but often infuriating observations. Nevertheless, the reader wants to add a 'but' and find some way of saying that it is all rather difficult. And that leads to a question. How did some writers of eminence view the difficulties? This anthology seeks to offer something of the variety of their experience.

The aim is to present a selection of their thoughts on the processes and techniques of creative writing and, in so doing, perhaps to assist those who today are eager to have suggestions and guidance in their own writing. The selection which has been made does not follow any literary mode or fashion. There has been no attempt to relate an author's approach to issues of literary theory although that is not to dismiss the role of such analysis; it is just not the concern in this collection. But it is relevant to quote one academic commentator, Jonathan Culler, Professor of English and Comparative Literature at Cornell University. He has written: 'Literature is a paradoxical institution because to create literature is to write according to existing formulas – to produce something that looks like a sonnet or that follows the conventions of the novel – but it is also to flout those conventions, to go beyond them.' Thus the extracts in this anthology are varied in nature as befits writers who sought to be unconventional, but the pieces also reveal some uniformity in working practices and routines. Much can stem from them.

The criteria for inclusion have been simple: the author has written in English and is no longer living. Such rules may seem unnecessarily restrictive but they do perhaps produce a certain

unity for readers in the English-speaking world and an opportunity to consider views on authorship against all the writer's published work. And there is a further factor which affects all anthologies: the selection is clearly determined by what is known to the collector.

It could have been useful if every writer quoted had written at some standard length and dealt in turn with topics such as plot, characterization, dialogue and style. But normally they have not been concerned with instructional manuals. Nor could they reflect the theme of Henry Reed's *Naming of Parts*. We may regard some as people of genius but they do not help us to gain any significant understanding of what that word really means. What they do is to make us aware that any idea about the nature of creativity is usually based on hard work. That emerges from the extracts. To quote but one remark, John Braine said that he had never met a professional writer who did not work set hours.

The majority of the pieces are by authors of 'literary fiction', but even those who have not attained such a classification and are regarded by the critics, sometimes with condescension, as 'popular', have been faced with similar problems and frustrations. They have had to wrestle with the 'creative process'. There are few who would argue that Graham Greene is not one of the most significant literary figures of the twentieth century and many would contend, for example, that Nevil Shute, although a distinguished writer, was not in the same class. Be that as it may, they both had to know their craft. And that is the correct word. There has to be an apprenticeship in the craft and often a subsequent period of experimentation and rejection. It is perhaps easier to study this process in the visual arts. Visit a retrospective exhibition of the work of an artist and be made aware of the changing style as one leaves the early paintings for the galleries displaying the mature works. The process may be similar for all the arts, if not for all individuals.

Returning to the question of 'writing technique'. How does the experience of the author and his many and varied emotions find written expression? Reading, writing, listening and observing are mentioned frequently. The extracts reveal how often a

wide reading was the first and, indeed, the continuing element of the apprenticeship. Does that reading develop a style? 'Perhaps' is the answer we glean. John Buchan remarked that he was taught 'to be circumspect about structure and rhythm and fastidious about words'. That statement may contain the essence of the approach of all our authors. Read the piece by H.E. Bates and enjoy his talent and his ability to guide a struggling colleague. But there is more in the extracts than the purely literary lessons. Rudyard Kipling tells a story which stays in the mind when he relates how the head of the College of Surgeons visited him one Christmas and insisted on looking at his hens to verify some facts about their behaviour. He had to be sure of his facts. Kipling, the writer, allows us to absorb the lesson by way of an amusing anecdote. It is also a story which can recall the rewards of visiting Bateman's, his house in Sussex which is now open to the public. Visiting such houses is, of course, a fascinating way of adding to an understanding of what influenced an author.

Story-telling is the natural gift of many of the writers and it surely *is* a gift. Some longer pieces have been included because they not only contain useful advice but are also a 'good read'. Daphne du Maurier's account of her early experience of authorship is a delight in its own right. And ponder the ability of Mark Twain to amuse and instruct by offering history as news. Agatha Christie entertains and teaches, and so do many others.

Not all the selections relate to what might be called the cerebral aspect of authorship. There is the anxiety of George Eliot to find a comfortable manner of sitting and there is the general preoccupation about staying at the desk once seated there. That problem can sometimes become entangled with the great fear of 'writer's block'. Techniques are shared. Hemingway wrote, 'I always worked until I had something done and I always stopped when I knew what was going to happen next. That way I could be sure of going on the next day.' But still he had his problems. The discipline of work is described again and again.

Publishers are often a bother to authors and money, or the lack of it, is frequently an overwhelming consideration. There is a love-hate relationship and this is frequently revealed in the

letters of writers which have been published posthumously. Such letters are the source of numerous extracts; how fortunate we are to have the text of so great a number. And what compulsive correspondents they were. We may rejoice in the fact that the telephone and the fax, the e-mail and the Internet were not features of the lives of earlier generations. They had manuscripts and they could be kept. Naturally, we can never be certain whether the writer of a letter had eventual publication in mind but there is often the clear impression that we are party to a private exchange. Much of the correspondence can suggest an expression of thoughts which would not have found their way into public talks and published articles.

The letters of Robert Louis Stevenson have to be savoured. He emerges as a most pleasant man. But do we have to like an author? That is a difficult question but some help may come from Virginia Woolf and her piece 'How Should One Read?' Knowledge of the person may be helpful in forming an opinion on their literary skill.

Many of the authors who are quoted were working before there were summer schools in creative writing or universities with 'writers in residence' or the proliferation of classes and workshops on how to write arranged by local education authorities. The interest is phenomenal – and welcome. How would the men and women who are the source of the quotations have fared in such an environment? It is amusing to speculate. We can be confident that Charles Dickens would have been greatly in demand and enjoyed himself hugely. But what about Jane Austen? The advantage for us is that so many earlier writers left evidence of their approach to their craft.

The fascination attached to letters applies with almost greater force to diaries. There are few pleasures in light reading to compare with the enjoyment of a good diary. We like to pry. Again we may doubt whether the entries were really meant solely as an expression of private interests but, even if there is evidence of an ambition for later publication, the insights can often be rewarding. How annoyed we can get when we learn that a relative destroyed some texts after a writer's death. It may be an unreasonable reaction but it occurs.

Introduction

Autobiographies, biographies and memoirs meet some of the need to understand the working of the creative mind and the events and experiences which have shaped that mind. We are fortunate in the wealth of material available to us and to the talents of contemporary biographers such as Victoria Glendinning, Norman Sherry, Andrew Motion and Claire Tomalin to mention but a few. As for autobiography, those who have not yet read Anthony Trollope's account of his life have a pleasure awaiting them. V.S. Pritchett is quoted in this collection, and is yet another of an entertaining and instructive group.

There is a special form of autobiography used by authors which gives an impression of thoughts on reading and writing and is invaluable to those trying to understand the creative process and the manner of communicating with readers. The keeping of commonplace books has perhaps gone out of fashion and that is a pity. Anyone can buy a book of blank pages and make notes of their reading, of striking quotations, of anything which in their judgement is worthy of recording from the life of the mind. E.M. Forster has much to offer in his commonplace book, which has been published. Go to the British Library and see the manuscript of 'George Eliot's Blotter'. That is a work of art in itself. And do not forgo browsing through other commonplace books. Publishers and booksellers seem to excel in the field. They may not tell us how to write but they know how to read. John G. Murray and Christina Foyle are worthy of attention.

In all these various ways we may gain some understanding of the craft. Creative writing may require the mind of an Angus Wilson, who often thought in terms of geography. Graham Greene wrote that one evening he walked up Piccadilly and went into a Gents in Brick Street where suddenly in his mind he saw three chunks of a new book. And so the examples come. Shaw wrote that you start a play anywhere you can. It makes clear sense but we need Shaw to give force to the point. William Faulkner's address upon receiving the Nobel Prize for Literature takes the craft to the level of art. But even for the greatest, everything has to be planned and written and revised.

The extracts do not lead to the formulation of a set of general

rules to be applied on every occasion, but what is said may be useful to those wishing to follow such good tutors. We started with a remark by Samuel Johnson and we may finish with another of his provocative lines. He was quoting a college tutor who had said: 'Read over your compositions, and where ever you meet with a passage which you think is particularly fine, strike it out.' That is too severe a prescription. Our authors give more encouragement than that.

Louisa M. Alcott (1832–1888)

The personality of Louisa M. Alcott emerges with force and clarity from her letters. Like many other writers, she received numerous requests for details of her working methods, particularly after her success as the author of *Little Women*. There is much to learn from the three letters quoted.

To John Preston True

Concord, October 24 [1878]

Dear Sir

I never copy or 'polish', so I have no old manuscripts to send you; and if I had it would be of little use, for one person's method is no rule for another. Each must work in his own way; and the only drill needed is to keep writing and profit by criticism. Mind grammar, spelling, and punctuation, use short words, and express as briefly as you can your meaning. Young people use too many adjectives to try to 'write fine'. The strongest, simplest words are best, and no *foreign* ones if it can be helped.

Write, and print if you can; if not, still write, and improve as you go on. Read the best books, and they will improve your style. See and hear good speakers and wise people, and learn of them. Work for twenty years, and then you may some day find that you have a style and place of your own, and can command good pay for the same things no one would take when you were unknown.

I know little of poetry, as I never read modern attempts, but

advise any young person to keep to prose, as only once in a century is there a true poet; and verses are so easy to do that it is not much help to write them. I have so many letters like your own that I can say no more, but wish you success, and give you for a motto Michael Angelo's wise words: 'Genius is infinite patience'.

Your friend
L.M. Alcott

P.S. The lines you send me are better than many I see; but boys of nineteen cannot know much about hearts, and had better write of things they understand. Sentiment is apt to become sentimentality; and sense is always safer, as well as better drill, for young fancies and feelings.

Read Ralph Waldo Emerson, and see what good prose is, and some of the best poetry we have. I much prefer him to Longfellow.

To Viola Price

Boston, Dec. 18th, 1885

Dear Madam

My replies to your questions are as follows: I write in the morning. Any paper or pen suits me. Quiet is all I require. I work till tired, then rest. Winter is the best time. I enjoy solitude very much. I often have a dozen plots in my head at once and keep them for years. I do not make notes of ideas, etc.

I do not enjoy society, and shirk its duties as much as possible.

I read anything that attracts me. Never study. Have no special method of writing except to use the simplest language, take everyday life and make it interesting and try to have my characters alive.

I take many heroes and heroines from real life – much truer than any one can imagine.

My favorite authors are Shakespeare, Dante ... Emerson, Carlyle, Thoreau ... Geo. Eliot and C. Brontë ... I read no modern

fiction. It seems poor stuff when one can have the best of the old writers.

St Nicholas and *Harper* are my favorite magazines. I dislike to receive strangers who come out of mere curiosity, as some hundreds do, forgetting that an author has any right to privacy. Autograph letters I do not answer, nor half the requests for money and advice upon every subject from 'Who shall I marry' to 'Ought I to wear a bustle?' Mss I have no time to read and 'gush' is very distasteful to me.

If you can teach your five hundred pupils to love books but to let authors rest in peace, you will give them a useful lesson and earn the gratitude of the long-suffering craft, whose lives are made a burden to them by the modern lion hunter and auto-graph fiend.

Please give my regards to the young people and thank them for their interest in the little books.

<div align="center">

Yrs truly

L.M. Alcott

</div>

P.S. I am an invalid from too much head work, and my right hand is partially paralysed with writer's cramp, so my writing is, as you see, not a copy for your young people to imitate.

To Frank Carpenter

<div align="right">

April 1st [1887]

</div>

Dear Sir

My methods of work are very simple and soon told. My head is my study, and there I keep the various plans of stories for years some times, letting them grow as they will till I am ready to put them on paper. Then it is quick work, as chapters go down word for word as they stand in my mind and need no alteration. I never copy, since I find by experience that the work I spend the least time upon is best liked by critics and readers.

Any paper, any pen, any place that is quiet suit me, and I used to write from morning till night without fatigue when 'the

steam was up'. Now, however, I am paying the penalty of twenty years of overwork, and can write but two hours a day, doing about twenty pages, sometimes more, though my right thumb is useless from writer's cramp.

While a story is under way I live in it, see the people, more plainly than the real ones, round me, hear them talk, and am much interested, surprised or provoked at their actions, for I seem to have no power to rule them, and can simply record their experiences and performances.

Materials for the children's tales I find in the lives of the little people about me, for no one can invent anything so droll, pretty or pathetic as the sayings and doings of these small actors, poets and martyrs. In the older books the events are mostly from real life, the strongest the truest, and I yet hope to write a few of the novels which have been simmering in my brain while necessity and unexpected success have confined me to juvenile literature.

I gave Mrs Moulton many facts for her article in *Famous Women*, and there are many other sketches which will add more if they are wanted. The first edition of *Jo's Boys* was 20,000 I believe, and over 50,000 were soon gone. Since January I know little about the sales. People usually ask, 'How much have you made?' I am contented with 100,000, and find my best success in the comfort my family enjoy; also a naughty satisfaction in proving that it was better *not* to 'stick to teaching' as advised, but to write.

<div style="text-align:center">

Respectfully yrs
L.M. Alcott

</div>

Kingsley Amis (1922–1995)

In his *The King's English: A Guide to Modern English Usage*, which was published posthumously, Kingsley Amis offered some characteristic comments on writing. In his introduction, he mentioned the reference works which he kept by his desk. His guide might well be a useful addition for others. Here are two extracts written from his own considerable experience as an author.

Feminism in Language

This is so notorious already, and such a joke, that I will offer only one comment. A sane feminist, and there must surely be such a creature, would presumably look forward to a perhaps far-off day when the feminist revolution is a fact like the Russian one, when women are so fully the equals of men that feminist propaganda and other pressures have ceased to be needed. Until that day comes, of course, propaganda etc. will continue as usual, if not more so.

I have to confess that I, no doubt among others, have already begun to yield. Unable or unwilling to face the chore of perpetually remembering to write 'he or she' in appropriate contexts, I fall back on plural or passive constructions. If after a quick search these seem not to be available I recast the sentence. Why? Because I would rather be safe than sorry, and to find myself the occasion of some feminist outburst about unconscious (or conscious) chauvinism would make me very sorry indeed. Has that ever happened to me? Not yet, but we know well enough by now that all men are cowards, do we not?

Rhythm

This is not the easiest of subjects. The seeker after advice on what rhythm in prose actually is, and how to achieve a kind of prose displaying it to advantage, is not likely to find an answer quickly. One is sometimes tempted to think that anybody with leisure to worry about how a message sounds is not overmasteringly concerned about the content of that message. Nevertheless one or two rules of thumb do emerge.

No careful writer of fiction, that is to say of realistic fiction, will be satisfied with a line of dialogue unless it sounds satisfactory when read out, spoken aloud. It may be less obvious that the writer of any and every kind of prose should also read aloud what it is proposed to print. Nobody who has not habitually done so can imagine the farrago of ineptitudes revealed by this obvious method: unintended rhymes, assonances and repetitions, continual failure of whatever organ might guard against bad sound. If a paragraph of prose is to sound satisfactory to the reader's inner or outer ear, it must already have satisfied its writer by the same criteria.

For all that, when a passage of prose is commended for its rhythmic or sonic beauty, it is often some passage of scripture or high drama or other solemn and emotional writing. This is a little hard on the non-scriptural writer. A meditation on first and last things, not to speak of an account of a human death, is bound to strike the reader as more impressive than a report on the strength of materials. Nevertheless both have their place. It strikes the reader as trenchant and witty when George Orwell rewords a well-known and splendid verse from Ecclesiastes in the style of a government pamphlet, but neither he nor anyone else I know of has tried the same sort of thing the other way round. Specialized expressions, technical terms and such often have the merits of clarity and definiteness, not to mention irreplaceability (if you get what I mean). So no, a *juvenile delinquent* is just that, neither more nor less, and cannot be paraphrased into anything else. And no, it will not do to reword *There is a total lack of ablution facilities* as *There is nowhere to wash*, however funny and brilliant it may be to do so, because those facilities

Kingsley Amis (1922–1995)

include means of not only washing in general but also of showering, having a bath, shaving, cleaning teeth and washing various bits and pieces and no doubt of other things, all summed up under the admittedly fussy and cacophonous but necessary and concise phrase, *ablution facilities*.

With that said, of course there are plenty of jargon-merchants, those who prefer sonorous, polysyllabic abstractions to plain words, and an eye must be kept out for such, not least within oneself. But to write graceful or stately prose you need a suitable subject with plenty of heavy monosyllables in it, one nearer the Last Judgement than the provision of visual aids and kindred apparatus in pre-teenage educational environments.

Jane Austen (1775–1817)

We are told that Jane Austen was read and admired by the Prince Regent and, although she had little regard for the man, she presented him with copies of her books. In one of his letters to her the royal librarian thought it appropriate to suggest that she might write about the life of a clergyman. Her reply was both forceful and annoyingly modest. But we are given a glimpse of her determination to write only about what she knew.

To James Stanier Clarke

Monday 11 December [1815]

Dear Sir

My Emma is now so near publication that I feel it right to assure you of my not having forgotten your kind recommendation of an early copy for Cn H— and that I have Mr Murray's promise of its being sent to HRH under cover to you, three days previous to the work being really out.

I must make use of this opportunity to thank you dear Sir, for the very high praise you bestow on my other novels – I am too vain to wish to convince you that you have praised them beyond their merit.

My greatest anxiety at present is that this fourth work should not disgrace what was good in the others. But on this point I will do myself the justice to declare that whatever may be my wishes for its success, I am very strongly haunted by the idea that to those readers who have preferred P&P it will appear inferior in

wit, and to those who have preferred MP very inferior in good sense. Such as it is however, I hope you will do me the favour of accepting a copy. Mr M. will have directions for sending one. I am quite honoured by your thinking me capable of drawing such a clergyman as you gave the sketch of in your note of Nov. 16. But I assure you I am *not*. The comic part of the character I might be equal to, but not the good, the enthusiastic, the literary. Such a man's conversation must at times be on subjects of science and philosophy of which I know nothing – or at least be occasionally abundant in quotations and allusions which a woman, who like me, knows only her own mother-tongue and has read very little in that, would be totally without the power of giving. A classical education, or at any rate, a very extensive acquaintance with English literature, ancient and modern, appears to me quite indispensable for the person who would do any justice to your clergyman – and I think I may boast myself to be, with all possible vanity, the most unlearned and uninformed female who ever dared to be an authoress.

> Believe me, dear Sir,
> Your obliged and faithful humble servant
> J.A.

Another exchange of letters between the two makes clear that Jane Austen was not going to be flattered into writing about the House of Saxe-Coburg.

From James Stanier Clarke

Pavilion – March 27th 1816

Dear Miss Austen

I have to return you the thanks of His Royal Highness the Prince Regent for the handsome copy you sent him of your last excellent novel – pray dear Madam soon write again and again. Lord St Helens and many of the nobility who have been staying here, paid you the just tribute of their praise.

The Prince Regent has just left us for London; and having been pleased to appoint me Chaplain and Private English Secretary to the Prince of Cobourg, I remain here with His Serene Highness and select party until the marriage. Perhaps when you again appear in print you may chuse to dedicate your volumes to Prince Leopold: any historical romance illustrative of the history of the august house of Cobourg, would just now be very interesting.

<div style="text-align:center">

Believe me at all times
Dear Miss Austen
Your obliged friend
J.S. Clarke

</div>

To James Stanier Clarke

My dear Sir

I am honoured by the Prince's thanks and very much obliged to yourself for the kind manner in which you mention the work. I have also to acknowledge a former letter, forwarded to me from Hans Place. I assure you I felt very grateful for the friendly tenor of it, and hope my silence will have been considered as it was truly meant, to proceed only from an unwillingness to tax your time with idle thanks.

Under every interesting circumstance which your own talents and literary labours have placed you in, or the favour of the Regent bestowed, you have my best wishes. Your recent appointments I hope are a step to something still better. In my opinion, the service of a Court can hardly be too well paid, for immense must be the sacrifice of time and feeling required by it.

You are very, very kind in your hints as to the sort of composition which might recommend me at present, and I am fully sensible that an historical romance, founded on the House of Saxe Cobourg might be much more to the purpose of profit or popularity, than such pictures of domestic life in country villages as I deal in – but I could no more write a romance than an epic poem. I could not sit seriously down to write a serious romance

under any other motive than to save my life, and if it were indispensable for me to keep it up and never relax into laughing at myself or other people, I am sure I should be hung before I had finished the first chapter. No – I must keep to my own style and go on in my own way; and though I may never succeed again in that, I am convinced that I should totally fail in any other.

I remain my dear Sir,
 Your very much obliged and very sincere friend
 J. Austen

Chawton near Alton April 1st 1816

H.E. Bates (1905-1974)

In his autobiographical work *The Blossoming World*, H.E. Bates offers an account of his apprenticeship as a writer. In the same manner as he brought enormous pleasure to many with his novels, and later with their dramatization on television, he can in a few lines of an autobiography produce a small story which lingers in the mind. The paragraphs which are given in the first extract below tell us something of his own methods of writing. The second extract takes us to the analogy with music. We do not get an answer to the problem of selecting the correct 'key' but we are led to appreciate its complexity.

Presently, also at the instigation of Edward Garnett, I was sending stories to *The Manchester Guardian*, whose perceptive literary editor Allan Monkhouse ran a back-page short story of about 1,000 words every day of the week in that then great newspaper; and to *The New Statesman* and *The Bermondsey Book*, the latter one part of a project, *The Bermondsey Centre*, designed to give some sort of hope to a particularly blighted corner of a blighted world. Whether it was the godsend to the poor of Bermondsey that it was intended to be I never quite knew, but *The Manchester Guardian* was a godsend, and in more ways than one, to me. To write a short story of 1,000 words may appear to be as easy, on the face of it, as one of those tricks with three or four matches that are sometimes presented to you, but that, in practice, turn out to be vastly more demanding. The task of pruning down a story to Monkhouse's desired length was an exercise both admirable and exhausting. It took me, lesson by lesson, through

H.E. Bates (1905–1974)

the exacting art of making one word do the work of two, and even sometimes of three or four. So great was my devotion to that particular lesson in fact that I was presently able, in one instance at any rate, to become master instead of pupil.

Among the few writing friends I had at that time were a group of local newspaper reporters who used to meet, mid-mornings, at an old Temperance Hotel-cum-café for coffee: a decaying, fusty, shabby haunt complete with bubbling hot water geysers, marble-topped tables, aspidistras, a general odour of stale tea and cabbage and an air of half-sanctified lassitude not so very far removed from my childhood Sunday schools. Here I sometimes used to join the reporters for a morning half an hour or so. I was induced to see in one of them, a rather podgy, groping fellow, a picture of myself as I might have been if I hadn't mercifully sacked myself at a tender age from the squalid local office of *The Northampton Chronicle*: not so much a man as a cypher, not so much a writer as a shabby collector of shabby facts for a shabby weekly, a scribbler for ever in pursuit of shattering events at bazaars, garden parties, fêtes, council meetings, funerals, weddings, police courts. While I continued to thank God I had so early made an escape from that kind of life sentence I felt an increasing pity for my older, podgy, slaving friend. He too was striving to write short stories, but with a total, dismal, stultifying lack of success. When it began to appear that I had contributed, so young, to *The Nation*, *The New Statesman*, *The Adelphi* and *The Manchester Guardian* he was moved, one morning, to ask if I would read what he diffidently called 'one of his efforts'.

It was a sprawling, fleshy, verbose thing, stuffed with clichés, of some 1,700 words. I read through it, over coffee, on the marble-topped table. The eye already guided by Garnett and made keener by the demands of Monkhouse then proceeded to take its podgy author through it, word by word, performing surgery on sentence after sentence as with a scalpel. I think, as he saw his many precious words mercilessly cut like diseased tissue and thrown out, he was near to despair; I even suspected he might well have thought I was merely showing off. But when the operation was at last over he seemed to revive a little under

my assurance that the whole piece now had both air and shape and might be printable. 'Send it to Monkhouse,' I advised, 'at *The Manchester Guardian*', which he duly did: to enter, a week later, for the first time, the joyous realms of acceptance.

The early conception of a novel or story greatly depends, it often seems to me, on setting it in the right key. Great geniuses in music often seem to make such choices in their art by some divine instinct. It is by no means so easy in literature, where there are no rules and no fixed set of keys, either minor or major, from which the writer can make his immediate or final choice. The composer knows more or less what something will sound like in C sharp minor or in F major. The writer has no way of knowing any such thing. He must invent his own key. If the key he selects is right then it is likely that his music and its themes will flow from it naturally. If the key he selects is wrong then he is likely to find himself in frustrations and troubles of every kind.

It is now my considered opinion that I somehow chose the wrong key for this novel. As to what key I ought to have chosen I have never since been able to determine. It was a book of almost unrelieved melancholy: of a woman searching for a kind of happiness that was not to be found and who could not break the fraternal stranglehold that everywhere frustrated her and for which she blamed the undying stupidity and waste of war. To the very end it had what is called a down-beat and it also went on and on, as Stephen Crane had complained of Tolstoy's *War and Peace*, like Texas.

Arnold Bennett (1867–1931)

Apart from his novels of the five towns, Arnold Bennett left us some work of autobiography. *The Truth About an Author* may not be one of his great books but it is certainly worth reading. He recalls there his early journalism, his preparatory reading, his experience as an editor and then as an author. Interspersed are glimpses of characters in the literary world of his time, and of the tasks of a publisher's reader and a reviewer.

It is a work which can be read in one sitting but that does not diminish the significance of what he has to offer.

All writers are familiar with the dreadful despair that ensues when a composition, on perusal, obstinately presents itself as a series of little systems of words joined by conjunctions and so forth, something like this – subject, predicate, object, *but*, subject, predicate, object. Pronoun, *however*, predicate, negative, infinitive verb. *Nevertheless*, participle, accusative, subject, predicate, etc., etc., etc., for evermore. I suffered that despair. The proper remedy is to go to the nearest bar and have a drink, or to read a bit of *Comus* or *Urn-Burial*, but at that time I had no skill in weathering anticyclones, and I drove forward like a sinking steamer in a heavy sea.

When my novel had been typewritten and I read it in cold blood, I was absolutely unable to decide whether it was very good, good, medium, bad, or very bad. I could not criticize it. All I knew was that certain sentences, in the vein of the *écriture artiste*, persisted beautifully in my mind, like fine lines from a favourite poet. I loosed the brave poor thing into the world over a post-office counter. 'What chance *has* it, in the fray?' I

exclaimed. My novel had become nothing but a parcel. Thus it went in search of its fate.

The extract which follows does not contain any specific guidance on the problems and skills of writing but it is an excellent piece of composition in its own right and we are able to enjoy a good story. That is the essence. At the same time we can digest the remarks of a literary adviser who could annotate a manuscript with phrases such as 'Character delineated by a succession of rare and subtle touches.'

'Will you step this way?' said the publisher's manager, and after coasting by many shelves loaded with scores of copies of the same book laid flat in piles – to an author the most depressing sight in the world – I was ushered into the sanctum, the star-chamber, the den, the web of the spider.

I beheld the publisher, whose name is a household word wherever the English language is written for posterity. Even at that time his imprint flamed on the title pages of one or two works of a deathless nature. My manuscript lay on an occasional table by his side, and I had the curious illusion that he was posing for his photograph with my manuscript. As I glanced at it I could not help thinking that its presence there bordered on the miraculous. I had parted with it at a post office. It had been stamped, sorted, chucked into a van, whirled through the perilous traffic of London's centre, chucked out of a van, sorted again, and delivered with many other similar parcels at the publisher's. The publisher had said: 'Send this to So-and-so to read.' Then more perils by road and rail, more risks of extinction and disorientation. Then So-and-so, probably a curt man, with a palate cloyed by the sickliness of many manuscripts, and a short way with new authors, had read it or pretended to read it. Then finally the third ordeal of locomotion. And there it was, I saw it once more, safe!

We discussed the weather and new reputations. I was nervous, and I think the publisher was nervous, too. At length, in a manner mysterious and inexplicable, the talk shifted to my manuscript. The publisher permitted himself a few compliments of the guarded sort.

Arnold Bennett (1867–1931)

'But there's no money in it, you know,' he said.

'I suppose not,' I assented. ('You are an ass for assenting to that,' I said to myself.)

'I invariably lose money over new authors,' he remarked, as if I was to blame.

'You didn't lose much over Mrs——,' I replied, naming one of his notorious successes.

'Oh, *well!*' he said, 'of *course* ... But I didn't make so much as you think, perhaps. Publishing is a very funny business.' And then he added: 'Do you think your novel will succeed like Mrs——'s?'

I said that I hoped it would.

'I'll be perfectly frank with you,' the publisher exclaimed, smiling beneficently. 'My reader likes your book. I'll tell you what he says.' He took a sheet of paper that lay on the top of the manuscript and read.

I was enchanted, spellbound. The nameless literary adviser used phrases of which the following are specimens (I am recording with exactitude): 'Written with great knowledge and a good deal of insight.' 'Character delineated by a succession of rare and subtle touches.' 'Living, convincing.' 'Vigour and accuracy.' 'The style is good.'

I had no idea that publishers' readers were capable of such laudation.

The publisher read on: 'I do not think it likely to be a striking success!'

'Oh!' I murmured, shocked by this bluntness.

'There's no money in it,' the publisher repeated, firmly. 'First books are too risky ... I should like to publish it.'

'Well?' I said, and paused. I felt that he had withdrawn within himself in order to ponder upon the chances of this terrible risk. So as not to incommode him with my gaze, I examined the office, which resembled a small drawing-room rather than an office. I saw around me signed portraits of all the roaring lions on the sunny side of Grub Street.

'I'll publish it,' said the publisher, and I believe he made an honest attempt not to look like a philanthropist; however, the attempt failed. 'I'll publish it. But of course I can only give you a small royalty.'

'What royalty?' I asked.

'Five per cent – on a three-and-six-penny book.'

'Very well. Thank you!' I said.

'I'll give you fifteen per cent after the sale of five thousand copies,' he added kindly.

O ironist!

I emerged from the web of the spider triumphant, an accepted author. Exactly ten days had elapsed since I had first parted with my manuscript. Once again life was plagiarizing fiction. I could not believe that this thing was true. I simply could not believe it. 'Oh!' I reflected, incredulous. 'Something's bound to happen. It can't really come off.'

Elizabeth Bowen (1899-1973)

Victoria Glendinning produced a sensitive biography of Elizabeth Bowen, which leads the reader to a quiet literary corner – to an exchange of views between Elizabeth Bowen, Graham Greene and V.S. Pritchett published under the title *Why Do I Write?* The following extract is taken from a letter which Elizabeth Bowen sent to V.S. Pritchett. It is a small gem.

One writes *for* the ideal reader, but not about him. At least, I don't, and you don't. One writes, in so many cases, about the man or woman who would throw a crooked glance at your or my page of prose and groan: 'What is *this* about?' I doubt – though the analogy on my part may be impertinent – whether, for instance, a Proust character could or would have read Proust. Oh yes, Oriane de Guermantes might have – but with a glance up at the clock, from time to time, to see if it was time to go and dress for the ball, alternating with a light sigh: '*Ce pauvre Marcel* ...' Oh yes, and Bloch would have. But how Proust loathed Bloch. Emma Bovary would have dropped asleep over *Madame Bovary* long before she came to anything she could like. But, of course, for Flaubert that was half the pleasure – making 'uninteresting' people (by which one implies, uninterested people) interesting to himself.

John Braine (1922–1986)

John Braine published a small but most useful book called *Writing a Novel* in 1974. It is worth studying. The following extract is taken from the opening chapter 'A Writer is a Person who Writes'. As he says, it is a simple but profound truth.

Once the late Sinclair Lewis arrived at Harvard, drunk as usual (alcoholism is our main occupational disease) to talk about writing. 'Hands up, all those who want to be writers!' he yelled. Everyone's hand went up. 'Then why the hell aren't you at home writing?' he asked, and staggered off the platform.

I begin with this anecdote because it illustrates a simple but profound truth: a writer is a person who writes. You don't wait to write until you have something to write about. As long as you're of normal intelligence and all your senses are functioning (though even this isn't essential), you have all the material which you need. You don't think before you write. Writing *is* thinking, because it's the arrangement of words, and words are the only possible medium of thought.

You must never wait for inspiration before you write. It isn't that inspiration doesn't exist, but it comes only with writing. I've never met any writer who waited for inspiration. One begins to write a novel with a conscious effort, by using what I'll term – regardless of physiological accuracy – the front part of the brain.

And here I contradict myself. For it isn't possible to write about the act of creation without contradicting oneself at some stage. And if you have the capacity to create you'll understand

34

this. There must be a moment of stillness for the picture to emerge. You must see some part of the novel. It will be only a small part and it will be from any point in the novel. With me it's always the end of the novel. It isn't an idea which visits me, because that's abstract. It's a picture of something happening to somebody. It can be based on something which has happened to me or to someone else or which I've been told happened to someone else. Not that it's necessary even to be aware of its origin; it's enough that one has the picture.

But the picture won't come unless the conscious decision to write the novel is taken and a date set to begin it. And here I become even more drearily down to earth. You must now draw up a timetable and stick to it. When you'll write and what rate you'll write at are a matter of individual capacity and circumstance, but I suggest that three two-hourly sessions a week are quite enough. It is essential that you record the number of words written each session. This has a valuable psychological effect: whether you're pleased with what you've written or not, you have before you the proof that you're achieving something, that you actually are working. What prevents most first novels from being written is the sheer magnitude of the task, the writer's feeling that such a huge achievement isn't within the realm of possibility. The record of a steadily growing number of words dispels this feeling.

The amount of words which you set yourself to produce each session is for you to decide, though I would suggest a minimum of 350. All that matters is to get the words down regardless of what you feel like. Unless you're very fortunate, you won't always feel irresistibly impelled to write. And tormenting problems and apparently irrecoverable disasters come to us all: but you must write the requisite number of words at the set time even if you're half-mad with worry or your heart is breaking. There is a bonus too: once the writing is under way, everything else disappears from the mind. But this happens only if one's purpose is to write; it won't happen if one's purpose is to forget one's troubles. The primary purpose of writing is not therapeutic.

That ends the most important part of this book. If you disregard it, there's no point in reading on. If you remember it, if you

act upon my advice, then everything you need will come to you. A writer is a person who writes, a writer is a person who counts words. Even now, after having been a professional writer since 1957, I have to remind myself of this every day. With part of me I always want merely to dream, to wait to be descended upon, to be possessed and used. I have never met any professional writer who wasn't haunted by this myth. I have never met any professional writer who didn't work set hours.

Vera Brittain (1893–1970)

Vera Brittain may not qualify in some lists as one of the great writers of the twentieth century but anyone who has not read her *Testament of Youth* has an extremely moving experience ahead of them.

After the Second World War she was commissioned to produce a book under the title *On Becoming a Writer*. Almost by definition, it is a work with many pages of practical advice which are best read in full. But one example gives an idea of her approach. In the following extract she discusses the illusion that books and articles can only be written when the author is 'in the mood'.

I should not care to calculate the amount of wasted time for which this illusion must be responsible. An author who waits for the right 'mood' will soon find that 'moods' get fewer and fewer until they cease altogether. The only way to write is to write, or, as Sinclair Lewis puts it more picturesquely, 'to apply the seat of the pants to the seat of the chair'.

The writer who compels himself to sit at his desk and struggle with his natural desire to read the paper, answer his letters, do his accounts, or take up any other little job which postpones the painful necessity for thought, will eventually discover that ideas begin to arrive. The attainment of concentration simply by such external acts as sitting at a table, picking up a pen, and arranging the material for an article or chapter, is a matter of practice and with persistence always comes. Today I can go to my desk feeling tired after a journey, angry after an argument, or perturbed by some letter or telegram, and after a few

moments find the ideas coming and, under their beneficent influence, the mood of fatigue, irritation or anxiety passing away.

But the writer, as I indicated in the previous section, has one practical obligation to himself: he must take all possible steps, once he has started work, to eliminate those extraneous interruptions which persons who are not authors are so ready to inflict on him. He can create his own mood by instituting regular hours of work and performing the external acts of concentration, but he cannot maintain that mood against all comers.

Creative concentration is a mental process which may be likened to the winding of a ball of wool. As the loose skein is converted into a tight ball the winding goes faster and faster, but if the wool is snapped in the middle it must be rejoined, and the process has to begin, slowly at first, all over again. Continuity of concentration means everything to a writer. Its gathering intensity often enables him to do at least twice as much in the last hour of a morning as he did during the first.

For this reason the writer owes it to himself, and to the 'mood' (i.e. state of concentration) which he has attained by self-discipline, to institute rules that others should be asked to keep. He must establish hours in which he will refuse to answer the telephone, see callers who 'will not detain him for more than half an hour', or indulge that member of the family who drops in to borrow a book and then stays for a little chat.

Admittedly, the establishment of such rules is a matter of household routine, and is much easier for some authors than others. It can be attained more readily by men than by women, not only because the tradition still lingers that a man's work is somehow more sacred than a woman's, but because a woman, even though she be the bread-winner, is regarded as the natural consultant in domestic worries by her staff if she has one, and by her family if she has not. Much training is required before the interrupter who wants to tell her that the bathroom pipe has burst, or the milk has not come, learns to deal with these disasters by his or her own resourcefulness.

In the same way it is difficult for a young writer to get others to respect his need for prolonged freedom from disturbance.

Vera Brittain (1893-1970)

Older members of the family are apt to be amused, irritated, or sceptical; they are working so hard shopping, or sweeping, or cleaning the bath, while he is 'doing nothing'. Even if they are ambitious for him and admire his work, his elders often find it hard to resist the temptation to send a younger pair of legs to the post office, or get younger eyes to decipher a number in the telephone directory.

Any young author for whose talent some real evidence exists is well advised, during the exacting creative period of writing a book which has a reasonable chance of publication, to monopolise a corner in a temporarily empty office, or use a quiet room in the house of a sympathetic friend. If he or she can afford it, it is often best to leave the family hearth and go into some inexpensive country lodging for a few weeks. This type of isolated freedom is especially valuable to a woman, for the feminine conscience, trained by centuries of tradition, is particularly sensitive to family claims. Most women, even after years of professional work, find it difficult to sit down to a morning's writing without a preliminary domestic flurry, though for them, as for men, the early hours are usually the best.

One small, but important, piece of practical advice in conclusion. Always arrange, if you can, to finish your day's work at some point where it is easy to begin again tomorrow. If the next stage of your book is a difficult paragraph, or the opening of a recalcitrant chapter, your natural reluctance to start will waste much time. I have found myself almost unconsciously doing 'little jobs' for an hour or two in order to postpone the bad moment of beginning again. But if you know exactly what you are going to say next, you will sit down to your task with enthusiasm.

Anne Brontë (1820–1849)

Although much of our interest is in methods of work, that does not preclude the relevance and, indeed, importance of an author's aims. In a preface to what has become known as the 'second edition' of *The Tenant of Wildfell Hall*, Anne Brontë set out her object in writing the novel. She made a powerful and fascinating case and one which we can study in the context of all the novels of the gifted family.

While I acknowledge the success of the present work to have been greater than I anticipated, and the praises it has elicited from a few kind critics to have been greater than it deserved, I must also admit that from some other quarters it has been censured with an asperity which I was as little prepared to expect, and which my judgement, as well as my feelings, assures me is more bitter than just. It is scarcely the province of an author to refute the arguments of his censors and vindicate his own productions; but I may be allowed to make here a few observations with which I would have prefaced the first edition, had I foreseen the necessity of such precautions against the misapprehensions of those who would read it with a prejudiced mind or be content to judge it by a hasty glance.

My object in writing the following pages was not simply to amuse the reader; neither was it to gratify my own taste, nor yet to ingratiate myself with the press and the public: I wished to tell the truth, for truth always conveys its own moral to those who are able to receive it. But as the priceless treasure too frequently hides at the bottom of a well, it needs some courage

Anne Brontë (1820–1849)

to dive for it, especially as he that does so will be likely to incur more scorn and obloquy for the mud and water into which he has ventured to plunge, than thanks for the jewel he procures; as, in like manner, she who undertakes the cleansing of a careless bachelor's apartment will be liable to more abuse for the dust she raises than commendation for the clearance she effects. Let it not be imagined, however, that I consider myself competent to reform the errors and abuses of society, but only that I would fain contribute my humble quota towards so good an aim; and if I can gain the public ear at all, I would rather whisper a few wholesome truths therein than much soft nonsense.

As the story of 'Agnes Grey' was accused of extravagant over-colouring in those very parts that were carefully copied from the life, with a most scrupulous avoidance of all exaggeration, so, in the present work, I find myself censured for depicting *con amore*, with 'a morbid love of the coarse, if not of the brutal', those scenes which, I will venture to say, have not been more painful for the most fastidious of my critics to read than they were for me to describe. I may have gone too far; in which case I shall be careful not to trouble myself or my readers in the same way again; but when we have to do with vice and vicious characters, I maintain it is better to depict them as they really are than as they would wish to appear. To represent a bad thing in its least offensive light is, doubtless, the most agreeable course for a writer of fiction to pursue; but is it the most honest, or the safest? Is it better to reveal the snares and pitfalls of life to the young and thoughtless traveller, or to cover them with branches and flowers? Oh, reader! If there were less of this delicate concealment of facts – this whispering, 'Peace, peace,' when there is no peace, there would be less of sin and misery to the young of both sexes who are left to wring their bitter knowledge from experience.

I would not be understood to suppose that the proceedings of the unhappy scapegrace, with his few profligate companions I have here introduced, are a specimen of the common practices of society – the case is an extreme one, as I trusted none would fail to perceive; but I know that such characters do exist, and if I have warned one rash youth from following in their steps, or

prevented one thoughtless girl from falling into the very natural error of my heroine, the book has not been written in vain. But, at the same time, if any honest reader shall have derived more pain than pleasure from its perusal, and have closed the last volume with a disagreeable impression on his mind, I humbly crave his pardon, for such was far from my intention; and I will endeavour to do better another time, for I love to give innocent pleasure. Yet, be it understood, I shall not limit my ambition to this – or even to producing 'a perfect work of art': time and talents so spent, I should consider wasted and misapplied. Such humble talents as God has given me I will endeavour to put to their greatest use; if I am able to amuse, I will try to benefit too; and when I feel it my duty to speak an unpalatable truth, with the help of God, I *will* speak it, though it be to the prejudice of my name and to the detriment of my reader's immediate pleasure as well as my own.

One word more, and I have done. Respecting the author's identity, I would have it to be distinctly understood that Acton Bell is neither Currer nor Ellis Bell, and therefore let not his faults be attributed to them. As to whether the name be real or fictitious, it cannot greatly signify to those who know him only by his works. As little, I should think, can it matter whether the writer so designated is a man, or a woman, as one or two of my critics profess to have discovered. I take the imputation in good part, as a compliment to the just delineation of my female characters; and though I am bound to attribute much of the severity of my censors to this suspicion, I make no effort to refute it, because, in my own mind, I am satisfied that if a book is a good one, it is so whatever the sex of the author may be. All novels are, or should be, written for both men and women to read, and I am at a loss to conceive how a man should permit himself to write anything that would be really disgraceful to a woman, or why a woman should be censured for writing anything that would be proper and becoming for a man.

Charlotte Brontë (1816–1855)

A letter from Charlotte Brontë (signed C. Bell) to G.H. Lewes, whom we perhaps know best in his relationship with George Eliot, offers a fascinating view of the problems of writing from experience and from the imagination. A second letter written some five years later to her publisher and friend George Smith makes clear that she 'cannot write books handling the topics of the day'. For our part we can simply rejoice in her imaginative talent.

To G.H. Lewes

November 6th, 1847

Dear Sir

Your letter reached me yesterday. I beg to assure you that I appreciate fully the intention with which it was written, and I thank you sincerely both for its cheering commendation and valuable advice.

You warn me to beware of melodrama, and you exhort me to adhere to the real. When I first began to write, so impressed was I with the truth of the principles you advocate, that I determined to take Nature and Truth as my sole guides, and to follow to their very footprints; I restrained imagination, eschewed romance, repressed excitement; over-bright colouring, too, I avoided, and sought to produce something which should be soft, grave, and true.

My work (a tale in one volume) being completed, I offered it to a publisher. He said it was original, faithful to nature, but he

did not feel warranted in accepting it; such a work would not sell. I tried six publishers in succession; they all told me it was deficient in 'startling incident' and 'thrilling excitement', that it would never suit the circulating libraries, and as it was on those libraries the success of works of fiction mainly depended, they could not undertake to publish what would be overlooked there.

Jane Eyre was rather objected to at first, on the same grounds, but finally found acceptance.

I mention this to you, not with a view of pleading exemption from censure, but in order to direct your attention to the root of certain literary evils. If, in your forthcoming article in *Fraser*, you would bestow a few words of enlightenment on the public who support the circulating libraries, you might, with your powers, do some good.

You advise me, too, not to stray far from the ground of experience, as I become weak when I enter the region of fiction; and you say 'real experience is perennially interesting, and to all men'.

I feel that this also is true; but, dear sir, is not the real experience of each individual very limited? And, if a writer dwells upon that solely or principally, is he not in danger of repeating himself, and also becoming an egotist? Then, too, imagination is a strong, restless faculty, which claims to be heard and exercised: are we to be quite deaf to her cry, and insensate to her struggles? When she shows us bright pictures, are we never to look at them, and try to reproduce them? And when she is eloquent, and speaks rapidly and urgently in our ear, are we not to write to her dictation?

I shall anxiously search the next number of *Fraser* for your opinions on these points. Believe me, dear sir, yours gratefully

C. Bell

To George Smith

You must notify honestly what you think of *Villette* when you have read it. I can hardly tell you how I hunger to hear some opinion beside my own, and how I have sometimes desponded,

and almost despaired, because there was no one to whom to read a line, or of whom to ask a counsel. *Jane Eyre* was not written under such circumstances, nor were two-thirds of *Shirley*. I got so miserable about it, I could bear no allusion to the book. It is not finished yet; but now I hope. As to the anonymous publication, I have this to say: If the withholding of the author's name should tend materially to injure the publisher's interest, to interfere with booksellers' orders, etc., I would not press the point; but if no such detriment is contingent I should be much thankful for the sheltering shadow of an incognito. I seem to dread the advertisements – the large-lettered 'Currer Bell's New Novel', or 'New Work by the author of *Jane Eyre*'. These, however, I feel well enough, are the transcendentalisms of a retired wretch; so you must speak frankly ... I shall be glad to see *Colonel Esmond*. My objection to the second volume lay here: I thought it contained decidedly too much history – too little story.

You will see that *Villette* touches on no matter of public interest. I cannot write books handling the topics of the day; it is of no use trying. Nor can I write a book for its moral. Nor can I take up a philanthropic scheme, though I honour philanthropy; and voluntarily and sincerely veil my face before such a mighty subject as that handled in Mrs Beecher Stowe's work, *Uncle Tom's Cabin*. To manage these great matters rightly they must be long and practically studied – their bearings known intimately, and their evils felt genuinely; they must not be taken up as a business matter and a trading speculation. I doubt not Mrs Stowe had felt the iron of slavery enter into her heart, from childhood upwards, long before she ever thought of writing books. The feeling throughout her work is sincere and not got up. Remember to be an honest critic of *Villette*, and tell Mr Williams to be unsparing: not that I am likely to alter anything, but I want to know his impressions and yours.

John Buchan (1873–1940)

Early in his memoirs, *Memory: Hold the Door*, John Buchan referred to his attempts at writing and overcoming the problem of his 'style'. It is revealing, but later remarks enable us to understand something about a master storyteller. It may be that today our impressions of Buchan are overlaid by another master – Alfred Hitchcock – with the superb *The Thirty-Nine Steps*. What a story that is – the train crossing the Forth Bridge must be part of the national memory.

Meantime I was trying to teach myself to write. Having for years wallowed and floated in the ocean of letters I now tried to learn to swim. My attempts were chiefly flatulent little essays and homilies and limp short stories. My models were the people who specialized in style – Walter Pater and Stevenson principally; but my uncle, my father's youngest brother, was a great lover of French literature, and under his guidance I became an earnest student of Flaubert and Maupassant. There was also Kipling, then a rising star in the firmament, but he interested me more because of his matter than his manner. The consequence of those diverse masters was that I developed a slightly meretricious and 'precious' style, stiff-jointed, heavily brocaded, and loaded with philsophical terms. It took me years to supple it. But those imitative exercises did me good in the long run, for they taught me to be circumspect about structure and rhythm and fastidious about words. My performance, heaven knows, was faulty enough, but the intention was sound.

I wrote copiously, but I also read widely in English and French

literature. Certain blind spots I discovered which alas! have remained blind. I had no taste for most of the minor Elizabethans or the Restoration dramatists. I thought the eighteenth-century novelists on the whole over-valued. Only a little of Shelley pleased me, and, though I revered Emily Brontë, I found it impossible to read Charlotte. While I revelled in Alexandre Dumas I could not rank him high. With Carlyle I was easily satiated. I think my chief admiration, so far as style was concerned, was for John Henry Newman and T.H. Huxley.

I was beginning to deserve the name of man of letters. As an author I was a link with the past, for in my extreme youth in the nineties I had contributed to the old *Yellow Book*. As an impecunious undergraduate I read manuscripts for John Lane, who was a good friend to me, and had the privilege of accepting Arnold Bennett's first book, *A Man from the North*. Then for a little my literary activities flagged, but in the post-war years I was responsible for a good deal of military history – the story of my family regiment, the Royal Scots Fusiliers; a record of the doings of the South African Infantry Brigade in France; and a memoir of my friends, the Grenfell twins, Francis and Riversdale, who fell in the first year of war. Meantime I had become a copious romancer. I suppose I was a natural story-teller, the kind of man who for the sake of his yarns would in prehistoric days have been given a seat by the fire and a special chunk of mammoth. I was always telling myself stories when I had nothing else to do – or rather, being told stories, for they seemed to work themselves out independently. I generally thought of a character or two, and then of a set of incidents, and the question was how my people would behave. They had the knack of just squeezing out of unpleasant places and of bringing their doings to a rousing climax.

I was especially fascinated by the notion of hurried journeys. In the great romances of literature they provide some of the chief dramatic moments, and since the theme is common to Homer and the penny reciter it must appeal to a very ancient instinct in human nature. We live our lives under the twin categories of time and space, and when the two come into conflict we get the great moment. Whether failure or success is the result, life is

sharpened, intensified, idealized. A long journey, even with the most lofty purpose, may be a dull thing to read of if it is made at leisure; but a hundred yards may be a breathless business if only a few seconds are granted to complete it. For then it becomes a sporting event, a race; and the interest which makes millions read of the Derby is the same, in a grosser form, as when we follow an expedition straining to relieve a beleaguered fort, or a man fleeting to a sanctuary with the avenger behind him.

In my undergraduate days I had tried my hand at historical novels, and had then some ambition to write fiction in the grand manner, by interpreting and clarifying a large piece of life. This ambition waned and, apart from a few short stories, I let fiction alone until 1910, when, being appalled as a publisher by the dullness of most boys' books, I thought I would attempt one of my own, based on my African experience. The result was *Prester John*, which has since become a school-reader in many languages. Early in 1914 I wrote *Salute to Adventurers*, the fruit of my enthusiasm for American history. In that book I described places in Virginia which I had never seen, and I was amazed, when I visited them later, to find how accurate had been my guesses.

Then, while pinned to my bed during the first months of war and compelled to keep my mind off too tragic realities, I gave myself to stories of adventure. I invented a young South African called Richard Hannay, who had traits copied from my friends, and I amused myself with considering what he would do in various emergencies. In *The Thirty-Nine Steps* he was spy-hunting in Britain; in *Greenmantle* he was on a mission to the East; and in *Mr Standfast*, published in 1919, he was busy in Scotland and France. The first had an immediate success, and, since that kind of thing seemed to amuse my friends in the trenches, I was encouraged to continue. I gave Hannay certain companions – Peter Pienaar, a Dutch hunter; Sandy Arbuthnot, who was reminiscent of Aubrey Herbert; and an American gentleman, Mr John S. Blenkiron. Soon these people became so real to me that I had to keep a constant eye on their doings. They slowly aged in my hands, and the tale of their more recent deeds will be found in *The Three Hostages*, *The Courts of the Morning* and *The Island of Sheep*.

I added others to my group of musketeers. There was Dickson McCunn, the retired grocer, and his ragamuffin boys from the Gorbals, whose saga is written in *Huntingtower, Castle Gay* and *The House of the Four Winds*. There was Sir Edward Leithen, an eminent lawyer, who is protagonist or narrator in *The Power House, John Macnab, The Dancing Floor* and *The Gap in the Curtain*; and in his particular group were the politician, Lord Lamancha, and Sir Archibald Roylance, airman, ornithologist and Scots laird. It was huge fun playing with my puppets, and to me they soon became very real flesh and blood. I never consciously invented with a pen in my hand; I waited until the story had told itself and then wrote it down, and, since it was already a finished thing, I wrote it fast. The books had a wide sale, both in English and in translations, and I always felt a little ashamed that profit should accrue from what had given me so much amusement. I had no purpose in such writing except to please myself, and even if my books had not found a single reader I would have felt amply repaid.

Anthony Burgess (1917–1993)

Anthony Burgess wrote an autobiography which he described as 'confessions'. It is much concerned with his career as a writer but there are few succinct and quotable passages. They have to be read in context. However, the paragraphs which follow do offer very practical comment on the detail of writing a novel such as the choice of title and the need for a 'scaffolding' in a long work.

The question is always arising – how important is the title of a novel? Not very, I think; I would be satisfied with something like *Novel Number Twenty*, on the analogy of symphonies. There is no copyright on titles, and there is always the danger of accidental duplication, even triplication: there are three books called *No Laughing Matter*. I have already mentioned my novel *One Hand Clapping* and its eclipse by a biography of John Middleton Murry under the same name. Titles are a great nuisance. I think of *Earthly Powers* as *The Prince of the Powers of the Air*. Korda's title does not mean anything, though critics bravely tried to show how apt it was.

In the great days of the novel, meaning of serialization, length, sometimes inordinate, was imposed by publishing procedure. Dickens's novels show a technique of accumulation, essentially picaresque: structure is not important. Write a long novel today – one, say, of 650 printed pages – and you have to erect a scaffolding in advance of setting down the first word. The structure can be arithmological in the medieval manner, meaning that the

number of its parts has a symbolic significance. The number of chapters I proposed matched the number of years of the man telling the story. He celebrates his eighty-first birthday in the first chapter: let then the total of chapters be eighty-one. 81 is 3 × 3 × 3 × 3. I spelt this out at the beginning. 'I looked at the gilt Maltese clock on the wall of the stairwell. It said nearly three ... We were three steps from the bottom ... I minced the three treads down to the hall ... Three steps away ... lay a fresh batch of felicitations brought by Cable and Wireless motor cyclists.' It was only when proofs came from the printer that I saw that I had miscounted; there are eighty-two chapters. It did not, does not, matter greatly. Joyce said of *Ulysses* that, when his eighteen episodes had marched across their Homeric bridges, those structures could be blown to the moon. And, when you come to think about it, a man who has celebrated his eighty-first birthday has to be in his eighty-second year.

Burgess is known for his large vocabulary and, indeed, he might be regarded as pretentious in his use of words which are seldom if ever found in other writing. There is an amusing account in his autobiography of an interview he conducted with Graham Greene.

I went to Antibes to interview Graham Greene for the *Observer*. I limped up the hill to Monte Carlo station, caught the stopping train – Cap d'Ail, Eze, Beaulieu-sur-Mer, Nice, St Laurent-du-var, Cros-de-Cagnes, Cagnes-sur-Mer, Villeneuve-Loubet, Biot. Greene's apartment was only a hundred yards up the hill from Antibes station, but I had to take a taxi. Greene, in his middle seventies, living with a *chic* French *bourgeoise* whose leg was not broken, was fitter than I at sixty-three. We talked and I bought him lunch. He seemed pleased at what he termed my suffering venerability and, when I sent him the typescript of our colloquy, accepted that this was a true account. I did not, of course, use a tape recorder. Later he contributed to 'Sayings of the Week' in the *Observer* the following remark: 'Burgess put words in my mouth which I had to look up in the dictionary.' This turned me against him.

Lewis Carroll (1832–1898)

The experience of writing can lead to other experiences, as Lewis Carroll discovered when he found himself in the witness box of a magistrate's court. It provided him with an amusing anecdote.

His own small adventure goes back to 1886 when a facsimile of the original manuscript of *Alice's Adventures Underground* (the work from which *Alice in Wonderland* was developed) was published. Writing under his real name of C.L. Dodgson, he sent a letter to Alice Liddell, the girl who inspired the great work, who by that time was a married woman, Mrs Hargreaves. The reference to hospitals at the beginning of the letter concerns the intention that the profits should go to children's hospitals.

CHRIST CHURCH, OXFORD,
November 11, 1886.

My dear Mrs Hargreaves

Many thanks for your permission to insert 'Hospitals' in the Preface to your book. I have had almost as many adventures in getting that unfortunate facsimile finished, *above* ground, as your namesake had *under* it!

First, the zincographer in London, recommended to me for photographing the book, page by page, and preparing the zinc-blocks, declined to undertake it unless I would entrust the book to *him*, which I entirely refused to do. I felt that it was only due to you, in return for your great kindness in lending so unique a book, to be scrupulous in not letting it be even *touched* by the workmen's hands. In vain I offered to come and reside in London

with the book, and to attend daily in the studio, to place it in position to be photographed, and turn over the pages as required. He said that could not be done because 'other authors' works were being photographed there, which must on no account be seen by the public'. I undertook not to look at *anything* but my own book; but it was no use: we could not come to terms.

Then — recommended me a certain Mr X—, an excellent photographer, but in so small a way of business that I should have to *prepay* him, bit by bit, for the zinc-blocks: and *he* was willing to come to Oxford, and do it here. So it was all done in my studio, I remaining in waiting all the time, to turn over the pages.

But I daresay I have told you so much of the story already.

Mr X— did a first-rate set of negatives, and took them away with him to get the zinc-blocks made. These he delivered pretty regularly at first, and there seemed to be every prospect of getting the book out by Christmas, 1885.

On October 18, 1885, I sent your book to Mrs Liddell, who had told me your sisters were going to visit you and would take it with them. I trust it reached you safely?

Soon after this – I having prepaid for the whole of the zinc-blocks – the supply suddenly ceased, while twenty-two pages were still due, and Mr X— disappeared!

My belief is that he was in hiding from his creditors. We sought him in vain. So things went on for months. At one time I thought of employing a detective to find him, but was assured that 'all detectives are scoundrels'. The alternative seemed to be to ask you to lend the book again, and get the missing pages rephotographed. But I was most unwilling to rob you of it again, and also afraid of the risk of loss of the book, if sent by post – for even 'registered post' does not seem *absolutely* safe.

In April he called at Macmillan's and left *eight* blocks, and again vanished into obscurity.

This left us with fourteen pages (dotted up and down the book) still missing. I waited awhile longer, and then put the thing into the hands of a solicitor, who soon found the man, but could get nothing but promises from him. 'You will never get

the blocks,' said the solicitor, 'unless you frighten him by a summons before a magistrate.' To this at last I unwillingly consented: the summons had to be taken out at — (that is where this aggravating man is living), and this entailed two journeys from Eastbourne – one to get the summons (my *personal* presence being necessary), and the other to attend in court with the solicitor on the day fixed for hearing the case. The defendant didn't appear; so the magistrate said he would take the case in his absence. Then I had the new and exciting experience of being put into the witness box, and sworn, and cross-examined by a rather savage magistrate's clerk, who seemed to think that, if he only bullied me enough, he would soon catch me out in a falsehood! I had to give the magistrate a little lecture on photo-zincography, and the poor man declared the case was so complicated he must adjourn it for another week. But this time, in order to secure the presence of our slippery defendant, he issued a warrant for his apprehension, and the constable had orders to take him into custody and lodge him in prison, the night before the day when the case was to come on. The news of *this* effectually frightened him, and he delivered up the fourteen negatives (he hadn't done the blocks) before the fatal day arrived. I was rejoiced to get them, even though it entailed the paying a second time for getting the fourteen blocks done, and withdrew the action.

The fourteen blocks were quickly done and put into the printer's hands; and all is going on smoothly at last: and I quite hope to have the book completed, and to be able to send you a very special copy (bound in white vellum, unless you would prefer some other style of binding) by the end of the month.

<div align="center">

Believe me always,
Sincerely yours,
C.L. Dodgson
</div>

Willa Cather (1876–1947)

Willa Cather opened up the American Midwest for many readers of her novels. A tireless researcher in Lincoln, Nebraska, has gathered together in one volume her interviews, speeches and letters, and it contains numerous accounts of her approach to her work. The full text of an interview given in 1915 makes instructive reading.

The Vision of a Successful Fiction Writer

by Ethel M. Hockett

For the benefit of the many young people who have literary ambitions and to whom the pinnacle of success attained by this Nebraska novelist appears as the most desirable thing to be gained in the world, Miss [Willa] Cather was persuaded to give the time from her busy hours in Lincoln of living over school days with old acquaintances, to give a number of valuable suggestions from her rich fund of experiences.

'The business of writing is a personal problem and must be worked out in an individual way,' said Miss Cather. 'A great many people ambitious to write, fall by the wayside, but if they are the discourageable kind it is better that they drop out. No beginner knows what he has to go through with or he would never begin.

'When I was in college and immediately after graduation, I did newspaper work. I found that newspaper writing did a great

deal of good for me in working off the purple flurry of my early writing. Every young writer has to work off the "fine writing" stage. It was a painful period in which I overcame my florid, exaggerated, foamy-at-the-mouth, adjective-spree period. I knew even then it was a crime to write like I did, but I had to get the adjectives and the youthful fervor worked off.

'I believe every young writer must write whole books of extravagant language to get it out. It is agony to be smothered in your own florescence, and to be forced to dump great carloads of your posies out in the road before you find one posy that will fit in the right place. But it must be done, just as a great singer must sacrifice so many lovely lyrical things in herself to be a great interpreter.'

Miss Cather is pre-eminently qualified to give advice to young writers, not only from her own experiences in traveling the road which led her to literary success, but because she has had opportunities to study the writings of others from the viewpoint of a buyer.

After she had worked on Lincoln newspapers, one of which was edited by Mrs Sarah Harris Dorris whom she visited last week, Miss Cather went to Pittsburgh where she worked on a newspaper for several years. She tired of newspaper work and became the head of the English Department in the Allegheny High School in Pittsburgh where she remained three years. It was while teaching that she wrote the verses which appeared in the book *April Twilights*, and the short stories which made up the book *The Troll Garden*. These stories and verses were published by McClure's, most of them appearing in the *McClure's* magazine. A year after their publication, Mr McClure went to Pittsburgh and offered Miss Cather a position on his magazine which she accepted. Exceptional opportunities were shortly afterward afforded Miss Cather, as Miss Ida Tarbell, Mr Philipps, Mr Baker and several other prominent writers left *McClure's* and bought the *American* magazine. Within two years, therefore, Miss Cather was managing editor of *McClure's*. She held that position for six years. Although life as managing editor was stimulating, affording Miss Cather opportunity for travel abroad and in this country, she could do no creative work, so left in order to produce the stories

pent up in her mind. She says the material used in her stories was all collected before she was twenty years old.

'Aside from the fact that my duties occupied much of my time, when you are buying other writers' stuff, it simply isn't the graceful thing to do to do any writing yourself,' she said.

Leaving *McClure's*, Miss Cather moved to a suburb of New York and wrote *Alexander's Bridge* and *The Bohemian Girl*. She went to Arizona for the summer and returned to New York to write *O Pioneers!*

Miss Cather's books all have western settings, in Nebraska, Colorado and Arizona, and she spends part of each year in the west reviewing the early impressions and stories which go to make up her books.

'No one without a good ear can write good fiction,' was a surprising statement made by Miss Cather. 'It is an essential to good writing to be sensitive to the beauty of language and speech, and to be able to catch the tone, phrase, length of syllables, enunciation, etc., of persons of all types that cross a writer's path. The successful writer must also be sensitive to accomplishment in others.

'Writers have such hard times if they just have rules and theories. Things that make for integrity in writing are quite as unnameable as the things that make the difference between an artist and a near-artist in music. And it is the longest distance in the world between the artist and the near-artist.

'It is up to the writer and no one else. He must spend thousands of uncounted hours at work. He must strive untiringly while others eat and sleep and play. Some people are more gifted than others, but it takes brains in the most gifted to make a success. Writing has to be gone at like any other trade. One trouble is that people aren't honest with themselves; they are awfully unfrank about sizing themselves up. They have such queer ways of keeping half-done things stored by and inconsistently saying to themselves that they will finish them after a while, and never admitting they shrink from that work because they are not qualified for it.

'One trouble with young writers is that they imitate too much, often unconsciously,' said Miss Cather. 'Ninety-nine out

of every hundred stories received by magazines are imitations of some former success. This is a natural mistake for young people to make. The girl or boy of twenty-four or twenty-five is not strong enough to digest experiences in the raw, therefore they take them predigested from things they read. That is why young writing does not as a rule amount to much. These young writers can sometimes give cries of pain and of rapture and even the cry from a baby sometimes moves.

'Young writers must care vitally, fiercely, absurdly about the trickery and the arrangement of words, the beauty and power of phrases. But they must go on and on until they get more out of life itself than out of anything written. When a writer reaches the stage where a tramp on a rail pile in Arizona fills him with as many thrills as the greatest novel ever written, he has well begun on his career.

'William Jones once expressed this idea well when he told me great minds like Balzac or Shakespeare got thousands and thousands more of distinct impressions and mental pictures in every single day of life than the average man got in all his life.

'I can remember when Kipling's *Jungle Tales* meant more to me than a tragic wreck or big fire in the city. But I passed through that stage. If I hadn't again grasped the thrills of life, I would have been too literary and academic to ever write anything worth while.

'There are a great many young people who like good literature and go to work on a magazine or newspaper with the idea of reforming it and showing it what to print. It is all right to have ideas, but they should be kept locked up, for the beginner should do the things in his employer's way. If his ideas are worth anything, they will come out untarnished; if they are not, they will get mixed up with crooked things and he will be disillusioned and soured.

'I have seen a great many western girls and boys come to New York and make a living around magazines and newspapers, and many rise to very good positions. They must be wide awake, adaptable and not afraid to work. A beginner can learn a lot about magazine requirements and style by proof-reading, or doing other jobs other than writing the leading editorials. Every magazine has its individual style.

Willa Cather (1876–1947)

'Most people have the idea that magazines are like universities – existing to pass on the merits of productions. They think if stories and articles are accepted, it is an honor, and if they are refused, it is a disgrace. They do not realize the magazine is in the business of buying and selling.

'The truth is that many good stories are turned down every day in a magazine office. If the editor has twenty-five children's stories in the safe and a twenty-sixth good children's story comes in with one poor adventure story, he must buy the poor adventure story and return the good children's story. It is just like being overstocked in anything else. The magazine editor must have variety, and it is sometimes maddening the way the stories come in in flocks of like kinds.

'The young writer must learn to deal with subjects he really knows about. No matter how commonplace a subject may be, if it is one with which the author is thoroughly familiar it makes a much better story than the purely imaginational.

'Imagination, which is a quality writers must have, does not mean the ability to weave pretty stories out of nothing. In the right sense, imagination is a response to what is going on – a sensitiveness to which outside things appeal. It is a composition of sympathy and observation.'

Miss Cather makes the comparison between learning to write and learning to play the piano. If there is no talent to begin with, the struggler can never become an artist. But no matter what talent there is, the writer must spend hours and years of practice in writing just as the musician must drudge at his scales.

Miss Cather laughed merrily as she said that her old friends in Lincoln insist on dragging up what she pleased to call her 'shady past', and reminding her of her rhetorical and reformative flights of her youth. It was recalled by one friend that she led the last cane rush in the university, that she wore her hair cropped short and a stiff hat and that the boys among whom she was very popular, called her 'Billy'. Miss Cather graduated from the University of Nebraska in 1895.

Lincoln Daily Star, 24 October 1915.

Agatha Christie (1890–1976)

Agatha Christie's autobiography is a great pleasure to read. There is the charming account of her late Victorian childhood, the descriptions of her travels with her archaeologist second husband, Max Mallowan, and throughout the book, many references to her career as a writer and what it required. Here are two such references.

It was while I was working in the dispensary that I first conceived the idea of writing a detective story. The idea had remained in my mind since Madge's earlier challenge – and my present work seemed to offer a favourable opportunity. Unlike nursing, where there always was something to do, dispensing consisted of slack or busy periods. Sometimes I would be on duty alone in the afternoon with hardly anything to do but sit about. Having seen that the stock bottles were full and attended to, one was at liberty to do anything one pleased except leave the dispensary.

I began considering what kind of a detective story I could write. Since I was surrounded by poisons, perhaps it was natural that death by poisoning should be the method I selected. I settled on one fact which seemed to me to have possibilities. I toyed with the idea, liked it, and finally accepted it. Then I went on to the dramatis personae. Who should be poisoned? Who would poison him or her? When? Where? How? Why? And all the rest of it. It would have to be very much of an *intime* murder, owing to the particular way it was done; it would have to be all in the family, so to speak. There would naturally have to be a detective. At that

date I was well steeped in the Sherlock Holmes tradition. So I considered detectives. Not like Sherlock Holmes, of course: I must invent one of my own, and he would also have a friend as a kind of butt or stooge – that would not be too difficult. I returned to thoughts of my other characters. Who was to be murdered? A husband could murder his wife – that seemed to be the most usual kind of murder. I could, of course, have a very *unusual* kind of murder for a very *unusual* motive, but that did not appeal to me artistically. The whole point of a *good* detective story was that it must be somebody obvious but at the same time, for some reason, you would then find that it was *not* obvious, that he could not possibly have done it. Though really, of course, he *had* done it. At that point I got confused, and went away and made up a couple of bottles of extra hypochlorous lotion so that I should be fairly free of work the next day.

I went on playing with my idea for some time. Bits of it began to grow. I saw the murderer now. He would have to be rather sinister-looking. He would have a black beard – that appeared to me at that time very sinister. There were some acquaintances who had recently come to live near us – the husband had a black beard, and he had a wife who was older than himself and who was very rich. Yes, I thought, that might do as a basis. I considered it at some length. It might do, but it was not entirely satisfactory. The man in question would, I was sure, never murder anybody. I took my mind away from them, and decided once and for all that it is no good thinking about real people – you must create your characters for yourself. Someone you see in a tram or a train or a restaurant is a possible starting point, because you can make up something for yourself about them.

Sure enough, next day, when I was sitting in a tram, I saw just what I wanted: *a man with a black beard, sitting next to an elderly lady who was chattering like a magpie.* I didn't think I'd have *her*, but I thought *he* would do admirably. Sitting a little way beyond them was a large, hearty woman, talking loudly about spring bulbs. I liked the look of her too. Perhaps I could incorporate her? I took them all three off the tram with me to work upon – and walked up Barton Road muttering to myself just as in the days of the Kittens.

Very soon I had a sketchy picture of some of my people. There was the hearty woman – I even knew her name: Evelyn. She could be a poor relation or a lady gardener or a companion – perhaps a lady housekeeper? Anyway, I was going to have her. Then there was the man with the black beard whom I still felt I didn't know much about, except for his beard, which wasn't really enough – or *was* it enough? Yes, perhaps it was; because you would be seeing this man from the *outside* – so you could only see what he liked to show – not as he really was: that ought to be a clue in itself. The elderly wife would be murdered more for her money than her character, so she didn't matter very much. I now began adding more characters rapidly. A son? A daughter? Possibly a nephew? You had to have a good many suspects. The family was coming along nicely.

I left it to develop, and turned my attention to the detective. Who could I have as a detective? I reviewed such detectives as I had met and admired in books. There was Sherlock Holmes, the one and only – I should never be able to emulate *him*. There was Arsene Lupin – was he a criminal or a detective? Anyway, not my kind. There was the young journalist Rouletabille in *The Mystery of the Yellow Room* – that was the *sort* of person whom I would like to invent: someone who hadn't been used before. Who could I have? A schoolboy? Rather difficult. A scientist? What did I know of scientists? Then I remembered our Belgian refugees. We had quite a colony of Belgian refugees living in the parish of Tor. Everyone had been bursting with loving kindness and sympathy when they arrived. People had stocked houses with furniture for them to live in, had done everything they could to make them comfortable. There had been the usual reaction later, when the refugees had not seemed to be sufficiently grateful for what had been done for them, and complained of this and that. The fact that the poor things were bewildered and in a strange country was not sufficiently appreciated. A good many of them were suspicious peasants, and the last thing they wanted was to be asked out to tea or have people drop in upon them; they wanted to be left alone, to be able to keep to themselves; they wanted to save money, to dig their garden and to manure it in their own particular and intimate way.

Agatha Christie (1890–1976)

Why not make my detective a Belgian? I thought. There were all types of refugees. How about a refugee police officer? A retired police officer. Not too young a one. What a mistake I made there. The result is that my fictional detective must really be well over a hundred by now.

Anyway, I settled on a Belgian detective. I allowed him slowly to grow into his part. He should have been an inspector, so that he would have a certain knowledge of crime. He would be meticulous, very tidy, I thought to myself, as I cleared away a good many untidy odds and ends in my own bedroom. A tidy little man. I could see him as a tidy little man, always arranging things, liking things in pairs, liking things square instead of round. And he should be very brainy – he should have little grey cells of the mind – that was a good phrase: I must remember that – yes, he would have little grey cells. He would have rather a grand name – one of those names that Sherlock Holmes and his family had. Who was it his brother had been? Mycroft Holmes.

How about calling my little man Hercules? He would be a small man – Hercules: a good name. His last name was more difficult. I don't know why I settled on the name Poirot, whether it just came into my head or whether I saw it in some newspaper or written on something – anyway it came. It went well not with Hercules but Hercule – Hercule Poirot. That was all right – settled, thank goodness.

Now I must get names for the others – but that was less important. Alfred Inglethorpe – that might do: it would go well with the black beard. I added some more characters. A husband and wife – attractive – estranged from each other. Now for all the ramifications – the false clues. Like all young writers, I was trying to put far too much plot into one book. I had too many false clues – so many things to unravel that it might make the whole thing not only more difficult to solve, but more difficult to read.

In leisure moments, bits of my detective story rattled about in my head. I had the beginning all settled, and the end arranged, but there were difficult gaps in between. I had Hercule Poirot involved in a natural and plausible way. But there had to be

more reasons why other people were involved. It was still all in a tangle.

It made me absent-minded at home. My mother was continually asking why I didn't answer questions or didn't answer them properly. I knotted Grannie's pattern wrong more than once; I forgot to do a lot of the things that I was supposed to do; and I sent several letters to the wrong addresses. However, the time came when I felt I could at last begin to write. I told mother what I was going to do. Mother had the usual complete faith that her daughters could do anything.

'Oh!' she said. 'A detective story? That will be a nice change for you, won't it? You'd better start.'

It wasn't easy to snatch much time, but I managed. I had the old typewriter still – the one that had belonged to Madge – and I battered away on that, after I had written a first draft in longhand. I typed out each chapter as I finished it. My handwriting was better in those days and my longhand was readable. I was excited by my new effort. Up to a point I enjoyed it. But I got very tired, and I also got cross. Writing has that effect, I find. Also, as I began to be enmeshed in the middle part of the book, the complications got the better of me instead of my being the master of them. It was then that my mother made a good suggestion.

'How far have you got?' she asked.

'Oh, I think about halfway through.'

'Well, I think if you really want to finish it you'll have to do so when you take your holidays.'

'Well, I did mean to go on with it then.'

'Yes, but I think you should go away from home for your holiday, and write with nothing to disturb you.'

I thought about it. A fortnight quite undisturbed. It *would* be rather wonderful.

'Where would you like to go?' asked my mother. 'Dartmoor?'

'Yes,' I said, entranced. 'Dartmoor – that is exactly it.'

So to Dartmoor I went. I booked myself a room in the Moorland Hotel at Hay Tor. It was a large, dreary hotel with plenty of rooms. There were few people staying there. I don't think I spoke to any of them – it would have taken my mind

away from what I was doing. I used to write laboriously all morning till my hand ached. Then I would have lunch, reading a book. Afterwards I would go out for a good walk on the moor, perhaps for a couple of hours. I think I learnt to love the moor in those days. I loved the tors and the heather and all the wild part of it away from the roads. Everybody who went there – and of course there were not many in wartime – would be clustering round Hay Tor itself, but I left Hay Tor severely alone and struck out on my own across country. As I walked I muttered to myself, enacting the chapter that I was next going to write; speaking as John to Mary, and as Mary to John; as Evelyn to her employer, and so on. I became quite excited by this. I would come home, have dinner, fall into bed and sleep for about twelve hours. Then I would get up and write passionately again all morning.

I finished the last half of the book, or as near as not, during my fortnight's holiday. Of course that was not the end. I then had to rewrite a great part of it – mostly the over-complicated middle. But in the end it was finished and I was reasonably satisfied with it. That is to say it was roughly as I had intended it to be. It could be much better, I saw that, but I didn't see just how *I* could make it better, so I had to leave it as it was. I rewrote some very stilted chapters between Mary and her husband John who were estranged for some foolish reason, but whom I was determined to force together again at the end so as to make a kind of love interest. I myself always found the love interest a terrible bore in detective stories. Love, I felt, belonged to romantic stories. To force a love motif into what should be a scientific process went much against the grain. However, at that period detective stories always had to have a love interest – so there it was. I did my best with John and Mary, but they were poor creatures. Then I got it properly typed by somebody, and having finally decided I could do no more to it, I sent it off to a publisher – Hodder and Stoughton – who returned it. It was a plain refusal, with no frills on it. I was not surprised – I hadn't expected success – but I bundled it off to another publisher.

We are all the same people as we were at three, six, ten or twenty years old. More noticeably so, perhaps, at six or seven, because

we were not pretending so much then, whereas at twenty we put on a show of being someone else, of being in the mode of the moment. If there is an intellectual fashion, you become an intellectual; if girls are fluffy and frivolous, you are fluffy and frivolous. As life goes on, however, it becomes tiring to keep up the character you invented for yourself, and so you relapse into individuality and become more like yourself every day. This is sometimes disconcerting for those around you, but a great relief to the person concerned.

I wonder if the same holds good for writing. Certainly, when you begin to write, you are usually in the throes of admiration for some writer, and, whether you will or no, you cannot help copying their style. Often it is not a style that suits you, and so you write badly. But as time goes on you are less influenced by admiration. You still admire certain writers, you may even wish you could write like them, but you know quite well that you can't. Presumably, you have learned literary humility. If I could write like Elizabeth Bowen, Muriel Spark or Graham Greene, I should jump to high heaven with delight, but I know that I can't, and it would never occur to me to attempt to copy them. I have learned that I am *me*, that I can do the things that, as one might put it, *me* can do, but I cannot do the things that *me* would like to do. As the Bible says, 'Who by taking thought can add one cubit to his stature?'

Joseph Conrad (1857–1924)

The ability to write well in a foreign language is rare enough. Conrad's achievement was amazing, as he developed in the last years of the nineteenth century into one of the outstanding men of letters writing in English. His published letters show how much he treasured his exchanges with, for example, the rising Galsworthy or his contemporary H.G. Wells. Quiller-Couch was an established figure when he wrote to Conrad in 1897. The first extract is from Conrad's response. The next letter was written to Galsworthy in 1901 when the apprentice was a qualified master and both reveal much of the man.

To A.T. Quiller-Couch

23rd Dec. 1897.
Stanford-le-Hope
Essex

My dear Sir

The best way in which I could prove to you how much I appreciate your letter is to answer it at once. It has reached me an hour ago – and it has made me very happy on this frosty morning.

To a man who has steadily pursued your literary work over the dismal ocean of printed matter your letter is of immense significance. It is a sign that endeavour has come somewhere within sight of achievement, that the thought has cast its shadow upon the wall of the cavern and the discriminating eyes of a fellow

captive have seen it pass, wavering and dim, before vanishing for ever. The difficulty is in justifying one's work to oneself. One quarrels bitterly with one's own thoughts – then, perhaps, a friend speaks, and for a time all is peace. And yours is, distinctly, a friend's voice.

Writing in a solitude almost as great as that of the ship at sea the great living crowd outside is somehow forgotten; just as on a long, long passage the existence of continents peopled by men seems to pass out of the domain of facts and becomes, so to speak, a theoristical belief. Only a small group of human beings – a few friends, relations – remain to the seaman always distinct, indubitable, the only ones who matter. And so to the solitary writer. As he writes he thinks only of a small knot of men – three or four perhaps – the only ones who matter. He asks himself: will this one read what I am writing – will that other one? Will Q read these pages? And behold! Q has read the pages. Not only has he read the pages but he writes about them! It is like seeing unexpectedly a friend's face in the crowd at the dock head after a two years' voyage ending with four months at sea.

Twenty years of life, six months of scribbling and a lot of fist-gnawing and hair tearing went to the making of that book. If I could afford it I would never write any more – not because I think the book good, but because it is what it is. It does not belong to the writing period of my life. It belongs to the time when I also went in and out of the Channel and got my bread from the sea, when I loved it and cursed it. *Odi et amo* – what does the fellow say? – I was always a deplorable schoolboy. But I don't hate it now. It has the glamour of lost love, the incomparable perfection of a woman who has been loved and has died – the splendour of youth. *Tempi passati*. I need not tell you how delighted I was to hear of the forthcoming *causerie* in the P.M. Mag: you will understand my feeling better if I confess to you that it has been my desire to do for seamen what Millet (if I dare pronounce the name of that great man and good artist in this connection) has done for peasants. Of course the ambition is honourable but I am well aware that it may provoke a smile. Still? I am sure, if you smile it will be with indulgence and sympathy. I am concerned for the men – and for the men only.

It is a great relief and a great pleasure to know you've taken them up – for it is not to dismiss them at once as 'brutes and ruffians'. (*vide* reviews)

The only unkind passage in your letter is that sentence about ('needs no answer'). There is no room now to explain to you what a shock it has given me. And I even yet do not know what you meant exactly. Perhaps you did not want an answer? However, as Belfast shouted before leaping: 'Here goes!' and if you once open the envelope you will no doubt read to the end – unless you are made of very stern stuff indeed.

Believe me, dear Sir, very gratefully and faithfully yours
Jph Conrad

To John Galsworthy

[Pent Farm]
11th Nov. 1901.

Dearest Jack

I didn't write about the book before, first because Jess had it – and she reads slowly – and then I had at last some proofs of mine a whole batch which it took me several days to correct. Nevertheless I've read the book twice – watching the effect of it impersonally during the second reading – trying to ponder upon its reception by the public and discover the grounds of *general* success – or the reverse.

There is a certain caution of touch which will militate against popularity. After all to please the public (if one isn't a sugary imbecile or an inflated fraud) one must handle one's subject intimately. Mere intimacy with the subject won't do. And conviction is found (for others – not for the author) only in certain contradictions and irrelevancies to the general conception of character (or characters) and of the subject. Say what you like man lives in his eccentricities (so called) alone. They give a vigour to his personality which mere consistency can never do. One must explore deep and believe the incredible to find the few particles of truth floating in an ocean of insignificance. And

before all one must divest oneself of every particle of respect for one's characters. You are really most profound and attain the greatest art in handling the people you do not respect. For instance the minor characters in V[illa] R[ubein]. And in this volume I am bound to recognize that Forsythe is the best. I recognize this with a certain reluctance because indubitably there is more beauty (and more felicity of style too) in the M of D. The story of the mine shows best your strength and your weakness. There is hardly a word I would have changed; there are things in it that I would give a pound of my flesh to have written. Honestly – there are. And your mine-manager remains unconvincing because he is too confoundedly perfect in his very imperfections. The fact is you want more scepticism at the very foundation of your work. Scepticism the tonic of minds, the tonic of life, the agent of truth – the way of art and salvation. In a book you should love the idea and be scrupulously faithful to your conception of life. There lies the honour of the writer, not in the fidelity to his personages. You must never allow them to decoy you out of yourself. As against your people you must preserve an attitude of perfect indifference – the part of creative power. A creator must be indifferent; because directly the 'Fiat!' has issued from his lips there are the creatures made in his image that'll try to drag him down from his eminence – and belittle him by their worship. Your attitude to them should be purely intellectual, more independent, freer, less rigorous than it is. You seem for their sake to hug your conceptions of right or wrong too closely. There is exquisite atmosphere in your tales. What they want now is more air.

You may wonder why I write you these generalities. But first of all in the matter of technique, where your advance has been phenomenal and which has almost (if not quite) reached the point of crystallization, we have talked so much and so variously that I could tell you now nothing that you have not heard already. And secondly these considerations are not so general as they look. They are even particular in as much that they have been inspired by the examination of your work as a whole. I have looked into all the volumes; and this – put briefly, imperfectly and obscurely – is what they suggested to me.

70

Joseph Conrad (1857–1924)

That the man who has written once the *Four Winds* has written now the M of D volume is a source of infinite gratification to me. It vindicates my insight, my opinion, my judgment – and it satisfies my affection for you – in whom I believed and am believing. Because that *is* the point: I *am* believing. You've gone now beyond the point where I could be of any use to you otherwise than just by my belief. It is if anything firmer than ever before, whether my remarks above find their way to your conviction or not. You may disagree with what I said here but in our main convictions we are at one.

<div align="center">

Ever Yours

Conrad

</div>

Two contrasting moods are reflected in two other letters which call for quotation. Writer's block is described to David Meldrum, a literary adviser at Conrad's publisher, but John Galsworthy was the recipient of a letter with the details of a flow of writing as *Lord Jim* was finished in twenty-one hours.

I *never mean* to be slow. The stuff comes out at its own rate. I am always ready to put it down; nothing would induce me to lay down my pen if I *feel* a sentence – or even a word ready to my hand. The trouble is that too often – alas! – I've to wait for the sentence – for the word.

What wonder then that during the long blank hours the doubt creeps into the mind and I ask myself whether I am fitted for that work. The worst is that while I am thus powerless to produce my imagination is extremely active: whole paragraphs, whole pages, whole chapters pass through my mind. Everything is there: descriptions, dialogue, reflexion – everything – everything but the belief, the conviction, the only thing needed to make me put pen to paper. I've thought out a volume in a day till I felt sick in mind and heart and gone to bed, completely done up, without having written a line. The effort I put out should give birth to masterpieces as big as mountains – and it brings forth a ridiculous mouse now and then.

The end of *L.J.* has been pulled off with a steady drag of twenty-one hours. I sent wife and child out of the house (to London) and sat down at 9 a.m. with a desperate resolve to be done with it. Now and then I took a walk round the house out at one door in at the other. Ten-minute meals. A great hush. Cigarette ends growing into a mound similar to a cairn over a dead hero. Moon rose over the barn looked in at the window and climbed out of sight. Dawn broke, brightened. I put the lamp out and went on, with the morning breeze blowing the sheets of MS all over the room. Sun rose. I wrote the last word and went into the dining-room. Six o'clock. I shared a piece of cold chicken with Escamillo (who was very miserable and in want of sympathy having missed the child dreadfully all day). Felt very well only sleepy; had a bath at seven and at 8.30 was on my way to London.

Charles Dickens (1812–1870)

Dickens so dominates nineteenth-century fiction that his views on writing expressed in his letters demand careful attention. Reading some of those which have been published leaves the reader with two particular words to bear in mind – 'pruning' and 'compression'.

The letters or extracts which follow are both entertaining and educative. The man, as a writer, a magazine editor and simply an attractive personality, comes through in a remarkably few lines. He really was a giant.

To Miss Mary Boyle

> Devonshire Terrace, Friday Night, late,
> Twenty-first February, 1851.

My Dear Miss Boyle,

I have devoted a couple of hours this evening to going very carefully over your paper (which I had read before) and to endeavouring to bring it closer, and to lighten it, and to give it that sort of compactness which a habit of composition, and of disciplining one's thoughts like a regiment, and of studying the art of putting each soldier into his right place, may have gradually taught me to think necessary. I hope, when you see it in print, you will not be alarmed by my use of the pruning-knife. I have tried to exercise it with the utmost delicacy and discretion, and to suggest to you, especially towards the end, how this sort of writing (regard being had to the size of the journal in which it appears) requires to be compressed, and is made pleasanter by compression. This all reads very solemnly, but only because I want you to read it (I mean the article) with as loving an eye as I have truly tried to touch it with

a loving and gentle hand. I propose to call it 'My Mahogany Friend'. The other name is too long, and I think not attractive. Until I go to the office tomorrow and see what is actually in hand, I am not certain of the number in which it will appear, but Georgy shall write on Monday and tell you. We are always a fortnight in advance of the public, or the mechanical work could not be done. I think there are many things in it that are *very pretty*. The Katie part is particularly well done. If I don't say more, it is because I have a heavy sense, in all cases, of the responsibility of encouraging anyone to enter on that thorny track, where the prizes are so few and the blanks so many; where—

But I won't write you a sermon. With the fire going out, and the first shadows of a new story hovering in a ghostly way about me (as they usually begin to do, when I have finished an old one), I am in danger of doing the heavy business, and becoming a heavy guardian, or something of that sort, instead of the light and airy Joe.

So good-night, and believe that you may always trust me, and never find a grim expression (towards you) in any that I wear.

Ever yours.

To Miss King

Tavistock House, Friday Evening,
Ninth February, 1855.

My dear Miss King,

I wish to get over the disagreeable part of my letter in the beginning. I have great doubts of the possibility of publishing your story in portions.

But I think it possesses *very great merit*. My doubts arise partly from the nature of the interest which I fear requires presentation as a whole, and partly on your manner of relating the tale. The people do not sufficiently work out their own purposes in dialogue and dramatic action. You are too much their exponent; what you do for them, they ought to do for themselves. With reference to publication in detached portions (or, indeed, with a reference to the force of the story in any form), that long stoppage and going back to possess the reader with the antecedents of the clergyman's biography, are rather crippling. I may mention that

Charles Dickens (1812–1870)

I think the boy (the child of the second marriage) a little too 'slangy'. I know the kind of boyish slang which belongs to such a character in these times; but, considering his part in the story, I regard it as the author's function to elevate such a characteristic, and soften it into something more expressive of the ardour and flush of youth, and its romance. It seems to me, too, that the dialogues between the lady and the Italian maid are conventional but not natural. This observation I regard as particularly applying to the maid, and to the scene preceding the murder. Supposing the main objection surmountable, I would venture then to suggest to you the means of improvement in this respect.

The paper is so full of good touches of character, passion, and natural emotion, that I very much wish for a little time to reconsider it, and to try whether condensation here and there would enable us to get it say into four parts. I am not sanguine of this, for I observed the difficulties as I read it the night before last; but I am very unwilling, I assure you, to decline what has so much merit.

I am going to Paris on Sunday morning for ten days or so. I purpose being back again within a fortnight. If you will let me think of this matter in the meanwhile, I shall at least have done all I can to satisfy my own appreciation of your work.

But if, in the meantime, you should desire to have it back with any prospect of publishing it through other means, a letter – the shortest in the world – from you to Mr. Wills at the *Household Words* office will immediately produce it. I repeat with perfect sincerity that I am much impressed by its merits, and that if I had read it as the production of an entire stranger, I think it would have made exactly this effect upon me.

My dear Miss King,
Very faithfully yours.

Tavistock House,
Twenty-fourth February, 1855.

My dear Miss King

I have gone carefully over your story again, and quite agree with you that the episode of the clergyman could be told in a very few lines. Startling as I know it will appear to you, I am bound to say that I think the purpose of the whole tale would

be immensely strengthened by great compression. I doubt if it could not be told more forcibly in half the space.

It is certainly too long for *Household Words*, and I fear my idea of it is too short for you. I am, if possible, more unwilling than I was at first to decline it; but the more I have considered it, the longer it has seemed to grow. Nor can I ask you to try to present it free from that objection, because I already perceive the difficulty, and pain, of such an effort.

To the best of my knowledge, you are wrong about the lady at last, and to the best of my observation, you do not express what you explain yourself to mean in the case of the Italian attendant. I have met with such talk in the romances of Maturin's time – certainly never in Italian life.

These, however, are slight points easily to be compromised in an hour. The great obstacle I must leave wholly to your own judgment, in looking over the tale again.

Believe me always, very faithfully yours.

To Miss Emily Jolly

3, Albion Villas, Folkestone, Kent,
Tuesday, Seventeenth July, 1855.

Dear Madam

Your manuscript, entitled a 'Wife's Story', has come under my own perusal within these last three or four days. I recognize in it such great merit and unusual promise, and I think it displays so much power and knowledge of the human heart, that I feel a strong interest in you as its writer.

I have begged the gentleman, who is in my confidence as to the transaction of the business of *Household Words*, to return the MS to you by the post, which (as I hope) will convey this note to you. My object is this: I particularly entreat you to consider the catastrophe. You write to be read, of course. The close of the story is unnecessarily painful – will throw off numbers of persons who would otherwise read it, and who (as it stands) will be deterred by hearsay from so doing, and is so tremendous a piece of severity, that it will defeat your purpose. All my knowledge and experience, such as they are, lead me straight to the recom-

mendation that you will do well to spare the life of the husband, and of one of the children. Let her suppose the former dead, from seeing him brought in wounded and insensible – lose nothing of the progress of her mental suffering afterwards when that doctor is in attendance upon her – but bring her round at last to the blessed surprise that her husband is still living, and that a repentance which can be worked out, *in the way of atonement for the misery she has occasioned to the man whom she so ill repaid for his love, and made so miserable,* lies before her. So will you soften the reader whom you now as it were harden, and so you will bring tears from many eyes, which can only have their spring in affectionately and gently touched hearts. I am perfectly certain that with this change, all the previous part of your tale will tell for twenty times as much as it can in its present condition. And it is because I believe you have a great fame before you if you do justice to the remarkable ability you possess, that I venture to offer you this advice in what I suppose to be the beginning of your career.

I observe some parts of the story which would be strengthened, even in their psychological interest, by condensation here and there. If you will leave that to me, I will perform the task as conscientiously and carefully as if it were my own. But the suggestion I offer for your acceptance, no one but yourself can act upon.

Let me conclude this hasty note with the plain assurance that I have never been so much surprised and struck by any manuscript I have read, as I have been by yours.

Your faithful Servant.

3, Albion Villas, Folkestone,
Twenty-first July, 1855.

Dear Madam

I did not enter, in detail, on the spirit of the alteration I propose in your story; because I thought it right that you should think out that for yourself if you applied yourself to the change. I can now assure you that you describe it exactly as I had conceived it; and if I had wanted anything to confirm me in my conviction of its being right, our both seeing it so precisely from the same point of view, would be ample assurance to me.

I would leave her new and altered life to be inferred. It does not appear to me either necessary or practicable (within such limits) to

do more than that. Do not be uneasy if you find the alteration demanding time. I shall quite understand that, and my interest will keep. *When* you finish the story, send it to Mr Wills. Besides being in daily communication with him, I am at the office once a week; and I will go over it in print, before the proof is sent to you.
Very faithfully yours

Tavistock House,
Saturday Morning, Thirtieth May, 1857.
Dear Madam
I read your story, with all possible attention, last night. I cannot tell you with what reluctance I write to you respecting it, for my opinion of it is not favourable, although I perceive your heart in it, and great strength.

Pray understand that I claim no infallibility. I merely express my honest opinion, formed against my earnest desire. I do not lay it down as law for others, though, of course, I believe that many others would come to the same conclusion. It appears to me that the story is one that cannot possibly be told within the compass to which you have limited yourself. The three principal people are, every one of them, in the wrong with the reader, and you cannot put any of them right, without making the story extend over a longer space of time, and without anatomizing the souls of the actors more slowly and carefully. Nothing would justify the departure of Alice, but her having some strong reason to believe that in taking that step, *she saved her lover.* In your intentions as to that lover's transfer of his affections to Eleanor, I descry a striking truth; but I think it confusedly wrought out, and all but certain to fail in expressing itself. Eleanor, I regard as forced and overstrained. The natural result is, that she carries a train of anticlimax after her. I particularly notice this at the point when she thinks she is going to be drowned.

The whole idea of the story is sufficiently difficult to require the most exact truth and the greatest knowledge and skill in the colouring throughout. In this respect I have no doubt of its being extremely defective. The people do not talk as such people would; and the little subtle touches of description which, by making the country house and the general scene real, would

Charles Dickens (1812–1870)

give an air of reality to the people (much to be desired) are altogether wanting. The more you set yourself to the illustration of your heroine's passionate nature, the more indispensable this attendant atmosphere of truth becomes. It would, in a manner, oblige the reader to believe in her. Whereas, for ever exploding like a great firework without any background, she glares and wheels and hisses, and goes out, and has lighted nothing.

Lastly, I fear she is too convulsive from beginning to end. Pray reconsider, from this point of view, her brow, and her eyes, and her drawing herself up to her full height, and her being a perfumed presence, and her floating into rooms, also her asking people how they dare, and the like, on small provocation. When she hears her music being played, I think she is particularly objectionable.

I have a strong belief that if you keep this story by you three or four years, you will form an opinion of it not greatly differing from mine. There is so much good in it, so much reflection, so much passion and earnestness, that, if my judgment be right, I feel sure you will come over to it. On the other hand, I do not think that its publication, as it stands, would do you service, or be agreeable to you hereafter.

I have no means of knowing whether you are patient in the pursuit of this art; but I am inclined to think that you are not, and that you do not discipline yourself enough. When one is impelled to write this or that, one has still to consider: 'How much of this will tell for what I mean? How much of it is my own wild emotion and superfluous energy – how much remains that is truly belonging to this ideal character and these ideal circumstances?' It is in the laborious struggle to make this distinction, and in the determination to try for it, that the road to the correction of faults lies. (Perhaps I may remark, in support of the sincerity with which I write this, that I am an impatient and impulsive person myself, but that it has been for many years the constant effort of my life to practise at my desk what I preach to you.)

I should not have written so much, or so plainly, but for your last letter to me. It seems to demand that I should be strictly true with you, and I am so in this letter, without any reservation either way.

Very faithfully yours.

79

Daphne du Maurier
(1907–1989)

Daphne du Maurier published an autobiographical piece under
the title *Growing Pains: The Shaping of a Writer*. The narrative
carries the reader along as if it were a novel and the relatively
long extract which follows has deliberately not been cut so that
the story of her apprenticeship can be enjoyed as a 'good read'.

The last day of September came. In a couple of days everyone,
including M and Angela, would have gone. The house was to be
shut up, and it was arranged that I should lodge with Miss
Roberts at The Nook, the cottage opposite. I could keep my
bedroom at Ferryside open so as to write there during the day.
But I would sleep, eat and live at The Nook, dear Bingo with
me. No bathroom – Miss Roberts would fill a hip-bath with hot
water every morning – and the 'usual office', as Geoffrey always
called it, up the garden path. Who cared? I'd be on my own.
And Miss Roberts, cheerful, smiling, gave Bingo and me a warm
welcome, the first of many which would follow through the
years to come. Dear Miss Roberts, who never looked askance at
my shorts, or trousers, or muddy sea-boots, who struggled
upstairs each morning with her can of hot water, who pretended
not to notice when, disliking sausages for supper, I furtively
threw them on the sitting-room fire where they crackled loudly,
and whose pleasant tittle-tattle of village gossip, invariably
without malice, proved so entertaining.
 It was strange to look across at Ferryside, bolted and shut-
tered, but I had a key, and went across the first morning,

Daphne du Maurier (1907–1989)

October 3rd, to the desk in my old bedroom, wrapped a rug around my knees, spread out sheets of paper and, filling my fountain-pen, wrote in capital letters THE LOVING SPIRIT. Beneath it the lines from Emily Brontë's poem.

> Alas, the countless links are strong,
> That bind us to our clay,
> The loving spirit lingers long,
> And would not pass away.

The original Jane Slade should become Janet Coombe, Polruan across the harbour become Plyn, and Janet's loving spirit must endure through four generations. So, here goes.

'Such a step, this, as I took up my pen. It went fairly well and smoothly, though the writing of it is an entirely fresh style for me. There were no dire pauses and lapses of thoughts, but a book of this sort mustn't rattle ahead. Weather right for starting too. A terrible wild day, with a howling sou'westerly wind and slashing rain. It doesn't matter a pin to me because it's all in tune with my writing. In fact it's a good thing, because I wasn't tempted to be out all the while.'

I had soon settled down to a routine. Work in the morning, across to Miss Roberts' for lunch, then a pull down-harbour in *Annabelle Lee* in the afternoon or a tramp with Bingo. A cup of tea at The Nook, and back to work at Ferryside until it was time to pack up for the evening, and go back for supper at Miss Roberts'. Lamplight and candles in the sitting-room, alone in privacy, with Miss Roberts 'dishing up' my sups in the kitchen alongside, after which she would retire early to bed, and I would stretch myself on the small hard-backed sofa to read. The reading diet consisted chiefly of Mary Webb, lately discovered, and my uncrowned king of Fowey, the famous 'Q'. One of his novels, *Shining Ferry*, was all about my village of Bodinnick. How humble, even abashed, I should have felt then had I known that some thirty years later, dear Sir Arthur in his grave, his daughter Foy would ask me to complete the unfinished manuscript of the last novel her father ever wrote, *Castle Dor*. Nor was this the only link between the great man and myself. The title of my own

novel published in 1941 – *Frenchman's Creek* – was not original: 'Q' had used it many years before in one of his short stories, and graciously gave me permission to use it again, saying, if I remember rightly, that he looked forward to seeing what I had made of it, while adding a laughing though very genuine warning, that 'no critic would ever forgive me for the success of *Rebecca*'. Truly a prophet! But in 1929 all that concerned me was the story of *The Loving Spirit*.

Work progressed well. I had finished Part One in a fortnight and Part Two by November 3rd, which, I told myself, was really good going.

'I don't think it's scrappy or carelessly done, at least I hope not. Anyway, I *felt* it all, which was of supreme importance. If only the hours were longer – I keep being aware of time slipping away. It was fun becoming Joseph, a man of fifty madly wanting his silly virgin of nineteen. I got so worked up over it all I could think of nothing else. I only snatched three-quarters of an hour for exercise, and leapt up Hall Walk and round by the farm and back, but I could have gone on working all night. Can't help it if I get brain fever, I can't stop where I am now, it's too exciting. Blast, tomorrow I must do some letters or everyone will think me dead.'

Part Three would be more of a problem. The member of the third generation did not interest me as much as Janet and her son Joseph, and he also had to live in London for a while. I wished I had a history book, giving some details of the years 1888-1912. Word got around through Miss Roberts, and two days later Richard Bunt from Lamellon, 'up the hill and across the fields', appeared with an armful of superb volumes, profusely detailed and illustrated. 'Oh, the darling man. How terribly sweet to take the trouble. Oh, these are my people, they really are. What have I to do with London? I shall live and die here in Cornwall and do my best to write about them. What's the use of being clever and witty? It's a heart that is the needful thing. P.S. I wish I was a really good writer.'

Many years later, after the war, myself married with three children, the same Richard Bunt would be skipper of the motor-sailer *Fanny Rosa*, which my soldier-husband would bring back

from Singapore; but in the autumn of 1929 I did not even know that such a soldier existed.

November 1929, and I was still pegging away at Part Three, with a lump on my third finger from holding my pen too tightly. A pity I didn't own a typewriter. The autumn gales blew continuously but this never worried me, for I had brought the leading member of the third generation of my Slade-Coombe family back to Plyn, and the harder the wind blew the faster sped the story.

Sunday suppers with the Quiller-Couches became a routine, a happy relaxation after the week's work, and back at The Nook Miss Roberts' cheerful prattle proved an additional amusement. Tales of a former male lodger who had been 'a little over-indulgent' where alcohol was concerned, and, although it was totally unconnected with this unfortunate gentleman, knowing my fondness for verse she produced a book of poems by a Mr Postlethwaite which contained the lines,

> O! rear no stone above my head,
> Carve no Hic Jacet on my tomb.

I had an instant vision of the lodger reading these lines and spluttering Hic Jacet as he stumbled up the steps of The Nook *en route* from the Ferry Inn.

On Sunday November 17th I had finished Part Three, and laying aside the manuscript I went up to the hills above the harbour and listened to the church bells ringing for Evensong from Lanteglos church, where my Jane was buried. It was a fitting climax. For in two days' time I was due back home at Hampstead, and there would be no more writing until after Christmas. A letter from M the day before I left contained a warning. 'I hope when you come home you won't start that practice of going out again in the evenings, which was so worrying.' Really! It made me feel like a maid receiving reproof from the mistress of the house. Why did she not add, 'Otherwise, we shall have to make a change'?

So I should have to sit every evening reading a book, Shakespeare or Dickens, and just accept it. It was the principle

I minded, the knowledge that returning to Cannon Hall meant loss of freedom. Well, I was determined it would not be for long. Poor Bingo seemed to know, as I packed my suitcase. But Miss Roberts was going to look after him, so I had no worries on that score. And it seemed altogether right that I should leave on a wet, dismal day, the trees dank and lifeless; even Miss Roberts' macaw Rob, perched as usual on the sea-wall, sat with his fine head humped between bedraggled feathers. But why, oh why, I asked myself, after the first family greeting, all smiles and how well I was looking, must I be the one to have restraint put upon my outings while Angela could do as she liked? 'Whoopee ad lib, so she told me. Lord, how she made me laugh!'

Fortunately there was no restriction put upon my days, and after a hair-cut and shampoo in London the first morning home I met cousin Geoffrey for lunch. 'He looked pale and tired, and showed, for the first time, little signs of fussiness and irritation. His good humour didn't bubble up as it used to do, in its old careless spontaneity. No job, which must be lowering to his whole outlook. And I've let him down terribly, I haven't helped him as I swore I always would. So lonely for him, living in rooms alone in Holland Road.' He was forty-four, which, D always maintained, was the du Maurier unlucky number. Perhaps Geoffrey would brighten up when he reached the lucky number forty-eight. But it seemed a fair time to wait.

I myself could not wait until five o'clock when I had a date with Carol at the Park Lane Hotel. 'Oh, it was lovely to see him again. We sat in the lounge and drank orangeades, and talked for an hour. Then he drove me home, for me to be in time for dinner, and we stopped in Regent's Park for ten minutes because we simply had to kiss each other!'

Did I look guilty, I wonder, as, with hair patted into place and fresh lipstick added, I rushed down to the dining-room as the gong sounded, all of forty-seven years ago? For such was to be the hurried routine, at least four days a week, until Christmas; and with D busy rehearsing to play Captain Hook, his old part, once more with Jean Forbes-Robertson as Peter Pan, there was no time for searching questions from Alexander Borgia. And

Carol was busy too. He also had matinées and rehearsals, and was not always free, which meant days at Cannon Hall with little to do.

'The day has a thousand hours. Jeanne was out, Angela is away for the weekend, and M was busy doing the flowers. What good did I do anyone by moping upstairs in the schoolroom? It's the last time, I vow. I rang up Doodie, I rang up Dora, both were out. I tidied my desk and read Shakespeare, and it poured with rain. If I had been at Fowey there would have been peace. It's no use, I don't belong here.'

Why did I not offer to help M with the flowers? Fear of a rebuff or total lack of interest? A chance, surely, for companionship, ignored by both of us. A mutual shyness between mother and daughter which would endure until after D died five years later, when, hearing the news by telephone, I hurried home and found her lying in bed, crying, and she put her arms round me and said, 'He was so fond of you', and I held her close, for the first time, and tried to comfort her. Twenty-five years too late ...

Christmas was to be spent at home, and at least the buying of presents kept me fully occupied. Especially the one for Carol.

'I'd known for months what to give him. I went to Hay's and bought him a gramophone – Columbia portable – with eight records in the lid. Then I went to the Park Lane Hotel, knowing he was out, and went up to his room and arranged it there, all open and ready, with a record on it. I looked at his things in the wardrobe. Poor sweet, he had no buttons on anything, nobody looks after his clothes. It's these sort of touches that make me love him.'

On Boxing Day I heard the result of the Christmas gift. 'I went to the Park Lane and found Carol waiting for me. He was absolutely thrilled with his gramophone, and he had found it exactly as I planned. I've never seen anyone so pleased. He was just like a little boy, all red in the face and smiling. We went upstairs and played it, then I sat with him while he had his dinner before the evening show. But I think I shall have the song of *Am I Blue?* in my head till my dying day.'

Carol's present to me was a cigarette-lighter, and a handsome fountain-pen and pencil to match. Indeed, I did well that

Christmas, with five pounds from D, two sets of satin underwear from M, a bracelet from Angela, and handkerchiefs from Jeanne. Even dear out-of-work Geoffrey produced a diamond-paste necklace. While Michael Joseph from Curtis Brown, perhaps as subtle encouragement, sent me a work of his own entitled *Short Story Writing for Profit*. Thinking of the unfinished manuscript waiting for me down at Fowey I did not take the hint, and the last book of the year to be read on New Year's Eve, after a family party skating on the ice-rink at Golders Green, was *Good-bye to All That* by Robert Graves.

I awoke to despondency on January 1st, 1930. What if my novel turned out to be no good? 'I have a sudden conviction that my book is not only dull but badly written, that it might as well be in the waste-paper basket.' I shut myself up in the garage-room and scribbled some articles in case Uncle Willie might think them worth publishing in the *Bystander*. At ten guineas apiece they would bring in thirty quid, and I could keep myself at Miss Roberts' for weeks on that. A letter from Fernande brought further despondency. She had actually been over to London before Christmas and had never told me. But why? What had I done to deserve such treatment? It wasn't fair. Fowey in a couple of days would be the only salvation.

'Oh hell, if only one didn't care about anyone in the world. If only one could just laugh and be alone. I think of myself and how I live from week to week, from day to day, clutching at straws. I almost cried leaving Fowey some weeks ago, and this evening because I left Carol I had to put the newspaper in front of my face as I walked to the tube so as to hide the tears running down my cheeks. What in God's name does it mean? That I'm a bloody fool.'

So forget it, push it aside, and be on time to catch the train at Paddington. 'Once I arrived in Fowey, although it was dark, I saw the harbour thick with shipping, and the dark water gleaming, and Adams met me, and at the door of The Nook was Bingo, crazy with joy. Nothing changed since I left, the same identical piece of soap in the dish, surely the same candle. All as before. This was what I needed to reassure me. I might never

have gone away, and yet something is changed somewhere, inside myself. Is it because I'm uncertain of my writing?'

Rain, sleet, wind, hail – *and* snow; I had hardly expected this from my Fowey. It was too cold to work at Ferryside, so I settled down in the sitting-room at The Nook. But Part Four would not be easy. The last member of the four generations, Jane Slade's great-granddaughter Jennifer, was going to be rather tiresome. I was not sure what to do with her. Could it be that I had lost interest in the whole story? If so, heaven help me. I snuggled down under my blanket in the mornings, hearing the rain against the window, and when a smiling Miss Roberts knocked on the door and brought in my can of hot water she said, 'Why not stay where you are, Miss Daphne? After all, there is nothing for you to get up for, is there?'

Nothing to get up for.... And she had been bustling around since six. It was shaming, with Part Four waiting untouched in the sitting-room below.

'All right, Miss Roberts. I'll be down directly.'

Then with the post a welcome letter from Curtis Brown saying the *Bystander* had accepted one of the articles, and would pay fifteen guineas. This was better. But as I pegged away at Part Four down in the sitting-room Miss Roberts' quavering voice singing hymns in the kitchen across the hall put me off my stroke. Surely Katherine Mansfield would not have been so easily discouraged? Then came excitement. The rockets went off and the lifeboat was called out. The ferrymen told me there was a ship in distress off the Cannis Rock by Pridmouth. Too late to go and investigate now, but I would do so tomorrow.

'The day was fine, and after working like one possessed through the morning I crossed the ferry after lunch and walked to Pridmouth. There she was, sure enough, right in the bay on the rocks, the sea breaking against her, and already her iron bottom torn open. I was told the crew had all got off safely. The sight was mournful. On one side, pathetic, and spars and drift-wood cast on the shore. Even a magazine lying in a pool. People like busy flies on the beach scavenging.'

The sight would remain in memory. Not for *The Loving Spirit*

but for another book *Rebecca*, many years later, the seed as yet unsown.

I had completed three chapters of Part Four, and I had planned seven to come. One thing was certain. It would *not* be written in the style of a novel I had found on Miss Roberts' shelf called *Patricia of Pall Mall*. I couldn't forbear jotting a line from it in the diary, it made me laugh so much. ' "Plucky little girl," he said tenderly, for her aloofness attracted him. Man-like, he preferred shy game.' So now I knew how to behave. And perhaps if I wrote like that I should earn more than fifteen quid a story.

Meanwhile, news came from home that D, M and Angela were all off to Naples and then Capri for a three weeks' holiday. Good for them. I was not envious. I had only one plan, which was to finish the book, and Jennifer was turning out to be a hard-headed young woman, quite different from how I had intended her. This must surely mean I had no control over my characters.

A typist, employed by the famous 'Q', arrived to carry off the first part of the book to type. I hoped she would be able to read my handwriting and wouldn't be too shocked at the spelling. 'I felt awkward giving it to her, thinking of all the faults and mistakes, the lame style, the somewhat indelicate expressions used from time to time. I shan't look her in the eyes after she has read it. Then I washed my hair, and at once looked like a wild poet, frenzied, and in a decline. I met Mrs Burghard on the ferry, who said to me, "You don't look half so well as you did in the summer, you have got so skinny." 'Thank you for nothing, Mrs B.' Supper with the Quiller-Couches restored morale. They were so friendly and sympathetic always, and their quiet humour was a real tonic.

A few days later Mrs Smith brought back the first part typed. And hurrah! 'She warmed my heart by telling me she found it so interesting she could hardly wait for Part Two! What's the betting she will be the first and last person ever to read it? However, her opinion did me good.'

Thursday, March 30th. 'At last! The final stroke has been drawn, the final word written, and *The Loving Spirit* is now finished. It has taken me exactly ten weeks, I calculate, which

Daphne du Maurier (1907–1989)

seems to me to be an extraordinary quick piece of work when reckoned thus, and yet the labour has been enormous. There seems so much body in it, yet I don't know. I probably can't count, but I think it is over 200,000 words long! Oh God, that typing bill with Mrs Smith. The relief to have done it, though, is enormous. I was so excited I could hardly eat my lunch. In the afternoon I went over to Lanteglos church to make some sort of thanksgiving, and to visit the tombstone of Jane Slade. If Michael Joseph of Curtis Brown tells me he doesn't like it, or I must rewrite, he can go to hell. I can't go back to it any more.

'The future faces me with doubt and perplexity. "No coward soul is mine"?'

George Eliot (1819–1880)

There is a certain frustration in reading George Eliot's letters and journals because of her determination not to reveal much about herself as a person and a writer other than through her novels. But we can obtain some impressions of George Eliot the business woman from her letters to her publisher, John Blackwood. And Mr Lewes is often shown in his vital supporting role. The general business and financial aspects of writing matter to them both.

To John Blackwood

Blackbrook, Bickley, Kent,
September 19, 1873.

My dear Mr Blackwood

I quite assent to your proposal that there should be a new edition of *Middlemarch* in one volume at 7/6 – to be prepared at once, but not published too precipitately. Mr Lewes thinks that such an edition as you describe would be likely to answer, if one could make the public well aware of it. I like your project of an illustration. And the financial arrangements you mention are quite acceptable to me. For one reason especially I am delighted that the book is going to be reprinted – namely, *that I can see the proof-sheets and make corrections*. Pray give orders that the sheets be sent to me. I should like the binding to be of a rich sober colour, with very plain Roman lettering. It might be called a 'revised edition'.

Thanks for the extract from Mr Collins' letter. I did not know that there was really a Lowick, in a midland county too. Mr

George Eliot (1819–1880)

Collins has my gratitude for feeling some regard towards Mr Casaubon, in whose life *I* lived with much sympathy. When I was at Oxford in May, two ladies came up to me after dinner: one said, 'How could you let Dorothea marry *that* Casaubon?' The other: 'Oh I understand her doing that; but why did you let her marry the other fellow, whom I cannot bear?' Thus, two 'ardent admirers' wished that the book had been quite different from what it is.

I wonder whether you have abandoned – as you seemed to agree that it would be wise to do – the project of bringing out my other books in a cheaper form than the present 3/6 – which, if it were not for the blemish of the figure illustrations, would be as pretty an edition as could be, and perhaps as cheap as my public requires. Somehow, the cheap books that crowd the stalls are always those which look as if they were issued from Pandemonium. I cannot understand why W.H. Smith does not use his stalls for better works, when they are known to be popular. He seems not to renew his stock of your publications when the first lot has been sold – at least there is no systematic attention to the supply of the various stalls. . . .

<div align="center">

With our united kind regards I remain

Yours very sincerely

M.E. Lewes
</div>

It is rare for a writer to describe how the work is undertaken as a physical act. We often know where an author sits but it is not usual for us to learn about the problem of how to sit. George Eliot's letters offer a comment. And it is not to be dismissed as of little significance especially when the writer was frequently in poor health.

The letter which is quoted below has to be read with the introduction provided by Gordon S. Haight, who edited *Selections from George Eliot's Letters.*

To Thomas Clifford Allbutt

Dr Allbutt's monograph on the use of the ophthalmoscope was published in 1871 and his pioneer papers on the effect of strain

on the heart in 1870 and 1873. Richard Liebreich, an ophthalmic surgeon, called at the Priory with his wife 1 June 1873, and three days later the Leweses went to see his chairs.

<div align="right">

The Priory, 21. North Bank, Regents Park.
November 1. 73.

</div>

Dear Dr Allbutt

Your suggestions about lessening the inconvenience of writing could not come to a more appreciative person. I have for the last three years taken to writing on my knees, throwing myself backward in my chair, and having a high support to my feet. It is a great relief not to bend, and in this way at least I get advantage from the longsightedness which involves the early need of glasses. Mr Lewes is obliged to stoop close to his desk. But Dr Liebreich condemns my arrangement as forcing up my knees too much, and he has devised a sort of semi-couch which seems to be perfection so far as the physical conditions of my writing are concerned. But how if I have nothing else worth the writing! It is in vain to get one's back and knees in the right attitude if one's mind is superannuated. Some time or other, if death does not come to silence one, there ought to be deliberate abstinence from writing – self-judgment which decides that one has no more to say. The public conscience about authorship wants quickening sadly – don't you think so? Happily for me, I have a critic at hand whom I can trust to tell me when I write what ought to be put behind the fire.

Mr Lewes unites with me in best regards to Mrs Allbutt and yourself. We do not despair of being in your neighbourhood again some day, and taking a glimpse of you in your new home.

<div align="center">

Yours always warmly and sincerely,
M.E. Lewes.

</div>

T.S. Eliot (1888–1965)

In a letter to Lytton Strachey in June 1919, T.S. Eliot refers to the 'tone' of a poem and clearly he accepts that he has to find that himself. Perhaps there is guidance to be had from reading F.H. Bradley, but few would do that today. Eliot completed a doctoral dissertation on Bradley during his time at Oxford.

The second paragraph offers a glimpse of the life of Eliot the banker.

Whether one writes a piece of work well or not seems to me a matter of crystallization – the good sentence, the good word, is only the final stage in the process. One can groan enough over the choice of a word, but there is something much more important to groan over first. It seems to me just the same in poetry – the words come easily enough, in comparison to the core of it – the *tone* – and nobody can help one in the least with that. Anything *I* have picked up about writing is due to having spent (as I once thought, wasted) a year absorbing the style of F.H. Bradley – the finest philosopher in English – *Appearance and Reality* is the *Education Sentimentale* of abstract thought.

You are very – ingenuous – if you can conceive me conversing with rural deans in the cathedral close. I do not go to cathedral towns but to centres of industry. My thoughts are absorbed in questions more important than ever enter the heads of deans – as *why* it is cheaper to buy steel bars from America than from Middlesborough, and the probable effect – the exchange difficulties with Poland – and the appreciation of the rupee. My evenings in Bridge. The effect is to make me regard London with

disdain, and divide mankind into supermen, termites and wire-worms. I am sojourning among the termites. At any rate that coheres. I feel sufficiently specialized, at present, to inspect or hear any ideas with impunity.

William Faulkner (1897–1962)

This address by William Faulkner clearly does not require any introduction. It can stand on its own. The message to young men and women writers is a powerful one whatever the limit of their ambitions.

Address upon Receiving the Nobel Prize for Literature

STOCKHOLM, 10 DECEMBER 1950

I feel that this award was not made to me as a man, but to my work – a life's work in the agony and sweat of the human spirit, not for glory and least of all for profit, but to create out of the materials of the human spirit something which did not exist before. So this award is only mine in trust. It will not be difficult to find a dedication for the money part of it commensurate with the purpose and significance of its origin. But I would like to do the same with the acclaim too, by using this moment as a pinnacle from which I might be listened to by the young men and women already dedicated to the same anguish and travail, among whom is already that one who will some day stand here where I am standing.

Our tragedy today is a general and universal physical fear so long sustained by now that we can even bear it. There are no longer problems of the spirit. There is only the question: When will I be blown up? Because of this, the young man or woman writing today has forgotten the problems of the human heart in

conflict with itself which alone can make good writing because only that is worth writing about, worth the agony and the sweat.

He must learn them again. He must teach himself that the basest of all things is to be afraid; and, teaching himself that, forget it forever, leaving no room in his workshop for anything but the old verities and truths of the heart, the old universal truths lacking which any story is ephemeral and doomed – love and honor and pity and pride and compassion and sacrifice. Until he does so, he labors under a curse. He writes not of love but of lust, of defeats in which nobody loses anything of value, of victories without hope and, worst of all, without pity or compassion. His griefs grieve on no universal bones, leaving no scars. He writes not of the heart but of the glands.

Until he relearns these things, he will write as though he stood among and watched the end of man. I decline to accept the end of man. It is easy enough to say that man is immortal simply because he will endure: that when the last ding-dong of doom has clanged and faded from the last worthless rock hanging tideless in the last red and dying evening, that even then there will still be one more sound: that of his puny inexhaustible voice, still talking. I refuse to accept this. I believe that man will not merely endure: he will prevail. He is immortal, not because he alone among creatures has an inexhaustible voice, but because he has a soul, a spirit capable of compassion and sacrifice and endurance. The poet's, the writer's, duty is to write about these things. It is his privilege to help man endure by lifting his heart, by reminding him of the courage and honor and hope and pride and compassion and pity and sacrifice which have been the glory of his past. The poet's voice need not merely be the record of man, it can be one of the props, the pillars to help him endure and prevail.

Henry Fielding (1707–1754)

Fielding considered that he was 'the founder of a new province of writing'. He was certainly a man of distinction and, moreover, one who liked to share his thoughts about his art with his readers. George Eliot referred to the introductory chapters to his novels as those delightful resting-spaces where 'he seems to bring his armchair to the proscenium and chat with us'.

The extract given here is from the Introduction to *Tom Jones*. The analogy with the enjoyment of good food lingers in the mind.

The same animal which hath the honour to have some part of his flesh eaten at the table of a duke, may perhaps be degraded in another part, and some of his limbs gibbeted, as it were, in the vilest stall in town. Where, then, lies the difference between the food of the nobleman and the porter, if both are at dinner on the same ox or calf, but in the seasoning, the dressing, the garnishing, and the setting forth? Hence the one provokes and incites the most languid appetite, and the other turns and palls that which is the sharpest and keenest.

In like manner, the excellence of the mental entertainment consists less in the subject than in the author's skill in well dressing it up. How pleased, therefore, will the reader be to find that we have, in the following work, adhered closely to one of the highest principles of the best cook which the present age, or perhaps that of Heliogabalus, hath produced. This great man, as is well known to all polite lovers of eating, begins at first by setting plain things before his hungry guests, rising afterwards by degrees as their stomachs may be supposed to decrease, to the

very quintessence of sauce and spices. In like manner, we shall represent human nature at first to the keen appetite of our reader, in that more plain and simple manner in which it is found in the country, and shall hereafter hash and ragoo it with all the high French and Italian seasoning of affectation and vice which courts and cities afford. By these means, we doubt not but our reader may be rendered desirous to read on forever, as the great person just above-mentioned is supposed to have made some persons eat.

Having premised thus much, we will now detain those who like our bill of fare no longer from their diet, and shall proceed directly to serve up the first course of our history for their entertainment.

E.M. Forster (1879–1970)

The intimacy of personal letters not surprisingly allows authors to reveal their doubts and fears. They may not appreciate at the time that the remarks may be made known more widely when subsequent fame brings publication of their papers. But E.M. Forster was simply experiencing a common reaction in the following extract from a letter of January 1924 to a friend, G.H. Ludolf. The novel which he sometimes thought of as bad was *A Passage to India*.

My chief news is that the novel is done at last and I feel – or shall feel when the typing's over – great relief. I am so weary, not of working but of not working; of thinking the book bad and so not working, and of not working and so thinking it bad: that vicious circle. Now it is done and I think it good. Publishers fall into ecstacies! But I know much about publishers (*toujours excepté Monsieur Homme* [Mann] and sent them those chapters that are likely to make them ecstatic, concealing the residue in the W.C. until the contracts are signed. They unite, though, in restraining their joy until the autumn. I'm afraid it won't come out till then.

Commonplace books are always a fascination especially when kept by writers and in his, E.M. Forster reveals not only his wide reading but something of his own thoughts as a novelist. The jottings, if that is not too casual a word, which are reproduced here are from entries for the year 1926.

Novels

1) *Living Character* in a novel best discovered by negative tests. If it is always startling us into approval it is a proof that it dies between the sentences. If a character lives, much else is apt to follow: we are distracted from deadness elsewhere. All characters alive, up to the edge of the book? Possible? Desirable? Happens in *War and Peace*, but that has no edges. Many books they might split, so a novelist's sterility may serve him well as well as badly.

 Axiom: Novel must have either one living character or a perfect pattern: fails otherwise. (Though what about Moby Dick?)

2) *Telling the Story*: atavistic element; shock-headed public gaping round the camp-fire, and only kept awake by *suspense* (or by *surprise* and the hope of further surprises. But this assumes a subtler audience, and leads us nearer to literature.) If story is about living beings, well and good, but public seems equally thrilled by dummies, indeed prefers them because they recall the other stories that lie piled in his mind. ('Oh no, that won't do, it's what we should say ourselves' they complained about the 'Prisoners of War' at Woolaston) N.B. Story-teller needn't pick up loose threads. As long as he keeps his shock-heads excited he needs no plot. Films. Reading aloud – Scott said to seem better then.

3) *Pattern* or rhythm seems to me the third great element in a novel, but these are words easier to use than to define. They have some connection with the Story (which must in its turn have some connection with Living Character). The Pattern may be the plot – in *The Brothers Karamazov* they run together so far as either is present: strengthens the book when this happens. Or they may run in different directions, as in *Bleak House*, where the plot is a complicated maze only of interest to detectives, and the pattern little more than the drifting of the London fog. (Mem.: read *The Golden Bowl*; one can approach the meaning of pattern by seeing what J. sacrificed to attain it – snipping beetroots and spring onions for his salad: for I know he would keep among the vegetables, if

only because their reproductive organs are not prominent.

P. Lubbock's *Roman Pictures* has a competent machine-made pattern. He thinks (*The Craft of Fiction* – a sensitive yet poor-spirited book) that the aim of a novel should be capable of being put into a phrase, 'ten words that reveal its unity', and so boggles at *War and Peace*, though he 'duly' recognizes its vitality. So pattern or rhythm shouldn't be difficult to define for him: for he connects them with the plot, and thinks that can be tersely stated. Must I read him through?

John Galsworthy (1867–1933)

Galsworthy had not only his own talent but also the good fortune to be guided by others of perception. Both his future wife and Joseph Conrad had an initial influence and Edward Garnett encouraged him as he developed. Galsworthy was generous in his recognition of these influences and wrote an instructive and amusing piece about the 'morals' to be learned.

Until I was twenty-seven years and eight months old it never occurred to me to write anything. And then it didn't occur to me; it occurred to one who was not then my wife. 'Why don't you write?' she said; 'you are just the person.' I received her remark with the smile of one who knows better. If one has been brought up at an English public school and university, is addicted to sport and travel, has a small independent income, and is a briefless barrister, one will not take literature seriously; but one may like to please her of whom one is fond. I began. In two years I wrote nine tales. They had every fault. Kiplingesque, crudely expressed, extravagant in theme, deficient in feeling, devoid of philosophy, with the exception of one or two perhaps, they had no temperament. I put them together, and sent them, at the recommendation of my one literary friend, Conrad, to a certain publisher. With praiseworthy caution, he would only publish them if I paid; and he sent me an estimate. I thought it a pity to waste either time or trouble on them and accepted it. In the meantime I had begun to write a novel, and to be conscious of what are called 'a feeling for character', and 'a sense of atmosphere'. It was, however, a bad novel; it was not what is

called: 'written'. The technique limped; the structure had string-halt; and the clothing sentences were redundant or deficient. It was accepted by another publisher on what is known as a deferred royalty, so deferred, in fact, that nothing came my way. I had now been writing four years, and had spent about a hundred pounds on it. About this time I began to read the Russian Turgenev (in English) and the Frenchman de Maupassant in French. They were the first writers who gave me, at once, real aesthetic excitement, and an insight into proportion of theme and economy of words. Stimulated by these, I began a second novel, *Villa Rubein*. It was more genuine, more atmospheric, better balanced, but still it was not 'written'.... The form in which it now survives underwent two thorough revisions some seven years later. It was published on the same sort of terms – again I got nothing; and I proceeded with the four short-long stories which are now bound up with *Villa Rubein*. From the writing of these I got more excitement and satisfaction than hitherto, and they were nearer being 'written' than anything I had yet done; but they too had to be severely dressed down before they were reissued with *Villa Rubein* some years later. One of these four stories, 'A Knight', was first published in a magazine and I actually got fifteen pounds for it; but nothing from the tales in book form; so that in 1902 after seven years and four books I was still some seventy-five pounds out of pocket, to say nothing of incidental expenses, and had made no name. Now came my tug of war. I began a book which in the end became *The Island Pharisees*. The first draft was called *A Pagan*, and was a string of episodes recounted by Ferrand in the first person. When it was nearly finished I showed it to Edward Garnett. 'No, my dear fellow,' he said, 'it's all very well, but you shouldn't have done that fellow subjectively. You can't possibly know the real inside of a vagabond like that; you ought to give him to us objectively, through a personality like your own.' I gnashed my teeth, set them, conceived Shelton, and rewrote the book. I made a half-baked job of it. 'Better,' said Edward Garnett, 'but do it again!' I re-gnashed my teeth, re-set them, and wrote it a third time. So in 1904 it was published – first of my books under my own name. Perhaps I made fifty pounds out

of it; but even this thrice-written book wasn't 'written'! It underwent a thorough spring-cleaning before it assumed its final form in 1908.

In 1906, therefore, before *The Man of Property* had appeared, I had been writing nearly eleven years without making a penny, or any name to speak of. *The Man of Property* had taken me nearly three years, but it *was* 'written'. My name was made; my literary independence assured; and my income steadily swollen.

The 'morals' of all this are not easy.

The first moral is that some writers at least are not born. The second moral is that such writers need either an independent income, or another job while they are learning to 'write'. The third moral is that he who is determined to 'write', and has the grit to see the job through, can 'get there' in time. The fourth moral is that the writer who steadily goes his own way, never writes to fulfil the demands of public, publisher, or editor, is the writer who comes off best in the end. The fifth moral is that to begin too young is a mistake. Live first, write afterwards. I had seen, unselfconsciously, a good deal of life before I began to write, but even at twenty-eight I began too young. The spiritually stressful years of my life came between then and 1904. That is why *The Island Pharisees* and *The Man of Property* had, in crescendo, so much more depth than the earlier books. The sixth moral is that a would-be writer can probably get much inspiration and help from one or two masters, but, in general, little good and more harm from the rest. Each would-be writer will feel inspired according to his temperament, will derive instruction according to his needs, from some older living master akin to him in spirit. And as his wings grow stronger under that inspiration, he will shake off any tendency to imitate.

Elizabeth Gaskell (1810–1865)

A group of dons, when asked to draw up a list of 'the 250 Literary Greats', included Elizabeth Gaskell's *Mary Barton*. Mrs Gaskell (and who else is known in that manner?) had her success in the mid-nineteenth century as a novelist and as the controversial biographer of Charlotte Brontë. She emerges from her letters as a woman with a warm and generous personality. The first one quoted here could only have been written by an author who was a mother and a housewife.

To an Unknown Correspondent

25 September 1862

Your MSS has not been forwarded to me along with your letter; so at present I have no opportunity of judging of its merits; when I have read it I will give you the best and truest opinion I can. I feel very sorry for you, for I think I can see that, at present, at least you are rather overwhelmed with all you have to do; and I think it possible that the birth of two children, one so close upon another may have weakened you bodily, and made you more unfit to cope with your many household duties. Try – even while waiting for my next letter, to strengthen yourself by every means in your power; by being very careful as to your diet; by cold-bathing, by resolute dwelling on the cheerful side of everything; and by learning to economize strength as much as possible in all your household labours; for I dare say you already know how much time may be saved, by beginning any kind of work in good time, and not driving all in a hurry to the last moment. I hope

(for instance), you soap and soak your dirty clothes well for some hours before beginning to wash; and that you understand the comfort of preparing a dinner and putting it on to cook *slowly*, early in the morning, as well as having *always* some kind of sewing ready arranged to your hand, so that you can take it up at any odd minute and do a few stitches. I dare say at present it might be difficult for you to procure the sum that is necessary to purchase a sewing machine; and indeed, unless you are a good workwoman to begin with, you will find a machine difficult to manage. But *try*, my dear, to conquer your 'clumsiness' in sewing; there are a thousand little bits of work, which no sempstress ever does so well as the wife or mother who knows how the comfort of those she loves depends on little peculiarities which no one but she cares enough for the wearers to attend to.

My first piece of advice to you would be *get strong* – I am almost sure you are out of bodily health and that, if I were you, I would make it my first object to attain. Did you ever try a teacup full of *hop-tea* the first thing in the morning? It is a very simple tonic, and could do no harm. Then again try *hard* to arrange your work well. That is a regular piece of head-work and taxes a woman's powers of organization; but the reward is immediate and great. I have known well what it is to be both wanting money, and feeling weak in body and entirely disheartened. I do not think I ever cared for literary fame; nor do I think it *is* a thing that ought to be cared for. It comes and it goes. The exercise of a talent or power *is* always a great pleasure; but one should weigh well whether this pleasure may not be obtained by the sacrifice of some duty. When I had *little* children I do not think I could have written stories, because I should have become too much absorbed in my *fictitious* people to attend to my *real* ones. I think you would be sorry if you began to feel that your desire to earn money, even for so laudable an object as to help your husband, made you unable to give your tender sympathy to your little ones in their small joys and sorrows; and yet, don't you know how you – how every one, who tries to write stories *must* become absorbed in them (fictitious though they be) if they are to interest their readers in them? Besides viewing the subject from a solely artistic point of view a good writer of fiction must

have *lived* an active and sympathetic life if she wishes her books to have strength and vitality in them. When you are forty, and if you have a gift for being an authoress you will write ten times as good a novel as you could do now, just because you will have gone through so much more of the interests of a wife and a mother.

All this does not help you over present difficulties, does it? Well then let us try what will – how much have you in your own power? How much must you submit to because it is God's appointment? You have it in your own power to arrange your day's work to the very best of your ability, making the various household arts into real studies (and there is plenty of poetry and association about them – remember how the Greek princesses in Homer washed the clothes etc. etc. etc. etc.). You would perhaps find a little book called *The Finchley Manual of Needlework* of real use to you in sewing; it gives patterns and directions etc. Your want of strength may be remedied *possibly* by care and attention; if not, you must submit to what is God's ordinance; only remember that the very hardest day's bodily work I have ever done has never produced anything like the intense exhaustion I have felt after writing the 'best' parts of my books.

All this letter is I fear disheartening enough: you must remember I have not seen your MSS as yet; and I can only judge of it from such a number of MSS sent me from time to time; and only *one* of these writers has ever succeeded in getting her writings published, though in several instances I have used my best endeavours on their behalf.

Have you no sister or relation who could come and help you for a little while till you get stronger, no older friend at hand who would help you to plan your work so that it should oppress you as little as possible? If this letter has been of *any* use to you, do not scruple to write to me again, if I can give you help.

The second – and earlier – letter does not tell us about Mrs Gaskell's own working regime but offers, by way of an anecdote, a detail of Wordsworth's anxiety to find the right words for a poem. We are left in no doubt that the creative process rests on hard work and effort.

To John Forster

<div align="right">28 October 1852</div>

We dined quietly and early with Mrs Wordsworth on Monday. She is charming. She told us some homely tender details of her early married days, how Miss Wordsworth made the bread, and got dinner ready, and Mrs W. nursed all the morning, and, leaving the servant to wash up after dinner, the three set out on their long walks, carrying all the babes amongst them; and certain spots are memorial places to Mrs W. in her old age, because there she sat, and nursed this or that darling. The walks they took were something surprising to our degenerate minds. To get news of the French Revolution they used to walk up the Raise for miles, in stormy winter evenings to meet the mail. One day when they were living at Grasmere (no post office there) Wordsworth walked over to Ambleside (more than four miles) to post some poem that was to be included in a volume just being printed. After dinner as he sat meditating, he became dissatisfied with one line, and grew so restless over the thought that towards bed-time he declared he must go to Ambleside and alter it; for 'in those days postage was very heavy, and we were obliged to be very prudent'. So he and Miss Wordsworth set off after nine o'clock, walked to Ambleside, knocked up the post-office people, asked for a candle, got the letter out of the box, sent the good people to bed again, and sat in the little parlour, 'puzzling and puzzling till they got the line right'; when they replaced the letter, put out the candle, and softly stole forth, and walked home in the winter midnight.

It is curious the loving reverence she retains for Coleridge, in spite of his rousing the house about one in the morning, after her confinement, when quiet was particularly enjoined, to ask for eggs and bacon! And similar vagaries.

Graham Greene (1904–1991)

In his biography of Greene, Norman Sherry reproduces a letter which Greene wrote to his mistress in 1947. We are told how 'the act of creation is awfully odd and inexplicable like falling in love'.

On 28 September 1947 Greene wrote to Catherine of his feelings after completing a novel: 'I sent *The Heart of the Matter* to Heinemann yesterday, and I have no ideas for another book and feel I never shall ... I feel very empty and played out ... This is always the way when a book is finally cleared. It affects one badly, so that even one's religion doesn't mean a thing.'

But two days later the situation changed dramatically – the creative impulse for Greene was always somewhat miraculous. That night at 11 p.m. he wrote to Catherine, then in America:

I believe I've got a *book* coming. I feel so excited that I spell out your name in full carefully sticking my tongue between my teeth to pronounce it right. The act of creation is awfully odd and inexplicable like falling in love ... Tonight I had a solitary good dinner where I usually go with My Girl and afterwards felt vaguely restless (not sexually, just restless) so I walked to the Café Royal and sat and read *The Aran Islands*, and drank beer till about 10 and then I still felt restless, so I walked all up Piccadilly and back and went into a Gents in Brick Street, and suddenly in the Gents, I saw the three chunks, the beginning, the middle and the end, and in some ways all the ideas I had – the first

sentence of the thriller about the dead Harry who wasn't dead, the Risen-from-the-dead story, and then the other day in the train all seemed to come together. I hope to God it lasts – they don't always. I want to begin the next book with you in Ireland – if possible at Achill, but on Aran or Inishboffin or the Galway Hotel or anywhere.

Now I shall go to bed with lots of aspirin, but I shan't sleep.

Another glimpse into Greene's mind and method of work comes in his dream diary, *A World of My Own*, which was published after his death. In her foreword Yvonne Cloetta explained how important the dreams were in his work. It is reproduced below together with the record of an actual dream in a chapter on 'The Art of Writing'.

In this world of the subconscious and the imagination – a world *farfelu* as he used to call it – where everything intersects and gets tangled up beyond time, Graham obviously feels at ease and happy. 'In a sense it is an autobiography,' he says in his Introduction; and it's true that between the secret world of dreams and the real world he lived in the divide is narrow. And the barriers have been lifted. Here he can gossip about others, or give free rein to his eagerness for adventure or his delight in the absurd. Dreaming was like taking a holiday from himself. As he confided to a friend: 'If one can remember an entire dream, the result is a sense of entertainment sufficiently marked to give one the illusion of being catapulted into a different world. One finds oneself remote from one's conscious preoccupations.'

I told him once that I was astonished by the clarity with which he remembered his dreams, the preciseness of detail he retained. He explained that the habit of remembering went back to the time he first kept a dream diary – when, as a boy, he underwent psychoanalysis and was required by his analyst to retell his dreams (sometimes with embarrassing results – as when he had to confess to an erotic dream about his analyst's beautiful wife). Later, when he again began to keep a dream diary, he always had a pencil and paper at hand on his bedside

table so that when he awoke from a dream, which happened on average four or five times a night, he could jot down key words that in the morning would allow him to reconstruct it. He would then transcribe it into his diary. I remember the very first diary that he had – a large notebook of dark green leather, given to him by friends. Another was the colour of Bordeaux wine.

It is well known that Graham was always very interested in dreams, and that he relied a great deal on the role played by the subconscious in writing. He would sit down to work straightway after breakfast, writing until he had 500 words (which in the last while he reduced to approximately 200). He was in the habit of then rereading, every evening before going to bed, the section of the novel or story he had written in the morning, leaving his subconscious to work during the night. Some dreams enabled him to overcome a 'blockage'; others provided him on occasion with material for short stories or even an idea for a new novel (as with *It's a Battlefield* and *The Honorary Consul*). Sometimes, as he wrote, 'identification with a character goes so far that one may dream his dream and not one's own – as happened during the writing of *A Burnt-Out Case*, so that he was able to attribute his own dream to his character Querry and so extricate himself from an impasse in the narrative.

On May 5, 1973, I had an awful experience which I am thankful never occurred in the Common World. I had sent a love scene in a new novel to my secretary to make a draft, but her draft was full of gaps – that was only tiresome. What was awful was that, as I read the scene aloud to the woman I loved, I realized how false it was, how sentimental, how permissive in the wrong way. She too knew how bad it was and that made me angry. I threw it away. 'How can I read it to you,' I demanded, 'if you interrupt and criticize? It's only a draft, after all.'

But I knew that the whole book was hopeless. I said, 'If only I could die before the book is published. It's got to be published to earn money for the family.' The thought of Russian roulette came to me. Had I recently bought a revolver or was that a dream? My mistress tried to comfort me but it only made things worse.

Thomas Hardy (1840–1928)

Thomas Hardy has been read with wide enjoyment since his first novels appeared in the 1870s. Fortunately, we know a lot about his life and work and his Wessex is now a noted tourist attraction. His collected letters were published by the Oxford University Press in the 1970s and 1980s, and they add value to his literary output. The few letters which are reproduced here reveal just a little of his approach to his craft and, indeed, to his art.

To Alexander Macmillan

Bockhampton, Dorchester, July 25. 1868

Sir

In writing the novel I wish to lay before you – *The Poor Man and the Lady* (sent by today's post) the following considerations had place.

That the upper classes of society have been induced to read, before any, books in which *they themselves* are painted by a comparative outsider.

That in works of such a kind, unmitigated utterances of strong feeling against the class to which these readers belong, may lead them to throw down a volume in disgust; whilst the very same feelings inserted edgewise so to say; half concealed beneath ambiguous expressions, or at any rate written as if they were not the chief aims of the book (even though they may be) – become the most attractive remarks of all.

That nowadays, discussions on the questions of manners, rising in the world, etc. (the main incidents of the novel) have grown to be particularly absorbing.

That as a rule no fiction will considerably interest readers poor or rich unless the passion of love forms a prominent feature in the thread of the story.

That novelty of *position* and *view* in relation to a known subject, is more taking among the readers of light literature than even absolute novelty of subject.

Hence the book took its shape, rightly or wrongly.

Mr Moule has very kindly written me a letter of introduction, which accompanies my own, and, I believe, sufficiently explains other points.

I am, Sir,

<div align="center">

Your obedient servant
Thomas Hardy.

</div>

To Dr Hugo Erichsen

<div align="right">Savile Club, London, July 26, 1884</div>

Mr Thomas Hardy begs to state in reply to Dr Hugo Erichsen's circular that (1) he prefers night for working, but finds daytime advisable as a rule; that (2) he follows no plan as to outline; that (3) he uses no stimulant unless tea can be considered as such; that (4) his habit is to remove boots or slippers as a preliminary to work; that (5) he has no definite hours for writing; that (6) he only occasionally works against his will.

To the Revd George Bainton

<div align="right">Dorchester, Oct 11. 1887</div>

Dear Sir

I am sorry that there should have been a delay in my answer to your question.

Any detailed rules as to the formation of style I could not possibly give, for I know of none that are of practical utility. A writer's style is according to his temperament, and my impression is that if he has anything to say which is of value, and words to say it with, the style will come of itself.

Yours faithfully
T. Hardy.

To R.D. Blackmore

18 Newton Road, Westbourne Grove, W.,
June 8. 1875

Dear Mr Blackmore

I have just read your finest book (as I think) – *Lorna Doone*, and I cannot help writing just one line to tell you how astonished I was to find what it contained – exquisite ways of describing things which are more after my own heart than the 'presentations' of any other writer that I am acquainted with. It seems almost absurd that I had never read it before, considering the kind of work I attempted in *Far from the Madding Crowd*, and it has been a continual regret to me – since I have found out what the book contains – that I had not read it before meeting you. Little phases of nature which I thought nobody had noticed but myself were continually turning up in your book – for instance, the marking of a heap of sand into little pits by the droppings from trees was a fact I should unhesitatingly have declared unknown to any other novelist till now. A kindred sentiment between us in so many things is, I suppose, partly because we both spring from the West of England.

I congratulate you on the reception of your new book. I always read far in the rear of the general public, and have therefore not got it yet. Believe me

Yours very truly
Thomas Hardy.

Thomas Hardy (1840–1928)

To Sir Frederick Macmillan

Private

Max Gate, Dorchester. 22 Nov. 1922

My dear Macmillan

Have you, in your large experience of authors, any idea of the general practice of that irritable genus in respect of autographing books for strangers? I am pestered by large parcels of my own volumes from unknown people for this purpose. For instance I have just received a package of half a dozen from Lady Sackville, a total stranger (Christian name Victoria – I fancy I recall a law-suit in connection with her) and she intends to send them *all* by degrees(!), the request being that I write in each 'To Lady Sackville – Thomas Hardy', as if she were a dear friend.

In these cases the alternatives are to throw them into a cupboard and take no notice (which brings a pelting of letters of inquiry), to send them back unsigned, or to say that I will sign them (with autograph only; I could not say they are from me, as I did not present them) for a fee of a guinea, or half a guinea, each to be given to our County Hospital here, of which I am a governor, or to some other charity I choose. I have adopted each plan at various times; but as these parcels increase I have to reconsider methods, which is why I write.

There is an amusing side to it all, of course, and don't trouble to answer till you are inclined to.

Sincerely yours
Thomas Hardy.

L.P. Hartley (1895–1972)

In an essay on 'The Novelist's Responsibility', L.P. Hartley explained the importance of creating a world in which the reader could believe. He also contended that the author and the characters in a novel should behave as if 'something matters'. It is a thought-provoking piece and the paragraphs at the beginning and end of the essay, which are set out here, may give some impression of its full argument.

Sensibility is a word much used in contemporary fiction criticism. What does it mean? It means, for one thing, the ability to feel what one is writing about. There is no recipe for it: it is like feeling in real life – one either has it or one has not. It has been said that a novelist will never be any good until he has learned to exteriorize himself and to write about characters who are in no way like him. He must learn to objectify. There is a certain truth in this. A novelist must give the impression of a world of external reality existing outside himself: if he mentions a table it must be a real table, and not an unsubstantial dream-table. And he must create a world which the reader can accept and live in, without feeling that it would dissolve like Prospero's if the author was not somehow behind it. It must exist independently of the author's testimony, but not of his sensibility, not of his feeling for it, which must be as strong as, or stronger than, the feeling he has for his own life.

And to be that it must, in some degree, be an extension of his own life; its fundamental problems must be his problems, its preoccupations his preoccupations – or something allied to

them. The reason why so many first novels are good novels is simply this: the author has an impulse to communicate his own experience, and his first attempt has a freshness which none of his later work, though it may have gained in literary skill, can show. *Castle Rackrent* was Maria Edgeworth's first novel, and also her best; *Evelina* was Fanny Burney's first novel, and also her best. Some of the best novels have been single novels – *Les Liaisons Dangereuses*, *Adolphe*, *Dominique*, *Wuthering Heights*, *Vathek*. Their authors achieved perfection, or something near it, without practice, because they were writing about what was essential to their thoughts and feelings.

I must make it clear that when I speak of novelists I mean those novelists who are trying to interpret the spirit of the age – not the novelists deplored by Mr E.M. Forster, and there are many good ones, who content themselves with telling a story, unaffected by the ethical outlook round them. But they will not be able always to remain unaffected by it, for nothing is so catching as a fashion in thought. The novelist – at least I think so – must believe that *something matters*, or at any rate his characters must believe that something matters. The popular catchwords of today or yesterday – 'It's just too bad,' or 'I couldn't care less,' or 'You've had it' – all suggest ironical acceptance of the inevitable, with the corollary that nothing really matters. I don't think a novel *can* be written in that frame of mind, or any art worthy of the name be born from it. Something must matter; either as an object of attainment or avoidance, and what is it to be? If the question 'Whither Fiction?' is raised, the novelist will have to make up his mind which side he is on. Is he to write: 'She was a beautiful woman, witty, clever, cultivated, sympathetic, charming, *but* alas she was a murderess?' Or is he to write: 'She was a beautiful woman, witty, clever, etc., *and* to crown all, she was a murderess?'

Ernest Hemingway (1899–1961)

If any writer may be said to have a distinctive style it is Hemingway. His stories and general approach may make some feminists unhappy but at least he has to be included in any debate on the major writers of the twentieth century. He could certainly find the 'true sentence'. A piece in his collection *A Moveable Feast* is called 'Miss Stein Instructs' and we are offered there an account of his early days in Paris. He reveals that he was yet another writer who only stopped the day's work when he knew how he would start the following morning. And the interval between one day and the next? His reference to the role of the subconscious is worth our attention.

I was always hungry with the walking and the cold and the working. Up in the room I had a bottle of kirsch that we had brought back from the mountains and I took a drink of kirsch when I would get towards the end of a story or towards the end of the day's work. When I was through working for the day I put away the notebook, or the paper, in the drawer of the table and put any mandarins that were left in my pocket. They would freeze if they were left in the room at night.

It was wonderful to walk down the long flights of stairs knowing that I'd had good luck working. I always worked until I had something done and I always stopped when I knew what was going to happen next. That way I could be sure of going on the next day. But sometimes when I was starting a new story and I could not get it going, I would sit in front of the fire and squeeze the peel of the little oranges into the edge of the flame

and watch the sputter of blue that they made. I would stand and look out over the roofs of Paris and think, 'Do not worry. You have always written before and you will write now. All you have to do is write one true sentence. Write the truest sentence that you know.' So finally I would write one true sentence, and then go on from there. It was easy then because there was always one true sentence that I knew or had seen or had heard someone say. If I started to write elaborately, or like someone introducing or presenting something, I found that I could cut that scroll-work or ornament out and throw it away and start with the first true simple declarative sentence I had written. Up in that room I decided that I would write one story about each thing that I knew about. I was trying to do this all the time I was writing, and it was good and severe discipline.

It was in that room too that I learned not to think about anything that I was writing from the time I stopped writing until I started again the next day. That way my subconscious would be working on it and at the same time I would be listening to other people and noticing everything, I hoped; learning, I hoped; and I would read so that I would not think about my work and make myself impotent to do it. Going down the stairs when I had worked well – and that needed luck as well as discipline – was a wonderful feeling and I was free then to walk anywhere in Paris.

Henry James (1843–1916)

In his notebook and journal Henry James made this entry for 22 January 1879:

I heard some time ago, that Anthony Trollope had a theory that a boy might be brought up to be a novelist as to any other trade. He brought up – or attempted to bring up – his own son on this principle, and the young man became a sheep-farmer, in Australia. The other day Miss Thackeray (Mrs Ritchie) said to me that she and her husband meant to bring up their little daughter in that way. It hereupon occurred to me (as it has occurred before) that one might make a little story upon this. A literary lady (a poor novelist) – or a poor literary man either – (this to be determined) – gives out to the narrator that this is their intention with regard to their little son or daughter. After this the narrator meets the parent and child at intervals, about the world, for several years – the child's peculiar education being supposed to be coming on. At last, when the child is grown, there is another glimpse; the intended novelist has embraced some extremely prosaic situation, which is a comment – a satire – upon the high parental views.

Not only do we discover the long 'gestation period' for the thought to turn into a short story for it was 1892 before it appeared in print in the *Illustrated London News*, but the piece itself takes on a further dimension when we know something of its background. It has, of course, to be read as a complete story but the following brief extract perhaps offers something about

'Greville Fane' as it was called. Mrs Stormer is the hard-working novelist mother of the fun-loving Leolin who failed the apprenticeship. The whole idea of a literary upbringing makes a nice talking point.

I remember asking her on that occasion what had become of Leolin, and how much longer she intended to allow him to amuse himself at her cost. She rejoined with spirit, wiping her eyes, that he was down at Brighton hard at work – he was in the midst of a novel – and that he *felt* life so, in all its misery and mystery, that it was cruel to speak of such experiences as a pleasure. 'He goes beneath the surface,' she said, 'and he *forces* himself to look at things from which he would rather turn away. Do you call that amusing yourself? You should see his face sometimes! And he does it for me as much as for himself. He tells me everything – he comes home to me with his *trouvailles*. We are artists together, and to the artist all things are pure. I've often heard you say so yourself.' The novel that Leolin was engaged in at Brighton was never published, but a friend of mine and of Mrs Stormer's who was staying there happened to mention to me later that he had seen the young apprentice to fiction driving, in a dogcart, a young lady with a very pink face. When I suggested that she was perhaps a woman of title with whom he was conscientiously flirting my informant replied: 'She is indeed, but do you know what her title is?' He pronounced it – it was familiar and descriptive – but I won't reproduce it here. I don't know whether Leolin mentioned it to his mother: she would have needed all the purity of the artist to forgive him. I hated so to come across him that in the very last years I went rarely to see her, though I knew that she had come pretty well to the end of her rope. I didn't want her to tell me that she had fairly to give her books away – I didn't want to see her cry. She kept it up amazingly, and every few months, at my club, I saw three new volumes, in green, in crimson, in blue, on the book-table that groaned with light literature. Once I met her at the Academy soirée, where you meet people you thought were dead, and she vouchsafed the information, as if she owed it to me in candour, that Leolin had been obliged to recognize insuperable difficulties

in the question of *form*, he was so fastidious; so that she had now arrived at a definite understanding with him (it was such a comfort) that *she* would do the form if he would bring home the substance. That was now his position – he foraged for her in the great world at a salary. 'He's my "devil", don't you see? as if I were a great lawyer: he gets up the case and I argue it.' She mentioned further that in addition to his salary he was paid by the piece: he got so much for a striking character, so much for a pretty name, so much for a plot, so much for an incident, and had so much promised him if he would invent a new crime.

'He *has* invented one,' I said, 'and he's paid every day of his life.'

'What is it?' she asked, looking hard at the picture of the year, 'Baby's Tub', near which we happened to be standing.

I hesitated a moment. 'I myself will write a little story about it, and then you'll see.'

Rudyard Kipling (1865–1936)

Kipling cannot stop telling a good story, even when he is offering an account of his experience as a writer. In his *Something of Myself* he has in a chapter on 'Working Tools' an amusing account of how important it is to check facts for oneself.

In respect to verifying one's references, which is a matter in which one can help one's Daemon, it is curious how loath a man is to take his own medicine. Once, on a Boxing Day, with hard frost coming greasily out of the ground, my friend, Sir John Bland-Sutton, the head of the College of Surgeons, came down to Bateman's very full of a lecture which he was to deliver on 'gizzards'. We were settled before the fire after lunch, when he volunteered that So-and-so had said that if you hold a hen to your ear, you can hear the click in its gizzard of the little pebbles that help its digestion. 'Interesting,' said I. 'He's an authority.' 'Oh yes, but' – a long pause – 'have you any hens about here, Kipling?' I owned that I had, two hundred yards down a lane, but why not accept So-and-so? 'I can't,' said John simply, 'till I've tried it.' Remorselessly, he worried me into taking him to the hens, who lived in an open shed in front of the gardener's cottage. As we skated over the glairy ground, I saw an eye at the corner of the drawn-down Boxing-Day blind, and knew that my character for sobriety would be blasted all over the farms before nightfall. We caught an outraged pullet. John soothed her for a while (he said her pulse was 126), and held her to his ear. 'She clicks all right,' he announced. 'Listen.' I did, and there was click enough for a lecture. '*Now* we can go back to the house,' I pleaded. 'Wait a bit. Let's catch that cock. He'll click better.' We

caught him after a loud and long chase, and he clicked like a solitaire-board. I went home, my ears alive with parasites, so wrapped up in my own indignation that the fun of it escaped me. It had not been *my* verification, you see.

But John was right. Take nothing for granted if you can check it. Even though that seem waste-work, and has nothing to do with the essentials of things, it encourages the Daemon. There are always men who by trade or calling know the fact or the inference that you put forth. If you are wrong by a hair in this, they argue: 'False in one thing, false in all.' Having sinned, I know. Likewise, never play down to your public – not because some of them do not deserve it, but because it is bad for your hand. All your material is drawn from the lives of men. Remember, then, what David did with the water brought to him in the heat of battle.

The second selection from the same work takes us yet again to the need to be concerned with 'shortening'. And it is apparent that literary pieces like good wine can mature and improve if kept for a few years.

This leads me to the Higher Editing. Take of well-ground Indian ink as much as suffices and a camel-hair brush proportionate to the interspaces of your lines. In an auspicious hour, read your final draft and consider faithfully every paragraph, sentence and word, blacking out where requisite. Let it lie by to drain as long as possible. At the end of that time, reread and you should find that it will bear a second shortening. Finally, read it aloud alone and at leisure. Maybe a shade more brushwork will then indicate or impose itself. If not, praise Allah and let it go, and 'when thou hast done, repent not'. The shorter the tale, the longer the brushwork and, normally, the shorter the lie-by, and vice versa. The longer the tale, the less brush but the longer lie-by. I have had tales by me for three or five years which shortened themselves almost yearly. The magic lies in the brush and the ink. For the pen, when it is writing, can only scratch; and bottled ink is not to compare with the ground Chinese stick. *Experto crede.*

124

D.H. Lawrence (1885–1930)

The choice of names in fiction is a well-known hazard. D.H. Lawrence's letters to his publisher, Martin Secker, provide a wonderful example of the care which is necessary.

It won't take me very long, I think, to finish the novel, so it won't be too lengthy – eighty to ninety thousand, I suppose. But you'll probably hate it. I want to call it *Lady Chatterley's Lover*, nice and old-fashioned sounding. Do look up in *Debrett* or *Who's Who* and see if there are any Chatterleys about, who might take offence. It's what they'll call *very* improper – in fact, impossible to print. But they'll have to take it or leave it, I don't care. It's really, of course, very 'pure in heart'. But the *words* are all used! Damn them anyhow.

A few months later the letters reveal that we might never have heard of Lady Chatterley, and that is an arresting thought. Authors and their often desperate desire to burn or otherwise discard their manuscripts are all too frequently met in their letters and diaries.

I heard from Pollinger of Curtis Brown's wanting to make a contract for *Lady Chatterley* and two other books. But I don't want to make contracts for *Lady Chatterley* – that young woman may still go in the fire, and I don't want to make contracts for anything. I don't like it. I feel I've got a string round my wrist, and it puts me off. And don't you bother me about it, I'm much nicer when I'm *not* contracted.

Another title problem without any connection with the fear of libel is revealed in a letter where Lawrence mentions his wife's preference for a change. Thank goodness the original idea survived.

Frieda doesn't like the title of *The Virgin and the Gipsy*, she prefers something with Granny, like *Granny Gone* or *Granny on the Throne*. What do you think?

C.S. Lewis (1898–1963)

C.S. Lewis was a conscientious correspondent and a selection of his letters makes appealing reading. In a collection edited by his brother, there are two to children about writing which are both clear and educative.

To a Child in America

26 June 1956

You describe your Wonderful Night very well. That is, you describe the place and the people and the night and the feeling of it all very well – but not the *thing* itself – the setting but not the jewel. And no wonder. Wordsworth often does just the same. His *Prelude* (you're bound to read it about ten years hence. Don't try it now or you'll spoil it for later reading), is full of moments in which everything except the thing itself is described. If you become a writer you'll be trying to describe the *thing* all your life; and lucky if out of dozens of books, one or two sentences, just for a moment, come near to getting it across.

About *amn't I, aren't I* and *am I not*, of course there are no right and wrong answers about language in the sense in which there are right and wrong answers in Arithmetic. 'Good English' is whatever educated people speak; so that what is good in one place or time would not be so in another. *Amn't I* was good fifty years ago in the North of Ireland where I was brought up, but bad in Southern England. *Aren't I* would have been hideously bad in Ireland but was good in England. And of course I just don't know which (if either) is good in modern Florida. Don't

127

take any notice of teachers and text-books in such matters. Nor of logic. It is good to say 'More than one passenger was hurt', although 'more than one' equals at least two and therefore logically the verb ought to be plural 'were' and not singular 'was'. What really matters is:

(1) Always try to use the language so as to make quite clear what you mean, and make sure your sentence couldn't mean anything else.

(2) Always prefer the plain direct word to the long vague one. Don't 'implement' promises, but 'keep' them.

(3) Never use abstract nouns when concrete ones will do. If you mean 'more people died', don't say 'mortality rose'.

(4) In writing, don't use adjectives which merely tell us how you want us to feel about the thing you are describing. I mean, instead of telling us a thing was 'terrible', describe it so that we'll be terrified. Don't say it was 'delightful', make *us* say 'delightful' when we've read the description. You see, all those words (horrifying, wonderful, hideous, exquisite) are only saying to your readers 'Please will you do my job for me.'

(5) Don't use words too big for the subject. Don't say 'infinitely' when you mean 'very'; otherwise you'll have no word left when you want to talk about something *really* infinite.

To a Schoolgirl in America,
who had written (at her teacher's suggestion) to request advice on writing.

14 December 1959

It is very hard to give any general advice about writing. Here's my attempt.

(1) Turn off the radio.

(2) Read all the good books you can, and avoid nearly all magazines.

(3) Always write (and read) with the ear, not the eye. You should hear every sentence you write as if it was being read aloud or spoken. If it does not sound nice, try again.

(4) Write about what really interests you, whether it is real things or imaginary things, and nothing else. (Notice this means that if you are interested *only* in writing you will never be a writer, because you will have nothing to write about...)

(5) Take great pains to be *clear*. Remember that though you start by knowing what you mean, the reader doesn't, and a single ill-chosen word may lead him to a total misunderstanding. In a story it is terribly easy just to forget that you have not told the reader something that he wants to know – the whole picture is so clear in your own mind that you forget that it isn't the same in his.

(6) When you give up a bit of work don't (unless it is hopelessly bad) throw it away. Put it in a drawer. It may come in useful later. Much of my best work, or what I think my best, is the rewriting of things begun and abandoned years earlier.

(7) Don't use a typewriter. The noise will destroy your sense of rhythm, which still needs years of training.

(8) Be sure you know the meaning (or meanings) or every word you use.

Jack London (1876–1916)

Jack London was an American who had rare gifts as a writer and who used his extraordinary experience of life in his many stories. And he *was* extraordinary: it does not fit the normal expectation that an adventurer making his way with the Klondike gold rush should carry with him Darwin and Milton as his reading matter. London did. His adventures were often harrowing and strengthened his left-wing views.

Apart from his literary output, Jack London was a letter-writer. He answered the many aspiring authors who sought his judgement on their manuscripts. He gave straight and unambiguous replies.

To Esther Anderson

Glen Ellen, California,
December 11, 1914.

My dear Miss Anderson

In my opinion, three positive things are necessary for success as a writer.

First, a study and knowledge of literature as it is commercially produced today,

Second, a knowledge of life, and

Third, a working philosophy of life.

Negatively, I would suggest that the best preparation for authorship is a stern refusal to accept blindly the canons of literary art as laid down by teachers of high school English and teachers of university English and composition.

The average author is lucky, I mean the average successful author is lucky, if he makes $1,200-$2,000 a year. Many successful authors earn in various ways from their writings as high as $20,000 a year and there are some authors, rare ones, who make from $50,000 to $75,000 a year from their writings; and some of the most successful authors in some of the most successful years have made as high as $100,000 or $200,000.

Personally, it strikes me that the one great special advantage of authorship as a means of livelihood is that it gives one more freedom than is given any person in business or in the various other professions. The author's office and business is under his hat and he can go anywhere and write anywhere as the spirit moves him.

<div style="text-align:center">

Thanking you for your good letter,
Sincerely yours,
Jack London

</div>

To H. Stoner Davis

<div style="text-align:right">

Glen Ellen, California,
February 5, 1915.

</div>

My Dear H. Stoner Davis

In reply to yours of January 17, 1915:

I have read your manuscript and I have enjoyed it; but I am thoroughly convinced that I would not care to read it three times. You tell me that you re-wrote it fifty-three times. I appreciate your energy but I am compelled to depreciate your misapplication of energy. Is there anything in all this world in written words that is worth any man's rewriting fifty-three times?

Why did you not instead write fifty-three different things? Instead of becoming set in an obsession by going over this fifty-three times why did you not take various forms and themes and develop plasticity?

Your fifty-three times repeated obsession was doomed to failure, else it would not have been so flatly refused by the editors.

Are you writing for editors? Then give the editors what they want.

Are you writing in spite of the editors? Then why bother if they do not accept what you write not for editors but in spite of editors?

Honest to God! Cross my heart and hope to die! if I do not tell the truth, it is my solemn conviction that your poem was not worth rewriting fifty-three times.

I am enclosing you herewith a few sample poems of the sort I always keep on hand, culled from current magazines, in order to show literary aspirants what a fine, delicious, artistic expression means.

Now concerning your book – I mean the book that you suggest mailing to me. Honest and true, and cross my heart, I doubt that you have any book to send me that will be the illumination you suggest. Please remember that I have burned the midnight oil for so many long years that I doubt the proffer of a book when unaccompanied by title or gist of contents.

Yours for the Revolution,
Jack London

To Ethel Jennings

Glen Ellen, California,
February 5, 1915.

My Dear Ethel Jennings
In reply to yours of January 12th, 1915:
By the way, January 12th, 1915 was my birthday – 39 years old, if you please.

I am returning you herewith your manuscript. First of all, just a few words as to your story. A reader who knew nothing about you and who read your story in a book or magazine would wonder for a long time after beginning as to what part of the world was the locality of your story. You should have worked in, artistically, and as a germane part of the story, right near the start, the locality of the story.

Your story, really, had no locality. Your story had no place as being distinctively different from any other place of the earth's surface. This is your first mistake in the story.

Jack London (1876–1916)

Let me tell you another mistake which I get from your letter, namely that you wrote this story at white heat. Never write any story at white heat. Hell is kept warm by unpublished manuscripts that were written at white heat.

Develop your locality. Get in your local color. Develop your characters. Make your characters real to your readers. Get out of yourself and into your readers' minds and know what impression your readers are getting from your written words. Always remember that you are not writing for yourself but that you are writing for your readers. In connection with this let me recommend to you Herbert Spencer's 'Philosophy of Style'. You should be able to find this essay, 'The Philosophy of Style,' in Herbert Spencer's collected works in any public library.

On page 3 of your manuscript you stop and tell the reader how awful it is for a woman to live with a man outside of wedlock. I am perfectly willing to grant that it is awful for a woman to live with a man outside of wedlock, but as an artist I am compelled to tell you, for heaven's sake, don't stop your story in order to tell your reader how awful it is. Let your reader get this sense of awfulness from your story as your story goes on.

Further I shall not go with you in discussing your manuscript with you except to tell you that no magazine or newspaper in the United States would accept your story as it now stands.

It has long been a habit of mine to have poems typed off in duplicate which I may send to my friends. I am sending you a few samples of said poems that I have on hand at the present time. I am sending them to you in order that you may study them carefully and try to know the fineness of utterance, the new and strong and beautiful way of expressing old, eternal things which always appear apparently as new things to new eyes who try to convey what they see to the new generations.

I am enclosing you also a letter to a young writer, a letter that I was compelled to write the other day. His situation is somewhat different from yours and yet the same fundamental truth and conditions underrun his situation and your situation. In line with this let me suggest that you study always the goods that are being bought by the magazines. These goods that the magazines publish are the marketable goods. If you want to sell such goods

you must write marketable goods. Any time that you are down in this part of California look up Mrs London and me on the ranch and I can tell you more in ten minutes than I can write you in ten years.

<div align="right">
Sincerely yours,

Jack London
</div>

To J.T. Hamada

<div align="right">
Honolulu,

April 5, 1915
</div>

My dear J.T. Hamada

In reply to yours of March 29, and returning you herewith your manuscript, 'The Tumult Over a Candy Robber'.

Now, remember that it takes from three to five years for a man to learn any ordinary handicraft trade such as that of blacksmith or carpenter. At the best, when he [is] not out of work because of slack times, a blacksmith or a carpenter can earn from $3 to $5 a day. A writer can earn from $10 to $500 a day. Now, if it takes the blacksmith or the carpenter from three to five years to learn his trade, you can see that it is well worth the while of a man to take a similar time to learn the writing trade – especially when he will be paid ever so much better for his work if he succeeds.

I read your manuscript with keen interest, but find that it is too young and amateurish for publication in any magazine or newspaper. But what of that? You've got the years of your apprenticeship before you. The first day an apprentice goes into a blacksmith shop, he sweeps the floor and does the dirty work. It requires years of devotion before he can undertake to shoe a horse or build a wagon. So with you. My harsh classification of your story merely points out that it is the result of your first day's work as an apprentice in the writing shop.

Subscribe to *The Editor*, study the game, continue your apprenticeship, and in later days send me more of your manuscripts, when I shall be as honest with you as a critic as I am now.

<div align="right">
Sincerely yours,

Jack London
</div>

Rose Macaulay (1881–1958)

Rose Macaulay is perhaps best remembered today for her post-war novel *The Towers of Trebizond*, but she was also an essayist and travel writer of standing. Her humour may have been personal but it could be associated with some revealing remarks. The pages which follow are taken from her essay 'Problems of a Writer's Life'. However, she did not seem to have problems, which is refreshing.

We all have our troubles, our little crosses to bear, as the hymn puts it. The primary trouble in the life of a writer is, of course, writing. Any form of work is insufferably tedious, and this not least (though assuredly not most, either). You cannot get round or escape this trouble; in the long run, defer it as you may, you will find that the law at last holds good: writers must write. They need not write much, and very certainly they need not write well, but a little something now and then they must produce, or they will, as the phrase is, go under. Very likely they will go under in any case, but this is more honourably done (if you are a writer) by writing than by abstaining from writing.

So, every now and then, the writer has to pull herself (or himself, but on the whole male writers seem to be more indus-trious, less inert of habit, knowing that men must toil) together, sit down with pen and paper (or typewriter, which is much worse, as it demands more concentration and a more upright position) and Write. It is a frightful compulsion. For what has to be produced is not mere agreeable dalliance, mere unthinking self-expression, with the pen instead of the tongue as medium, as was the pleasant habit of our childhood. Over all that we now

write hangs the shadow of an awful doom: it will Come Out. It will appear, in cold print (print is, we are informed, of low temperature – not that this makes appearing in it any worse) and make a fool of us in the eyes of all who run and read. Many (perhaps most) of these will be our valued friends. Others will be Reviewers. These, perhaps, will not care for what we write, and will say so. They are paid to do this, and we cannot blame them. Indeed, we are probably of them, for many writers are also reviewers, and know well the troubles of that foolish, prejudiced, fanciful, well-intentioned band, whose trade it is to invent thoughts about books which stir them to no thoughts at all, nor could, who are smothered, pile upon pile, by a nightmare of frightful volumes. For, whatever you may think of an exception here and there, books in the main *are* frightful: there is no doubt about it.

This is a digression. I was speaking of the awful doom of print which awaits the written or the typed word. But there is a worse doom than getting into print – not getting into print. The manuscript may go forth from the writer to return with a faithfulness passing the faithfulness of the boomerang or the homing pigeon. This is one of the heaviest troubles in a writer's life. Well may he wonder, was he born for this – to write and write, and never to be read? He does not demand to be a best seller; he does not even demand a *succès d'estime*, or that critics should call him clever. But he would like, he would very much like, just to be in print, so that those could read him who might so wish.

Print. Those dear little neat black letters, so different from the letters produced by the pen, or even by the typewriter. Never to get there! The bitter frustration of that closed door! What fearful complexes, psychoanalysts would doubtless tell us, are produced by that frustration, that suppression! It may well be that it is responsible for a larger number of the world's crimes than is generally supposed. For, though writers are very many, non-writers (or rather, non-publishers) are even more numerous. How many decoy telegrams, how many forged cheques, are written by those who would fain be writing newspaper articles or books, but cannot achieve either, so fall back on these lesser branches of the art!

Rose Macaulay (1881–1958)

But these are, perhaps, not strictly the troubles of a writer's life. As has been said, the chief of these is Writing. For, indeed, what can be written that is worth writing? Nothing, if one uses 'worth' to denote such ultimate standard of eternal value. If, on the other hand, by 'worth' one means worth (or anyhow productive of) money, then much writing falls into this category. Many novels, for instance.

Novels are among the queerest things in a queer world. Chunks out of the imagined life of a set of imagined persons, set down for others to read. For this is what you have to produce if you are a novelist. You will find it quite easy. Anyone can write novels and most people, at one time or another, do so. One novel is much like another, so you need not worry very much about what kind of novel to write. Take up your pen, and you may be sure that something will flow out of its nib, even if it be only ink. The great advantage of writing novels is that some people read novels. They are not, on the whole, very clever people, so yours need not be clever novels, and, indeed, had better not be. You may be sure that someone will tell you, in print, that it is clever, whatever it is like, for reviewers are very kind, and like to pay compliments, unless any of them have a private grudge against you, which they will, if you write a book, be happy to pay. You need not mind what reviews say, for they are not much read except by you and your publishers. But you must make your publishers say, often and conspicuously, in the public press (and, if possible, in tube lifts) that your book exists and has sold many copies, for if the general public are told this loudly and often, they hasten to read it; they do not mind whether or not it is good, so long as they believe that many others have read it. You must, therefore, make friends with your publisher and get him to proclaim you well. He should, for instance, in public announcements, always add a nought to the number of copies he has sold of your book, so that 500 has the air of being 5,000, and so forth.

For the rest, all you have to do is to think of something to write about. You should first decide whether you are going to try to please yourself or your readers. You will probably, of course, do neither; and you may be lucky enough to do both; but some-

times there seems to be a choice. You may have reason to believe, for instance, that your novel will be more pleasing to the majority if you introduce that curious thing known as 'a love interest'. You may be personally bored by the thought of introducing this interest, of treading such a familiar path; you may desire to confine yourself to adventure, conversation, crime, food, or drink. But you will, if wise, exercise compulsion on yourself; you will set your teeth and say: 'The people in my novel shall find time, among their avocations, to love. They shall desist from talking, eating, preaching, committing crimes, and shall feel one for the other that acute emotion we call sexual affection. They shall not only feel this, but they shall mention it, even discuss it; they shall take action on account of it; they shall give the subject their attention.' For this, you must remember, is what numbers of people like to read about. Probably because everyone knows about it from personal experience, and was, naturally, intensely moved by it when it entered his or her own life. And, indeed, it is the most moving of human experiences; though anything less moving than its treatment by very nearly all novelists can scarcely be imagined. But anyhow it is familiar, and puts no strain on the reader's imagination; whatever he does not know, he knows about that. And a strange penchant for the familiar seems to obsess many readers. Criminals (one is told) like to read about crime, gourmands about meals, business men about financial intrigues, children about school.

But the writer, on the other hand, often prefers to write about the unfamiliar, the strange; he prefers to describe life on tropic islands, long-laid schemes for revenge, elaborate and improbable intrigues, or those shades of feeling which are more subtle, more improbable, less universally felt, than the primary and elementary emotions. He finds it more interesting to write of odd persons in odder situations, treading paths not as a rule, possibly never, trodden, by actual human beings. On the other hand, he may desire to write of life as lived and be quite unable to do so. Novelists, even when they are trying their hardest to be realistic, are as a rule strangely the reverse, for between life as lived and life as recorded stands the muddled brain and impotent pen of the recorder.

Rose Macaulay (1881–1958)

Readers do not know how hard even the most improbable novelist may have tried to be truthful; he has difficulties to contend with that they know not of. He no doubt knows well enough how life – some life, that is – is actually lived, but his lips are sealed: he cannot tell. So he gabbles away in his infinitely strange system of symbols, which bear, except in his mind (and often not in that), no relation whatsoever to actual conversation, actual happenings, actual emotions. Let it pass for a record: truth, after all, is relative, and no one sees it but as through a glass darkly.

Anyhow, you will enjoy being a novelist, for it is very little trouble, and, to write novels, you need no preliminary education.

Katherine Mansfield (1888–1923)

Katherine Mansfield's published letters only occasionally reveal anything about her concerns as an author. But there is one which needs to be quoted in full. It was to Sarah Gertrude Millin who was herself a writer. (The Olive Schreiner who is referred to in the text was a South African author who wrote under the name Ralph Iron).

Victoria Palace Hotel,
6 Rue Blaise Desgoffes, Rue de Rennes, Paris
permanent address c/o *The Nation* and
The Athenaeum, 10 Adelphi Terrace
W.C.2, London, March [1922]

Dear Mrs Sarah Gertrude Millin

Your letter makes me want to begin mine with 'Do write again. Don't let this be your last letter. If ever you feel inclined for a talk with a fellow-writer summon me.' I cannot tell you how glad I am to hear from you, how interested I am to know about your work. Are you really going to send me a copy of *Adam's Rest* when it comes out? It would give me great pleasure to read it.

Now I am walking through the third page of your letter. Yes I do think it is 'desolate' not to know another writer. One has a longing to talk about writing sometimes, to talk things over, to exchange impressions, to find out how other people work – what they find difficult, what they really aim at expressing – countless things like that. But there's another side to it. Let me tell you my experience. I am a 'Colonial'. I was born in New Zealand, I came to Europe to 'complete my education' and when my parents thought that tremendous task was over I went back to New Zealand. I hated it. It seemed to me a small petty world; I longed

140

for 'my' kind of people and larger interests and so on. And after a struggle I did get out of the nest finally and came to London, at eighteen, *never* to return, said my disgusted heart. Since then I've lived in England, France, Italy, Bavaria. I've known literary society in plenty. But for the last four-five years I have been ill and have lived either in the south of France or in a remote little chalet in Switzerland – always remote, always cut off, seeing hardly anybody, for months seeing really nobody except my husband and our servant and the cat and 'the people who come to the back door'. It's only in those years I've really been able to work and always my thoughts and feelings go back to New Zealand – rediscovering it, finding beauty in it, reliving it. It's about my Aunt Fan who lived up the road I really want to write, and the man who sold goldfinches, and about a wet night on the wharf, and Tarana Street in the spring. Really, I am sure it does a writer no good to be transplanted – it does harm. One reaps the glittering top of the field but there are no sheaves to bind. And there's something, disintegrating, false, *agitating* in that literary life. It's petty and stupid like a fashion. I think the only way to live as a writer is to draw upon one's real *familiar* life – to find the treasure in that as Olive Schreiner did. Our secret life, the life we return to over and over again, the 'do you remember' life is always the past. And the curious thing is that if we describe this which seems to us so intensely personal, other people take it to themselves and understand it, as if it were their own.

Does this sound as though I'm dogmatizing? I don't mean to be. But if you knew the numbers of writers who have begun full of promise and who have succumbed to London! My husband and I are determined never to live in cities, always to live 'remote' – to have our own life – where making jam and discovering a new bird and sitting on the stairs and growing the flowers we like best is – are – just as important as a new book. If one lives in literary society (I don't know why it *is* so but it is) it means giving up one's peace of mind, one's leisure – the best of life.

But I'm writing as if to beg you to unpack your trunk, as if you were on the very point of leaving South Africa tomorrow. And that's absurd. But I am so awfully glad you have Africa to draw upon.

I am writing this letter in Paris where we are staying at [i.e. till] May. I am trying a new X-ray treatment which is supposed to be very good for lungs. It's early spring, weather very lovely and gentle, the chestnut trees in bud, the hawthorn coming into flower in the Luxembourg Gardens. I can't go out, except to the clinic once a week but my husband is a very faithful messenger. He reports on it all for me, and goes to the Luxembourg Gardens every afternoon. We work hard – we are both very busy – and read a great deal. And both of us are longing to be back in the country. If this treatment succeeds at all we'll be gone in May. But it's hard to write in a hotel. I can only do short things and think out long stories. Do you have anemones in South Africa. I have a big bowl of such beauties in this room. I should like to put them into my letter, especially the blue ones and a very lovely pearly white kind.

It is late – I must end this letter. Thank you again for yours. I warmly press your hand—

<div align="center">Katherine Mansfield</div>

An extract from another letter, written in 1921 to her brother-in-law, offers in only a few words a measure of her dedication to her art and her craft.

It's a very queer thing how *craft* comes into writing. I mean down to details. *Par exemple.* In Miss Brill I chose not only the length of every sentence, but even the sound of every sentence – I chose the rise and fall of every paragraph to fit her – and to fit her on that day at that very moment. After I'd written it I read it aloud – numbers of times – just as one would *play over* a musical composition, trying to get it nearer and nearer to the expression of Miss Brill – until it fitted her.

Don't think I'm vain about the little sketch. It's only the method I wanted to explain. I often wonder whether other writers do the same. If a thing has really come off it seems to me there mustn't be one single word out of place or one word that could be taken out. That's how I AIM at writing. It will take some time to get anywhere near there.

W. Somerset Maugham
(1874–1965)

In addition to his many hugely enjoyable novels, Somerset Maugham wrote two works which give some clues to the manner in which he approached his task. The first, *The Summing Up*, which was published in 1938, offers in its opening lines an indication of how he used himself in his writing.

This is not an autobiography nor is it a book of recollections. In one way and another I have used in my writings whatever has happened to me in the course of my life. Sometimes an experience I have had has served as a theme and I have invented a series of incidents to illustrate it; more often I have taken persons with whom I have been slightly or intimately acquainted and used them as the foundation for characters of my invention. Fact and fiction are so intermingled in my work that now, looking back on it, I can hardly distinguish one from the other. It would not interest me to record the facts, even if I could remember them, of which I have already made a better use. They would seem, moreover, very tame. I have had a varied, and often an interesting, life, but not an adventurous one. I have a poor memory. I can never remember a good story till I hear it again and then I forget it before I have had a chance to tell it to somebody else. I have never been able to remember even my own jokes, so that I have been forced to go on making new ones.

But it was not until some ten years later, when he produced *A Writer's Notebook*, that he provided some understanding of the

professional secrets of the master craftsman. It should be noted that the advice to an apprentice writer to live on £150 a year was given in 1922, but the import of the message may well be the same when inflation is taken into account.

Once a lady who had a son of a literary bent asked me what training I should advise if he was to become a writer; and I, judging by the enquirer that she would pay little attention to my answer, replied: 'Give him a hundred and fifty a year for five years and tell him to go to the devil.' I have thought of it since and it seems to me it was better advice than I imagined. On such an income a young man will not starve, but it is small enough for him to enjoy little comfort; and comfort is the writer's bitter-est foe. On such an income he can travel all over the world under conditions which will enable him to see life in aspects more varied and multicoloured than a man in more affluent circumstances is ever likely to happen upon. On such an income he will be often penniless and so constrained to many pleasant shifts to earn his board and lodging. He will have to try his hand at a variety of callings. Though very good writers have led narrow lives they have written well in spite of their circumstances rather than on account of them; many old maids who spent much of the year at Bath have written novels, but there is only one Jane Austen. A writer does well to place himself in such conditions that he may experience as many as possible of the vicissitudes which occur to men. He need do nothing very much, but he should do everything a little. I would have him be in turns tinker, tailor, soldier, sailor; I would have him love and lose, go hungry and get drunk, play poker with rough-necks in San Francisco, bet with racing touts at Newmarket, philander with duchesses in Paris and argue with philosophers in Bonn, ride with bull-fighters in Seville and swim with Kanakas in the South Seas. No man is not worth the writer's knowing: every occurrence is grist to his mill. Oh, to have the gift, to be twenty-three, to have five years before one, and £150 a year.

One fusses about style. One tries to write better. One takes pains to be simple, clear and succinct. One aims at rhythm and

balance. One reads a sentence aloud to see that it sounds well. One sweats one's guts out. The fact remains that the four greatest novelists the world has ever known, Balzac, Dickens, Tolstoi and Dostoievsky, wrote their respective languages very indifferently. It proves that if you can tell stories, create character, devise incidents, and if you have sincerity and passion, it doesn't matter a damn how you write. All the same it's better to write well than ill.

Unless a novelist makes you believe in him he is done, and yet if he is entirely believable he may very well be dull. That (complete verisimilitude) is at least one reason why people turn to detective fiction. It has suspense, it excites their curiosity, it gives them a thrill; and in return for so much they make no great demand that it should be probable. They want to know who done it, and they are willing to accept the most unlikely and inadequate motive for who done it having done it.

There is no need for the writer to eat a whole sheep to be able to tell you what mutton tastes like. It is enough if he eats a cutlet. But he should do that.

George Meredith (1828–1909)

George Meredith presents us with a problem. When he died in 1909, he was a respected poet and novelist and not only held the Order of Merit but also had the esteem of many of his fellow writers. He had a significant influence on, for example, Thomas Hardy and Henry James. J.B. Priestley claimed that the modern novel began with him. But today he is largely forgotten.

His letters have been collected, however, and those that are reproduced here offer some idea of his working methods. The third letter on reviews is rather good.

To Frederick A. Maxse

I have read your manuscript. The title is excellent. First I object to the classical names. You wish to avoid social distinctions, but you defeat your purpose. Theages and Corybas and Alcides are not only at the very top of the social scale, by virtue of the appellation you bestow on them, but at least 10 feet above the level of the earth. One can't grasp the reality of characters thus dignified. And consider what you do in producing such a speculative Alcides! We have English names that will serve you. Randall, Duncan, Drummond, and such like. You state the position of your personages over and over again. The classical names are an obstruction simply.

Now, as to the story: as yet I get very little glimpse of it, and I confess the time of the whole smacks to me too much of *Robert Mornay*. The 'Dream' is a little overdone with speculation. Your characters are in arbitrary contrast to one another, but are indi-

vidually not sharply enough defined. Between Miranda and the narrator passages are to [word missing], but you have not sufficiently warmed the reader, by leading up to them. The chapters I have read give the effect of the doldrums, as far as story is concerned. We want a breeze to spring up, and keep expecting it. Certainly the Riff attack is good, and here you had your chance, but pardon me if I tell you I think you missed it. The little bit with Miranda there is bewildering rather than effective. And this, as I think, because Mr Alcides is such a very limp philosopher. He lacks passion. In a prominent character it should at least be latent.

What I would do – it's what I have done in my own case, or could I advise it so coolly? – would be to cut up the MS, rewrite it, and see that each chapter has a point. You must keep striking on the key-note, and distinctly. If Alcides is to love Miranda, let us expect it. He need not be jealous even of Corybas. Love has a thousand disguises, but we must not be taken 'aback' towards the end of the book. I would bring the Riff scene (by resolute incision) into the third chapter. And avoid inflicting on your reader the languors of your Alcides quite so much. Remember that characters mainly (unless wonderfully struck out) are interesting to the world, not for themselves, but for the part they are playing. I will gladly counsel further, if you please, and will pardon my plain-speaking. I will also see through press.

To Miss Jennett Humphreys

The chief fault in your stories is the redundancy of words which overlays them; and the chief hope visible in them is the copious youthful feeling running throughout. Your characters do not speak the language of nature, and this is specially to be charged against them when they are under strong excitement and should most do so. Nor are the characters very originally conceived, though there is good matter in the Old Welshman C. Rees. Your defect at present lies in your raw feeling. Time will cure this, if you will get the habit of looking resolutely at the thing you would portray, instead of exclaiming about it and repeating yourself without assisting the reader on in any degree. We certainly think

that you are a hopeful writer, and possibly we have been enough outspoken to encourage you to believe us sincere in saying so.

You speak of the exclamatory style as being, you think, essentially and naturally feminine. If you will look at the works of the writer of *Adam Bede*, you will see that she, the greatest of female writers, manifests nothing of the sort. It is simply a quality of youth, and you by undertaking to study will soon tame your style. Interjections are commonly a sign of raw thought, and of vagrant emotion: a literary hysteria to which women may be more subject than men; but they can talk in another tongue, let us hope. We are anxious that you should not be chagrined by any remarks that we have made. There is real promise in your work: but remember that the best fiction is fruit of a well-trained mind. If hard study should kill your creative effort, it will be no loss to the world or to you. And if, on the contrary, the genius you possess should survive the process of mental labour, it will be enriched and worthy of a good rank. But do not be discouraged by what we say; and do not listen to the encomiums of friends. Read the English of the essayists; read de Stendhal (Henri Beyle) in French; Heinrich Zschokke in German (minor tales). Learn to destroy your literary offspring remorselessly until you produce one that satisfies your artistic feeling.

To Wilkinson Sherren

My practice with regard to reviews is to look for none and to read all that may come in my way. It is like expecting a windy day in our climate when we go out of the doors and face the air: an author must master sensitiveness when he publishes. He knows what he intended, and should be able to estimate the degree of his attainment. Criticism will then brace him. We have not much of it, and there will be indifference to wear through and sometimes brutality to encounter. Tell yourself that such is our climate. I began sensitively but soon got braced. Here and there a hostile review is instructive, if only that it throws us back on the consciousness of our latent strength.

A.A. Milne (1882–1956)

A.A. Milne tried to escape from the label 'children's writer' but it sticks. In her biography, published in 1990, Ann Thwaite at one point considered why he stopped writing for children and quoted him as follows:

Can I go on writing these books, and persuade myself that each is better than the one before? I don't see how it is possible. Darwin, or somebody, compared the world of knowledge to a circle of light. The bigger the circumference of light, the bigger the surrounding border of darkness waiting to be lit up. A child's world of the imagination is not like that. As children we have explored it from end to end, and the map of it lies buried somewhere in our hearts, drawn in symbols whose meaning we have forgotten. A gleam from outside may light it up for us, so that for a moment it becomes clear again, and in that precious moment we can make a copy of it for others. But when the light has gone, to go on making fair copies of that copy – is it worth it?

For writing, let us confess it unashamed, is fun. There are those who will tell you that it is an inspiration, they sing but as the linnet sings; there are others, in revolt against such priggishness, who will tell you that it is simply a business like any other. Others, again, will assure you (heroically) that it is an agony, and they would sooner break stones – as well they might. But though there is something of inspiration in it, something of business, something, at times, of agony, yet, in the main, writing is just thrill; the thrill of exploring. The more difficult the

country, the more untraversed by the writer, the greater (to me, anyhow) the thrill.

Well, I have had my thrill out of children's books, and know that I shall never recapture it. At least, not until I am a grandfather.

But Milne always puzzled over the question of what appealed to children. In one of his essays, which he published under the title 'Children's Books', he offered an answer.

I fancy that in verse, even if written for the young, there should be something more than grammar, the correct number of syllables in a line, and correct rhymes at prearranged intervals. If I write:

> When Tommy saw his dog again,
> A cry he then did give,
> And took him quickly back to where
> They both of them did live

– if I write this, it can only be because I am not bothering. Instead of spending days at it, I am working off my sleepless nights. How many children's books, one wonders, are the result of sleepless nights – the days, of course, being devoted to 'serious' work?

This brings us back to the old question, What do children like? The answer to the question concerns the writer for children as much as, and no more than, the answer to the question 'What do men and women like?' concerned Shakespeare or Dickens. In other words – and I have taken a long time coming to the obvious – a 'children's book' must be written, not for children, but for the author himself. That the book, when written, should satisfy children must be regarded as a happy accident, just as one regards it as a happy accident if a dog or a child loves one; it is a matter of personality, and personality is the last matter about which one can take thought. But whatever fears one has, one need not fear that one is writing too well for a child, any more than one need fear that one is becoming almost too lovable. It is

difficult enough to express oneself with all the words in the dictionary at one's disposal; with none but simple words the difficulty is much greater. We need not spare ourselves.

This, I think, is the one technical concession which must be made: the use of simple words. It is, of course, annoying when your second line ends in 'self' to realize suddenly that you are writing a 'children's book' and mustn't say 'pelf'; many a poet has torn up his manuscript at this point and started on a sex novel, as giving him more scope. Others have said 'pelf' and not bothered. They are the ones who dash off their poems during a sleepless night, thinking anything good enough for a child. But those who are themselves still children as they write will reject 'pelf' instinctively, as one of those short cuts which spoil the game. It makes writing more difficult; amazingly so, at a moment when we were hoping to relax a little from the serious work of describing Life in the Night Clubs, but alas! there seems to be no help for it.

George Orwell (1903–1950)

George Orwell made no secret of the political motivation of his writing. In an essay, 'Why I Write', in the collection *England Your England*, he listed such motivation among the reasons which he believed generally provided the impulse to write. The list provokes thought.

Putting aside the need to earn a living, I think there are four great motives for writing, at any rate for writing prose. They exist in different degrees in every writer, and in any one writer the proportions will vary from time to time, according to the atmosphere in which he is living. They are:

(1) Sheer egoism. Desire to seem clever, to be talked about, to be remembered after death, to get your own back on grown-ups who snubbed you in childhood, etc., etc. It is humbug to pretend that this is not a motive, and a strong one. Writers share this characteristic with scientists, artists, politicians, lawyers, soldiers, successful businessmen – in short, with the whole top crust of humanity. The great mass of human beings are not acutely selfish. After the age of about thirty they abandon individual ambition – in many cases, indeed, they almost abandon the sense of being individuals at all – and live chiefly for others, or are simply smothered under drudgery. But there is also the minority of gifted, wilful people who are determined to live their own lives to the end, and writers belong in this class. Serious writ-

ers, I should say, are on the whole more vain and self-centred than journalists, though less interested in money.

(2) Aesthetic enthusiasm. Perception of beauty in the external world, or, on the other hand, in words and their right arrangement. Pleasure in the impact of one sound on another, in the firmness of good prose or the rhythm of a good story. Desire to share an experience which one feels is valuable and ought not to be missed. The aesthetic motive is very feeble in a lot of writers, but even a pamphleteer or a writer of textbooks will have pet words and phrases which appeal to him for non-utilitarian reasons; or he may feel strongly about typography, width of margins, etc. Above the level of a railway guide, no book is quite free from aesthetic considerations.

(3) Historical impulse. Desire to see things as they are, to find out true facts and store them up for the use of posterity.

(4) Political purpose – using the word 'political' in the widest possible sense. Desire to push the world in a certain direction, to alter other people's idea of the kind of society that they should strive after. Once again, no book is genuinely free from political bias. The opinion that art should have nothing to do with politics is itself a political attitude.

Edgar Allan Poe (1809–1849)

Poe has a reputation for brevity. Appropriately, therefore, as a master of the short story, he described his method of writing such stories in only a few words.

A skilful literary artist has constructed a tale. If wise, he has not fashioned his thoughts to accommodate his incidents; but having conceived, with deliberate care, a certain unique or single *effect* to be wrought out, he then invents such incidents – he then combines such events as may best aid him in establishing this preconceived effect. If his very initial sentence tend not to the outbringing of this effect, then he has failed in his first step. In the whole composition there should be no word written, of which the tendency, direct or indirect, is not to the one pre-established design. And by such means, with such care and skill, a picture is at length painted which leaves in the mind of him who contemplates it with a kindred art, a sense of the fullest satisfaction. The idea of the tale has been presented unblemished, because undisturbed; and this is an end unattainable by the novel.

And how did he work? This extract from a letter to James Lowell in 1844 offers an insight.

I can feel for the 'constitutional indolence' of which you complain – for it is one of my own besetting sins. I am excessively slothful and wonderfully industrious – by fits. There are epochs when any kind of mental exercise is torture, and when

Edgar Allan Poe (1809–1849)

nothing yields me pleasure but solitary communion with the
'mountains and the woods' – the 'altars' of Byron. I have thus
rambled and dreamed away whole months, and awake, at last,
to a sort of mania for composition. Then I scribble all day, and
read all night, so long as the disease endures.

A final quotation from Poe's writings is a reminder of the very
different literary world which he knew in America during the
first half of the nineteenth century.

There was a time, it is true, when we cringed to foreign opinion
– let us even say when we paid a most servile deference to British
critical dicta. That any American book could, by any possibility,
be worthy perusal, was an idea by no means extensively preva-
lent in the land; and if we were induced to read at all the
productions of our native writers, it was only after repeated
assurances from England that such productions were not alto-
gether contemptible ... Not so, however, with our present follies.
We are becoming boisterous and arrogant in the pride of a too
speedily assumed literary freedom. We throw off with the most
presumptuous and unmeaning hauteur, *all* deference whatever
to foreign opinion – we forget, in the puerile inflation of vanity,
that *the world* is the true theatre of the biblical histrio – we get
up a hue and cry about the necessity of encouraging native writ-
ers of merit – we blindly fancy that we can accomplish this by
indiscriminate puffing of good, bad, and indifferent, without
taking the trouble to consider that what we choose to denomi-
nate encouragement is thus, by its general application, precisely
the reverse. In a word, so far from being ashamed of the many
disgraceful literary failures to which our own inordinate vanities
and misapplied patriotism have lately given birth, and so far
from deeply lamenting that these daily puerilities are of home
manufacture, we adhere pertinaciously to our original blindly
conceived idea, and thus often find ourselves involved in the
gross paradox of liking a stupid book the better, because, sure
enough, its stupidity is American.

J.B. Priestley (1894–1984)

The high standing of J.B. Priestley rests for many upon his plays and novels, but he was also an essayist of stature. His pieces repay reading time after time. And that applies as well to his longer non-fiction works such as the superb *Literature and Western Man*. The extracts below are taken from *The Moments and Other Pieces*, *Outcries and Asides* and *Instead of the Trees: A Final Chapter of Autobiography* respectively. Each volume is a delight.

Writers can be divided roughly into two kinds. There are those who do not know what they want to write until they have written something. So they dash away but then fill the waste-paper basket with one rejected draft after another. And I could never be one of these people, if only because I am very mean about paper and waste on this scale would appal me. I belong to the other group, the writers who set down what is in their heads and, apart from an occasional doubtful scene or clumsy passage, do no rewriting. Once we start we go steadily on and on. But this means we are always reluctant to start. We feel there is something inevitable, leading to triumph or disaster, about the way in which we begin. So we are afraid of beginning.

This dithering about for half an hour is merely to delay starting a short piece. When faced with a long and fairly ambitious work, I can dither for weeks. I make notes I am never going to look at again: I browse around in reference books, pretending there is something I may need in them; I order another kind of typewriter ribbon; I ring up people I don't really want to talk to; I answer letters that have been lying around for a week or so; I

am willing to do all manner of little jobs that I try to dodge at any other time. Anything, anything, rather than commit myself to that first page. I am like a man at the heart of a maze, wondering which of a dozen exits he should choose. And this is closer to my situation than it might first appear to be, because even before I have actually started I am longing to get out and be free, to walk easy and clear, free from the weight and pressure of this work I have condemned myself to do. The real Creative Process (American graduate, please note) has been going on for some time, hardly ever leaving me alone, and too often robbing my outer life of much of its colour, tone, flavour, like an endless honeymoon with a succubus. And through all this delaying and dithering – and I am at it still, now trying to find a notebook I don't really need – the Creative Process is at work, is indeed rapidly increasing the pressure until I am compelled to find some words.

It is now many years since there came a reaction against the elaborate descriptions of characters found in Victorian novels. Most of us, if we knew our job, contented ourselves with a fairly brief account of our characters' appearances, just about what you would take in when you first met them. But now, in one new novel after another, all too often nobody is described at all. This fascinating girl who – God knows why – keeps taking the anti-hero to bed – what does she look like? – is she tall, medium, short, plump, thin, fair, mousy, dark, long-nosed, snub-nosed, thick-lipped, thin-lipped, fat-cheeked, hollow-cheeked, what what, what? We don't know. We aren't given a clue. Perhaps the novelist hasn't one himself. We know what anti-hero looks like, because in the first chapter he stares at himself before shaving and of course cutting himself. But then we are tired of him. It would be all the same to most of us if he didn't cut his chin but his throat.

How are characters created? I have never discussed this with a fellow novelist; I can only answer for myself and then add a few guesses. Very superficial characters, probably quick sketches from life, can be dismissed: there is no mystery in their produc-

tion. But substantial characters of some depth must involve the co-operation of the unconscious, and this at once brings in a magical element. These characters take possession of their writers, often behaving as they please, defying any plan or synopsis, revealing unsuspected traits as people so often do in real life. And indeed a complete consistency of behaviour suggests that no major character of memorable stature has been created. If the novelist himself has been surprised, then so much the better. The unconscious has been at work as it always has in dreams. Perhaps a major character might be compared to an enduring dream figure.

However, there is another way of looking at character creation. Let us say I am brooding over a novel long before I have written a single word of it. I feel that my root idea demands a certain kind of character, who comes into my brooding. At first he is only a distant acquaintance. More brooding brings him nearer, and soon I seem to know a lot more about him: I see him, hear him, begin to understand him; he is now somebody I know very well indeed, almost a close friend, even though I may not particularly like him. At this point, as I have suggested earlier, I may even inject something of myself into him. With empathy now building up, I may now have here a character fit to play a major part in my novel.

V.S. Pritchett (1900–1997)

The short story can seem so deceptively simple to write but we know that that is not the case. V.S. Pritchett, as a modern master of the art, offers a few revealing paragraphs in his autobiographical work *Midnight Oil*. The 'creative imagination' is almost explained.

Because of its natural intensity the short story is a memorable if minor literary genre. There is the fascination of packing a great deal into very little space. The fact that form is decisive concentrates an impulse that is essentially poetic. The masters of the short story have rarely been good novelists: indeed the short story is a protest against the discursive. Tolstoy and Turgenev are exceptions, but Maupassant wrote only one novel of any account: *Une Vie*. Chekhov wrote no novels. D.H. Lawrence seems to me more penetrating as a short story writer than as a novelist. An original contemporary, Jorge Luis Borges, finds the great novels too loose. He is attracted to Poe's wish for the work of art one can see shaping instantly to the eye: the form attracts experiment. It is one for those who like difficulty, who like to write 150 pages in order to squeeze out twenty. At the time of the Spanish war when I had to go to a protest meeting in an industrial town, one of the speakers interested me. I wrote two pages about her and gave up. From year to year I used to look at this aborted piece. No difficulty: no progress. Suddenly, after twenty years I saw my chance. When one is making a speech one is standing with one's body and life exposed to the audience: the sensation is frightening. Write a story in which a woman making a speech in her public voice is silently telling by the private voice

159

her own life story *while* she declaims something else. To do this was extremely difficult. One learns one's craft and craftsmanship is not much admired nowadays, for the writer is felt to be too much in control; but, in fact, the writer has always, even if secretively, to be in control. And there is the supreme pleasure of putting oneself in by leaving oneself out.

I have written six volumes of short stories and many others that have never appeared in book form. I am surrounded, as writers are, by the wreckage of stories that are half done or badly done. I believe in the habit of writing. In one dead period when I thought I had forgotten how to write, I set myself a well-known exercise which Maupassant, Henry James, Maugham and Chekhov were not too grand to try their hands at. It is the theme of the real, false or missing pearls. I was so desperate that I had to say to myself 'I will write about the first person I see passing the window.' It happened by ill luck (for I thought I knew little about the trade) to be a window cleaner. Whatever may be thought of this story – I myself do not like the end, which should have been far more open – it revealed to me as I wrote two things of importance in the creative imagination. The first: there is scarcely a glint of invented detail in this tale; it is a mosaic that can be broken down into fragments taken from things seen, heard or experienced from my whole life, though I never cleaned a window or stole a pearl. The second thing – and this is where the impulse to write was *felt* and not willed – is the link with childhood. To write well one must never lose touch with that fertilizing time. And, in this story, some words of my mother's about her father came back to me. He was a working gardener and coachman. It was part of the legend of her childhood that one morning his employer's wife called 'Lock the drawers: the window cleaner is coming.' I did not write about my grandfather but the universal myth relating to theft came brimming into my mind.

Sir Walter Scott (1771–1832)

Walter Scott was a prodigious worker, not only as a poet and author but also as a lawyer, a diarist and a letter-writer. The extracts from his *Journals* and letters offer some knowledge about aspects of his writing regime.

The first two pieces are taken from letters written on 13 March and 9 June 1808 to Lady Abercorn.

You ask me why I do not rather think of original production than editing the works of others, and I will frankly tell your Ladyship the reason. In the first place, no one acquires a certain degree of popularity without exciting an equal degree of malevolence among those who, either from rivalship or the mere wish to pull down what others have set up, are always ready to catch the first occasion to lower the favoured individual to what they call his *real standard*. Of this I have enough of experience, and my political interferences, however useless to my friends, have not failed to make me more than the usual number of enemies. I am therefore bound in justice to myself, and to those whose good opinion has hitherto protected me, not to peril myself too frequently. The naturalists tell us that if you destroy the web which the spider has just made, the insect must spend many days in inactivity till he has assembled within his person the materials necessary to weave another. Now after writing a work of imagination one feels in nearly the same exhausted state with the spider. I believe no man now alive writes more rapidly than I do, (no great recommendation), but I never think of making verses till I have a sufficient stock of poetical ideas to supply them. I would as soon join the Israelites in Egypt in their heavy task of making bricks without

straw. Besides, I know as a small farmer that good husbandry consists in not taking the same crop too frequently from the same soil, and as turnips come after wheat according to the best rules of agriculture, I take it that an edition of Swift will do well after such a scourging crop as *Marmion*. Meantime I have by no means relinquished my thoughts of a Highland poem, but am gradually collecting the ideas and information necessary for that task. Perhaps I shall visit Green Erin to collect what I can learn of Swift; if so, I hope you will be at Barons Court when I undertake my pilgrimage to your native Land of Saints.

No one is so sensible as I am of what deficiencies occur in my poetry from the want of judicious criticism and correction, above all from the extreme hurry in which it has hitherto been composed. The worst is that I take the pet at the things myself after they are finished, and I fear I shall never be able to muster up the courage necessary to revise *Marmion* as he should be revised. But if I ever write another poem, I am determined to make every single couplet of it as perfect as my uttermost care and attention can possibly effect. In order to ensure the accomplishment of these good resolutions, I will consider the whole story in humble prose, and endeavour to make it as interesting as I can before I begin to write it out in verse, and thus I shall have at least the satisfaction to know where I am going, my narrative having been hitherto much upon the plan of *blind man's buff*. Secondly, having made my story, I will write my poem with all deliberation, and when finished lay it aside for a year at least, during which *quarantine* I would be most happy if it were suffered to remain in your escritoire or in that of the Marquis, who has the best ear for English versification of any person whom, in a pretty extensive acquaintance with literary characters, I have ever had the fortune to meet with; nor is his taste at all inferior to his power of appreciating the harmony of verse. In this way I hope I shall be able to gain the great advantage of his Lordship's revision and consideration, provided he should find it in any respect worthy his attention. You see what good resolutions I am forming; whether they will be better kept than good resolutions usually are, time, which brings all things to light, will show your Ladyship.

Sir Walter Scott (1771–1832)

The extracts from the *Journals* are of a much later date. The first is from the entry for 22 December 1825 when Scott was writing his *Life of Napoleon*. On 7 December 1827 he faced the problems of 'writer's block'.

December 22. I wrote six of my close pages yesterday which is about twenty-four pages in print. What is more, I think it comes off twangingly. The story is so very interesting in itself, that there is no fear of the book answering. Superficial it must be, but I do not disown the charge. Better a superficial book, which brings well and strikingly together the known and acknowledged facts, than a dull boring narrative, pausing to see further into a mill-stone at every moment than the nature of the mill-stone admits. Nothing is so tiresome as walking through some beautiful scene with a minute philosopher, a botanist, or pebble-gatherer, who is eternally calling your attention from the grand features of the natural scenery to look at grasses and chucky-stones. Yet, in their way, they give useful information; and so does the minute historian. Gad, I think that will look well in the preface.

December 7. Being a blank day in the rolls, I stayed at home and wrote four leaves – not very freely or happily; I was not in the vein. Plague on it! Stayed at home the whole day. There is one thing I believe peculiar to me – I work, that is, meditate for the purpose of working, best, when I have a *quasi* engagement with some other book for example. When I find myself doing ill, or like to come to a still stand in writing, I take up some slight book, a novel or the like, and usually have not read far ere my difficulties are removed, and I am ready to write again. There must be two currents of ideas going on in my mind at the same time, or perhaps the slighter occupation serves like a woman's wheel or stocking to ballast the mind, as it were, by preventing the thoughts from wandering, and so gives the deeper current the power to flow undisturbed. I always laugh when I hear people say, Do one thing at once. I have done a dozen things at once all my life. Dined with the family. After dinner Lockhart's proofs came in and occupied me for the evening. I wish I had not made that article too long, and Lockhart will not snip away.

George Bernard Shaw
(1856–1950)

G.B.S. has to have his say, but from what? Stanley Weintraub prepared an autobiography of Shaw 'selected from his writings'. It is a rather strange work but nevertheless very good value. There is a chapter on 'How to Write a Play', which sticks in the mind when visiting the theatre.

In writing a play you start anywhere you can. You may even have a plot, dangerous as that is. At the other extreme you may even not see a sentence ahead of you from the rise of the curtain to its fall. You mostly start with what is called a 'situation', and write your play by leading up to it and taking its consequences. The situation may be a mere incident, or it may imply a character or conflict of characters. That is, it may be schoolboyishly simple or sagely complex. Even a repartee may be the seedling of a play. . . . *Heartbreak House* ... began with an atmosphere and does not contain a word that was foreseen before it was written. *Arms and the Man*, *The Devil's Disciple*, and *John Bull's Other Island* grew around situations. The first fragment of *Man and Superman* that came into being was the repartee: 'I am a brigand: I live by robbing the rich: I am a gentleman: I live by robbing the poor', though it afterwards developed into a thesis play, which is always a Confession of Faith or a Confession of Doubt on the author's part. *The Philanderer* began with a slice of life; most of the first act really occurred. *Back to Methuselah* is prophecy, in the scriptural, not the race tipster's, sense.

A play with one big scene is like a farce with one joke. Where

is the big scene in *Lear* or *Hamlet?* They are all big scenes from end to end. *The Merchant of Venice* has a big scene – the trial scene – from the nature of the story, but *A Midsummer Night's Dream* has none. Sometimes the grand scene is left out when you come to it. That happened in *Pygmalion*; the only person who spotted it was Barrie. You can amuse yourself by guessing what the scene was.

Caesar and Cleopatra and *St Joan* are, of course, chronicles. They are all big scenes, with climaxes. The only play I ever planned and plotted was *Captain Brassbound's Conversion*, which was neither the better nor the worse for that perfunctory preliminary, and the *scène à faire* stands out so little that nobody but an expert could say which it is. That shows how little it matters what starts a play: what is important is to let it take you where it wants without the least regard to any plans you have formed. The more unforeseen the development the better. Nobody knows or cares about your plans and plots, and if you try to force your play to conform to them you will distort your characters, make the action unnatural, and bore and frustrate the audience. Trust your inspiration. If you have none, sweep a crossing. No one is compelled to write plays.

Nevil Shute (1899–1960)

Nevil Shute's writing is of particular interest because he used his professional knowledge as an engineer in his novels. Indeed, his autobiography *Slide Rule* carries the sub-title 'The Autobiography of an Engineer'. The following extract tells of his experience of getting his first novel published but hiding the fact from his employer.

In the middle of all this absorbing work *Marazan* was published. Perhaps no novelist ever treated the production of his first book more lightly; I expected to make little money out of it, and the expectation was realized. By the time the book went out of print it had just made the advance royalty of £30. It stayed out of print for twenty-six years; when it was finally reissued in a cheap edition it made £432 in royalties in the first six months. I think it is a very good thing that we cannot see into the future. If I had known that a future as an author awaited me I suppose I should have given up engineering at an early stage, and my life would certainly have been the poorer for it.

One or two points about the publication of that early book may interest young authors. Mr Newman Flower of Cassell asked me to come and see him, which I did before we moved to Howden. At that interview he said he liked the book and wanted to publish it, but that there was one obstacle; he said that it concerned a matter with which they frequently had trouble when dealing with young authors. I asked what it was, whereupon he said, 'The House of Cassell does not print the word "bloody".' So we changed them all into 'ruddy'.

He then posted me an agreement for the publication of the book. By that time I had joined the Authors' Society, and had made a study of the terms of a desirable literary agreement. I wrote back to him objecting to practically every clause of the agreement, with the result that he replied that there were so many differences between us that he thought that no business would be possible, and sent me back the book.

The firm of literary agents, A.P. Watt & Son, had been agents for my father in the past, and for more famous men, including Rudyard Kipling, Conan Doyle, and Edgar Wallace. I had been at Balliol with a young member of the firm, R.P. Watt, and at this stage I took my troubles to him, remarking, I think, that I had made a fool of myself. He undertook to put the matter right and handle the book for me, with the result that Cassell published it upon the standard agreement used by A.P. Watt & Son. Since then I have never done any of my own literary business at all, but I have left it all to Watt. I could not have a better agent, or a more loyal friend.

When this book was published, I had to face up to the question of acknowledging the authorship. Writing fiction in the evenings was a relaxation to me at that time, an amusement to which I turned as other people would play patience. I did not take it very seriously, and I don't think it entered my head at the time that it would ever provide me with a serious income. During the daytime I was working in a fairly important position on a very important engineering job, for a very large and famous engineering company. It seemed to me that Vickers would probably take a poor view of an employee who wrote novels on the side; hard-bitten professional engineers might well consider such a man to be not a serious person. Of my two activities the airship work was by far the more important to me in the interest of the work, apart from the fact that it was my livelihood, and I was pretty sure that in my case writing in the evening was no detriment to the engineering.

For these reasons I made up my mind to do what many other authors in a similar case have done in the past, and to write under my Christian names. My full name is Nevil Shute Norway; Nevil Shute was quite a good, euphonious name for a

novelist, and Mr Norway could go on untroubled by his other interest and build up a sound reputation as an engineer. So it started, and so it has gone on to this day.

John Steinbeck (1902–1968)

When he was writing *East of Eden*, John Steinbeck also wrote on each working day what might be regarded as a letter to his friend and editor, Pascal Covici, about his intentions for the development of the novel. He saw this exercise as a way of 'unblocking' himself and warming up for the day. These efforts were not meant for publication but, perhaps inevitably, they were made public after his death. Accordingly, we now have *Journal of a Novel: The East of Eden Letters*. The first day's thoughts for 29 January 1951 are set out below in the extract and they give a good indication of the nature of this possibly unique enterprise. We enter the mind.

We come now to the book. It has been planned a long time. I planned it when I didn't know what it was about. I developed a language for it that I will never use. This seems such a waste of the few years a man has to write in. And still I do not think I could have written it before now. Of course it would have been a book – but not this book. I remember when you gave me this thick – black – expensive book to write in. See how well I have kept it for this book. Only six pages are out of it. A puppy gnawed the corners of the front cover. And it is clean and fresh and open. I hope I can fill it as you would like it filled.

The last few years have been painful. I don't know whether they have hurt permanently or not. Certainly they have changed me. I would have been stone if they had not. I hope they have not taken too much away from me. Now I am married to Elaine and in two days I am moving into the pretty little house on 72nd St and there I will have a room to work in and I will have love

all around me. Maybe I can finally write this book. All the experiment is over now. I either write the book or I do not. There can be no excuses. The form will not be startling, the writing will be spare and lean, the concepts hard, the philosophy old and yet new born. In a sense it will be two books – the story of my county and the story of me. And I shall keep these two separate. It may be that they should not be printed together. But that we will have to see after the book is all over and finished and with it a great part of me.

I am choosing to write this book to my sons. They are little boys now and they will never know what they came from through me, unless I tell them. It is not written for them to read now but when they are grown and the pains and joys have tousled them a little. And if the book is addressed to them, it is for a good reason. I want them to know how it was, I want to tell them directly, and perhaps by speaking directly to them I shall speak directly to other people. One can go off into fanciness if one writes to a huge nebulous group but I think it will be necessary to speak very straight and clearly and simply if I address my book to two little boys who will be men before they read my book. They have no background in the world of literature, they don't know the great stories of the world as we do. And so I will tell them one of the greatest, perhaps the greatest story of all – the story of good and evil, of strength and weakness, of love and hate, of beauty and ugliness. I shall try to demonstrate to them how these doubles are inseparable – how neither can exist without the other and how out of their groupings creativeness is born. I shall tell them this story against the background of the county I grew up in and along the river I know and do not love very much. For I have discovered that there are other rivers. And this my boys will not know for a long time nor can they be told. A great many never come to know that there are other rivers. Perhaps that knowledge is saved for maturity and very few people ever mature. It is enough if they flower and reseed. That is all that nature requires of them. But sometimes in a man or a woman awareness takes place – not very often and always inexplainable. There are no words for it because there is no one ever to tell. This is a secret not kept a

secret, but locked in wordlessness. The craft or art of writing is the clumsy attempt to find symbols for the wordlessness. In utter loneliness a writer tries to explain the inexplicable. And sometimes if he is very fortunate and if the time is right, a very little of what he is trying to do trickles through – not ever much. And if he is a writer wise enough to know it can't be done, then he is not a writer at all. A good writer always works at the impossible. There is another kind who pulls in his horizons, drops his mind as one lowers rifle sights. And giving up the impossible he gives up writing. Whether fortunate or unfortunate, this has not happened to me. The same blind effort, the straining and puffing go on in me. And always I hope that a little trickles through. This urge dies hard.

This book will be the most difficult of all I have ever attempted. Whether I am good enough or gifted enough remains to be seen. I do have a good background. I have love and I have had pain. I still have anger but I can find no bitterness in myself. There may be some bitterness but if there is I don't know where it can be. I do not seem to have the kind of selfness any more that nourishes it.

And so I will start my book addressed to my boys. I think perhaps it is the only book I have ever written. I think there is only one book to a man. It is true that a man may change or be so warped that he becomes another man and has another book but I do not think that is so with me.

Robert Louis Stevenson
(1850–1894)

It is good to come across an explicit discussion of style. Robert Louis Stevenson did just that in a beautifully written and concise way in his *Essays in the Art of Writing,* where he had a section on its technical elements. His notion of the perfect sentence is one to haunt everyone who tries to link words together.

We may now briefly enumerate the elements of style. We have, peculiar to the prose writer, the task of keeping his phrases large, rhythmical, and pleasing to the ear, without ever allowing them to fall into the strictly metrical: peculiar to the versifier, the task of combining and contrasting his double, treble, and quadruple pattern, feet and groups, logic and metre – harmonious in diversity: common to both, the task of artfully combining the prime elements of language into phrases that shall be musical in the mouth; the task of weaving their argument into a texture of committed phrases and of rounded periods – but this particularly binding in the case of prose: and, again common to both, the task of choosing apt, explicit, and communicative words. We begin to see now what an intricate affair is any perfect passage; how many faculties, whether of taste or pure reason, must be held upon the stretch to make it; and why, when it is made, it should afford us so complete a pleasure. From the arrangement of according letters, which is altogether arabesque and sensual, up to the architecture of the elegant and pregnant sentence, which is a vigorous act of the pure intellect, there is scarce a faculty in man but has been exer-

cised. We need not wonder, then, if perfect sentences are rare, and perfect pages rarer.

Stevenson's letters are a pleasure and his attractive personality comes through in nearly every one. Three of the letters reproduced here are replies to aspiring writers while the fourth is to Henry James.

To John Williamson Palmer

13 February 1886
Skerryvore

Dear Mr Palmer

Thank you for your letter and book, which is of more promise (in my eyes) than performance. Will you let me preach? It is what I love to do. And the defect in manner seems to me to be a preciosity and wit in narration. Narrative style should be only witty by force of perspicuity and condensation: a touch of a quibble, or an ornament that seems not to have fallen there by accident and in pursuit of the bare fact, raises a fresh issue and steals the reader's attention from the tale. I think if you would trust more implicitly to your story, it would show its articulation better and take more hold upon the mind. Really great masters of imaginative narrative such as Scott, Dumas, Homer (when he is really dealing with events) keep to the nude fact, and for the more part, reserve their wit and flourishes for the mouths of the speakers. This we perhaps all too much forget nowadays; and this forgetfulness seems to me one cause why some of your good incidents produce less effect than they ought.

Have you read Blackmore not wisely? He is a great poet of nature, but a somewhat vicious model for narrative.

Excuse these remarks (upon my soul, if you care to apply them, you will write a better tale) and believe me, Yours truly
Robert Louis Stevenson

The decoration applicable enough to small issues, little descriptive pieces, treatment of things that are to be minutely seen etc. – is out of place with spirited events.

To Richard Harding Davis

Dear Sir

Why, thank you very much for your frank, agreeable, and natural letter. It is certainly very pleasant that all young fellows should enjoy my work, and get some good out of it; and it was very kind of you to write and tell me so. The tale of the suicide is excellently droll; and your letter, you may be sure, will be preserved. If you are to escape unhurt out of your present business you must be very careful, and you must find in your heart much constancy. The swiftly done work of the journalist, and cheap finish and ready-made methods to which it leads, you must try to counteract in private by writing with the most considerate slowness and on the most ambitious models. And when I say 'writing' – O, believe me, it is rewriting that I have chiefly in mind. If you will do this, I hope to hear of you some day.

Please excuse this sermon from, Your obliged
Robert Louis Stevenson

To an Unidentified Correspondent

Dear Miss [name obliterated]

I find your letter of September in overhauling arrears, and I have a horrible consciousness it may never have been answered. For this unkinsmanlike unkindness and ungentlemanly neglect, I have no excuse to offer. But in case my advice may still be in time to help you with this tale or with another, I hasten (months too late) to tell you what I can.

Guiding rules

1. MS written only on one side of the paper.
2. Stamped and addressed cover enclosed for the return.
3. Whole story sent in. An editor (a man much besieged) would probably not look at a portion.

I am not well up in quarters for children's stories. The best

pay is at *St Nicholas* (Century Co, Union Square, New York). But the SPCK publish a great deal of work of this class, and a cousin of mine (on my mother's side) works for them entirely and I believe largely supports herself and family. You may have seen her work – not that I think it very good, but it will give you an idea – Mrs Sitwell's. I believe you address *the Editor* at the SPCK; but here again I am not very sure.

The guiding principle is to see in what magazine you believe your work would go most suitably, then address: The Editor, such-and-such a magazine, care of Messrs So-and so (the publishers).

I wish I could think of more: all I can do now is to wish you success. With kind regards, I am, Yours sincerely

Robert Louis Stevenson

To Henry James

8 December 1884
Bonallie Towers

My dear Henry James

This is a very brave hearing from more points than one. The first point is that there is a hope of a sequel. For this I laboured. Seriously, from the dearth of information and thoughtful interest in the art of literature, those who try to practise it with any deliberate purpose run the risk of finding no fit audience. People suppose it is 'the stuff' that interests them: they think for instance that the prodigious fine thoughts and sentiments in Shakespeare impress by their own weight, not understanding that the unpolished diamond is but a stone. They think that striking situations, or good dialogue are got by studying life; they will not rise to understand that they are prepared by deliberate artifice and set off by painful suppressions. Now, I want the whole thing well ventilated: for my own education and the public's; and I beg you to look as quick as you can, to follow me up with every circumstance of defeat where we differ, and (to prevent the flouting of the laity) to emphasize the points where we agree. I trust your paper will show me the way to a rejoin-

der; and that rejoinder I shall hope to make with so much art, as to woo or drive you from your threatened silence. I would not ask better than to pass my life in beating out this quarter of corn with such a seconder as yourself.

Point the second, I am rejoiced indeed to hear you speak so kindly of my work: rejoiced and surprised. I seem to myself, a very rude, left-handed countryman; not fit to be read, far less complimented, by a man so accomplished, so adroit, so craftsmanlike as you. You will happily never have cause to understand the despair with which a writer like myself considers (say) the park scene in 'Lady Barberina'. Every touch surprises me by its intangible precision; and the effect when done, as light as syllabub, as distinct as a picture, fills me with envy. Each man among us prefers his own aim; and I prefer mine; but when we come to speak of performance, I recognize myself, compared with you, to be a lout and slouch of the first water.

Where we differ, both as to the design of stories and the delineation of character, I begin to lament. Of course, I am not so dull as to ask you to desert your walk; but could you not, in one novel, to oblige a sincere admirer, and to enrich his shelves with a beloved volume, could you not, and might you not, cast your characters in a mould a little more abstract and academic (dear Mrs Pennyman had already, among your other work, a taste of what I mean) and pitch the incidents, I do not say, in any stronger, but in a slightly more emphatic key – as it were an episode from one of the old (so-called) novels of adventure? I fear you will not; and I suppose I must sighingly admit you to be right. And yet, when I see, as it were, a book of *Tom Jones*, handled with your exquisite precision and shot through with those sidelights of reflection in which you excel, I relinquish the dear vision with regret. Think upon it.

As you know I belong to that besotted class of man, the invalid; this puts me to a stand in the way of visits. But it is possible that some day you may feel that a day near the sea and among pinewoods would be a pleasant change from town. If so, please let us know; and my wife and I will be delighted to put you up, and give you what we can to eat and drink (I have a fair

bottle of claret). On the back of which, believe me, Yours sincerely

Robert Louis Stevenson

P.S. I reopen this to say that I have reread my paper, and cannot think I have at all succeeded in being either veracious or polite. I know of course, that I took your paper merely as a pin to hang my own remarks upon; but alas! what a thing is any paper! what fine remarks can you not hang on mine! how I have sinned against proportion and, with every effort to the contrary, against the merest rudiments of courtesy to you! You are indeed a very acute reader to have divined the real attitude of my mind; and I can only conclude, not without closed eyes and shrinking shoulders, in the well-worn words Lay on Macduff!

Harriet Beecher Stowe (1811-1896)

Uncle Tom's Cabin is clearly a work of both literary and, perhaps greater, political significance. It is based on deeply held convictions and this was recognized by Harriet Beecher Stowe's son when he gathered together her letters and journals after her death. In one letter she said that she wrote with her 'heart's blood'. There should be no dispute about that.

I am now writing a work which will contain, perhaps, an equal amount of matter with *Uncle Tom's Cabin*. It will contain all the facts and documents on which that story was founded, and an immense body of facts, reports of trials, legal documents, and testimony of people now living South, which will more than confirm every statement in *Uncle Tom's Cabin*.

I must confess that till I began the examination of facts in order to write this book, much as I thought I knew before, I had not begun to measure the depth of the abyss. The law records of courts and judicial proceedings are so incredible as to fill me with amazement whenever I think of them. It seems to me that the book cannot but be felt, and, coming upon the sensibility awaked by the other, do something.

I suffer exquisitely in writing these things. It may be truly said that I write with my heart's blood. Many times in writing *Uncle Tom's Cabin* I thought my health would fail utterly; but I prayed earnestly that God would help me till I got through, and still I am pressed beyond measure and above strength.

Harriet Beecher Stowe (1811-1896)

This horror, this nightmare abomination! Can it be in my country! It lies like lead on my heart, it shadows my life with sorrow; the more so that I feel, as for my own brothers, for the South, and am pained by every horror I am obliged to write, as one who is forced by some awful oath to disclose in court some family disgrace. Many times I have thought that I must die, and yet I pray God that I may live to see something done.

Jonathan Swift (1667-1745)

Swift wrote an essay on style which is well worth our attention more than 250 years later. Who has not been bothered in their recent reading by words 'invented by some pretty fellows' or phrases 'worn to rags by servile imitators'?

On Style

The following letter has laid before me many great and manifest evils in the world of letters, which I had overlooked; but they open to me a very busy scene, and it will require no small care and application to amend errors which are become so universal. The affectation of politeness is exposed in this epistle with a great deal of wit and discernment; so that whatever discourses I may fall into hereafter upon the subjects the writer treats of, I shall at present lay the matter before the world, without the least alteration from the words of my correspondent.

To Isaac Bickerstaff, Esquire.

Sir

There are some abuses among us of great consequence, the reformation of which is properly your province; though, as far as I have been conversant in your papers, you have not yet considered them. These are the deplorable ignorance that for some years hath reigned among our English writers, the great depravity of our taste, and the continual corruption of our style. I say nothing here of those who handle particular sciences, divinity, law, physic,

and the like; I mean the traders in history, politics, and the *belles lettres*, together with those by whom books are not translated, but as the common expressions are *done* out of French, Latin, or other language, and made English. I cannot but observe to you that until of late years a Grub Street book was always bound in sheepskin, with suitable print and paper, the price never above a shilling, and taken off wholly by common tradesmen or country pedlars; but now they appear in all sizes and shapes, and in all places. They are handed about from lapfuls in every coffeehouse to persons of quality; are shown in Westminster Hall and the Court of Requests. You may see them gilt, and in royal paper of five or six hundred pages, and rated accordingly. I would engage to furnish you with a catalogue of English books, published within the compass of seven years past, which at the first hand would cost you £100, wherein you shall not be able to find ten lines together of common grammar or common sense.

These two evils, ignorance and want of taste, have produced a third; I mean the continual corruption of our English tongue, which, without some timely remedy, will suffer more by the false refinements of twenty years past than it hath been improved in the foregoing hundred. And this is what I design chiefly to enlarge upon, leaving the former evils to your animadversion.

But instead of giving you a list of the late refinements crept into our language, I here send you the copy of a letter I received, some time ago, from a most accomplished person in this way of writing; upon which I shall make some remarks. It is in these terms:

Sir
' "I *cou'd n't* get the things you sent for all *about town* – I *thot* to *ha* come down myself, and then *I'd h' brot'um*; but I *ha'nt don't*, and I believe I *can't do't*, that's *pozz* – Tom begins to *gi 'mself* airs, because *he's* going with the *plenipo's* – 'T is said the *French* king will *bamboozl us agen*, which causes many speculations. The

Jacks and others of that *kidney* are very *uppish* and *alert upon't,* as you may see by their *phizz's* – Will Hazard has got the *hipps,* having lost *to the tune of* five *hundr'd* pound, *tho'* he understands play very well, *no body better.* He has *promis't* me upon *rep,* to leave off play; but you know 't is a weakness *he's* too apt to *give in to, tho'* he has as much wit as any man, *no body more.* He has lain *incog* ever since – The *mob's* very quiet with us now – I believe you *thot I banter'd* you in my last, like a *country put* – I *shan't* leave town this month, etc.

This letter is in every point an admirable pattern of the present polite way of writing; nor is it of less authority for being an epistle. You may gather every flower in it, with a thousand more of equal sweetness, from the books, pamphlets, and single papers offered us every day in the coffeehouses: and these are the beauties introduced to supply the want of wit, sense, humour, and learning, which formerly were looked upon as qualifications for a writer. If a man of wit, who died forty years ago, were to rise from the grave on purpose, how would he be able to read this letter? And after he had got through that difficulty, how would he be able to understand it? The first thing that strikes your eye, is the breaks at the end of almost every sentence; of which I know not the use, only that it is a refinement, and very frequently practised. Then you will observe the abbreviations and elisions, by which consonants of most obdurate sound are joined together, without one softening vowel to intervene; and all this only to make one syllable of two, directly contrary to the example of the Greek and Romans, altogether of the Gothic strain, and a natural tendency towards relapsing into barbarity, which delights in monosyllables, and uniting of mute consonants, as it is observable in all the northern languages. And this is still more visible in the next refinement, which consists in pronouncing the first syllable in a word that has many, and dismissing the rest, such as *phizz, hipps, mob, pozz, rep,* and many more, when we are already overloaded with mono-

syllables, which are the disgrace of our language. Thus we cram one syllable, and cut off the rest, as the owl fattened her mice after she had bitten off their legs to prevent them from running away; and if ours be the same reason for maiming our words, it will certainly answer the end; for I am sure no other nation will desire to borrow them. Some words are hitherto but fairly split, and therefore only in their way to perfection, as *incog* and *plenipo*: but in a short time it is to be hoped they will be further docked to *inc* and *plen*. This reflection has made me of late years very impatient for a peace, which I believe would save the lives of many brave words, as well as men. The war has introduced abundance of polysyllables, which will never be able to live many more campaigns: *speculations, operations, preliminaries, ambassadors, pallisadoes, communication, circumvallation, battalions*: as numerous as they are, if they attack us too frequently in our coffeehouses, we shall certainly put them to flight, and cut off the rear.

The third refinement observable in the letter I send you consists in the choice of certain words, invented by some pretty fellows, such as *banter, bamboozle, country put*, and *kidney*, as it is there applied; some of which are now struggling for the vogue, and others are in possession of it. I have done my utmost for some years past to stop the progress of *mob* and *banter*, but have been plainly borne down by numbers, and betrayed by those who promised to assist me.

In the last place, you are to take notice of certain choice phrases scattered through the letter, some of them tolerable enough, until they were worn to rags by servile imitators. You might easily find them though they were not in a different print, and therefore I need not disturb them.

These are the false refinements in our style which you ought to correct: first, by argument and fair means; but if these fail, I think you are to make use of your authority as Censor, and by an annual *Index Expurgatorius* expunge all words and phrases that are offensive to good sense, and

condemn those barbarous mutilations of vowels and sylla-
bles. In this last point the usual pretence is, that they spell
as they speak. A noble standard for language! to depend
upon the caprice of every coxcomb who, because words are
the clothing of our thoughts, cuts them out and shapes
them as he pleases, and changes them oftener than his
dress. I believe all reasonable people would be content that
such refiners were more sparing in their words, and liberal
in their syllables: and upon this head I should be glad you
would bestow some advice upon several young readers in
our churches, who, coming up from the university full
fraught with admiration of our town politeness, will needs
correct the style of their prayer-books. In reading the
Absolution, they are very careful to say *pardons* and *absolves*:
and in the prayer for the royal family, it must be *endue'um*,
enrich'um, *prosper'um*, and *bring'um*. Then in their sermons
they use all the modern terms of art, *sham*, *banter*, *mob*,
bubble, *bully*, *cutting*, *shuffling*, and *palming*; all which, and
many more of the like stamp, as I have heard them often
in the pulpit from such young sophisters, so I have read
them in some of *those sermons that have made most noise of late*.
The design, it seems, is to avoid the dreadful imputation of
pedantry; to show us that they know the town, understand
men and manners, and have not been poring upon old
unfashionable books in the university.

I should be glad to see you the instrument of introduc-
ing into our style that simplicity which is the best and
truest ornament of most things in life, which the politer
age always aimed at in their building and dress, *simplex
munditiis*, as well as in their productions of wit. It is mani-
fest that all new affected modes of speech, whether
borrowed from the court, the town, or the theatre, are the
first perishing parts in any language; and, as I could prove
by many hundred instances, have been so in ours. The writ-
ings of Hooker, who was a country clergyman, and of
Parsons the Jesuit, both in the reign of Queen Elizabeth,
are in a style that, with very few allowances, would not
offend any present reader, and are much more clear and

intelligible than those of Sir Harry Wotton, Sir Robert Naunton, Osborn, Daniel the historian, and several others who wrote later; but being men of the court, and affecting the phrases then in fashion, they are often either not to be understood, or appear perfectly ridiculous.

What remedies are to be applied to these evils I have not room to consider, having, I fear, already taken up most of your paper. Besides, I think it is our office only to represent abuses, and yours to redress them. I am, with great respect, Sir, yours, etc.

William Makepeace Thackeray (1811-1863)

Thackeray was a keen letter-writer and just occasionally he offered advice to a correspondent. An aspiring author, Richard Bedingfield, was warned of the problems of the 'trade' but as the two letters quoted were written two years apart, he must have had determination.

To Richard Bedingfield

R.C. 21 Decr., 1843.

My dear Bedingfield

I am sincerely sorry to hear of the accident which has befallen Dr Turner, and fear with you that, at his time of life, the consequences may be very doubtful. Your mother, please God, will be able to bear up under this misfortune; and I trust, however it may affect her domestic happiness, it will not at all injure her worldly prospects.

I am only this moment come out after a five days' bout of illness at my lodgings. I sent on Tuesday week last a very pressing note to Jerdan regarding the 'Miser's Son', with a little notice which I myself had written so as to save him trouble.

It was, I need not tell you a favourable one as the story deserved; it has a great deal of talent of a great number of kinds, and many a man has made a fortune with a tithe of the merit.

But in spite of this, Jerdan has not inserted my article. Have you ever advertised in his paper or elsewhere? A laudatory paragraph here and there will do you no earthly good, unless the

name of your book is perpetually before the public. The best book I ever wrote I published with an unknown publisher, and we got off 250 copies of it, and this was after the success of the Paris book, with some £30 of advertisements, and hugely laudatory notices in a score of journals. Shakespeare himself would not get a hearing in Gray's Inn Lane.

Unless your publisher actually offers you money for a future work, I beg you to have nothing to do with him. Write short tales. Make a dash at all the magazines; and at one or two of them I can promise you, as I have said, not an acceptance of your articles, but a favourable hearing. It is, however, a bad trade at the best. The prizes in it are fewer and worse than in any other professional lottery; but I know it's useless damping a man who will be an author whether or no – men are doomed, as it were, to the calling.

Make up your mind to this, my dear fellow, that the 'Miser's Son' will never succeed – not from want of merit, but from want of a publisher. Shut it up without delay, and turn to some work that will pay you. Eschew poetry above all (you've had too much of it), and read all the history you can. Don't mind this patriarchal tone from me. I'm old in the trade now, and have lived so much with all sorts of people in the world that I plume myself on my experience. Give my best love to your mother and aunt. I will call tomorrow to ask after their health, and that of your poor patient, and am always truly yours,

W.M. Thackeray.

I shall give you a notice in *Fraser* in the February number; but I tell you it's no use.

88, St. James's Street.
Sunday, June 1 [1845]

My dear Bedingfield

I was very sorry not to see you the other day when you called, but I wasn't in fit state to receive anybody, labouring under a violent attack of bilious sickness, for which the only fit company was a basin. Luckily, my illnesses don't last long nor come very often.

I have read both your stories, and here you see they come back – that is cold encouragement to a man with a great deal of merit and imagination. I think they contain a great deal of good stuff, but I'm sure they are *not saleable* – that is the point. They are done in an old-fashioned manner, I think, and you could no more sell them than a tailor could a coat of 1830, or a milliner a bonnet which might have been quite the rage in the last reign.

It's not the merits of the thing I fall foul of – though I should like to quarrel with a little *fine writing* here and there – but only the question of trade. It is not because a story is bad or an author a fool that either should not be popular nowadays, as you and I know, who see many donkeys crowned with laurels, while certain clever fellows of our acquaintance fight vainly for a maintenance or a reputation. I can suit the magazines (but I can't hit the public, be hanged to them), and, from my knowledge of the former, I should say you will *never* get a good sale for commodities like these. Quiet, sentimental novelets won't do nowadays, I'm sure. Think of the high-seasoned dishes the British public has been feeding on for the last thirty years, and you'll agree with me that they won't go back to such simple fare as you give them in 'The Blind Lover'. All I can say, my dear fellow, is Try again. In reality, your system may be the right one and mine the wrong, but I'm sure I'm right as to *the state of the market*.

Ever yours,
W.M.T.

J.R.R. Tolkien (1892-1973)

There is little debate about one aspect of Tolkien's work: you are either attracted by it and are a member of the 'cult' or you are an outsider. But at the same time there is little argument about his achievement. The letter which is set out below can only be understood in its entirety by an enthusiast, but something of his approach to the writing of *The Lord of the Rings* is offered. For example, the reference to his calendar as a working tool is interesting. He had to be organized.

From a Letter to Caroline Everett

24 June 1957

Though it is a great compliment, I am really rather sorry to find myself the subject of a thesis. I do not feel inclined to go into biographical detail. I doubt its relevance to criticism. Certainly in any form less than a complete biography, interior and exterior, which I alone could write, and which I do not intend to write. The chief biographical fact to me is the completion of *The Lord of the Rings*, which still astonishes me. A notorious beginner of enterprises and non-finisher, partly through lack of time, partly through lack of single-minded concentration, I still wonder how and why I managed to peg away at this thing year after year, often under real difficulties, and bring it to a conclusion. I suppose, because from the beginning it began to catch up in its narrative folds visions of most of the things that I have most loved or hated.

I did not go to a 'public' school in the sense of a residential school; but to a great 'grammar school', of ultimately medieval

foundation. My experience had therefore nothing whatever in common with that of Mr Lewis. I was at the one school from 1900 to 1911, with one short interval. I was as happy or the reverse at school as anywhere else, the faults being my own. I ended up anyway as a perfectly respectable and tolerably successful senior. I did not dislike games. They were not compulsory, fortunately, as I have always found cricket a bore: chiefly, though, because I was not good at it ...

I have not published any other short story but 'Leaf by Niggle'. They do not arise in my mind. 'Leaf by Niggle' arose suddenly and almost complete. It was written down almost at a sitting, and very nearly in the form in which it now appears. Looking at it myself now from a distance I should say that, in addition to my tree-love (it was originally called 'The Tree'), it arose from my own preoccupation with *The Lord of the Rings*, the knowledge that it would be finished in great detail or not at all, and the fear (near certainty) that it would be 'not at all'. The war had arisen to darken all horizons. But no such analyses are a complete explanation even of a short story ...

I read the works of [E.R.] Eddison, long after they appeared; and I once met him. I heard him in Mr Lewis's room in Magdalen College read aloud some parts of his own works – from the *Mistress of Mistresses*, as far as I remember. He did it extremely well. I read his works with great enjoyment for their sheer literary merit. My opinion of them is almost the same as that expressed by Mr Lewis on p. 104 of the *Essays Presented to Charles Williams*. Except that I disliked his characters (always excepting the Lord Gro) and despised what he appeared to admire more intensely than Mr Lewis at any rate saw fit to say of himself. Eddison thought what I admire 'soft' (his word: one of complete condemnation, I gathered); I thought that, corrupted by an evil and indeed silly 'philosophy', he was coming to admire, more and more, arrogance and cruelty. Incidentally, I thought his nomenclature slipshod and often inept. In spite of all of which, I still think of him as the greatest and most convincing writer of 'invented worlds' that I have read. But he was certainly not an 'influence'.

The general idea of *The Lord of the Rings* was certainly in my

mind from an early stage: that is from the first draft of Book 1 Chapter 2, written in the 1930s. From time to time I made rough sketches or synopses of what was to follow, immediately or far ahead; but these were seldom of much use: the story unfolded itself as it were. The tying-up was achieved, so far as it is achieved, by constant rewriting backwards. I had a many-columned calendar with dates and a brief statement of where all the major actors or groups were on each day and what they were doing.

The last volume was naturally the most difficult, since by that time I had accumulated a large number of narrative debts, and set some awkward problems of presentation in drawing together the separated threads. But the problem was not so much 'what happened?', about which I was only occasionally in doubt – though praised for 'invention' I have not in fact any conscious memory of sitting down and deliberately thinking out any episode – as how to order the account of it. The solution is imperfect. Inevitably.

Obviously the chief problem of this sort, is how to bring up Aragorn unexpectedly on the raising of the Siege, and yet inform readers of what he had been up to. Told in full in its proper place (Vol. III, ch.2), though it would have been better for the episode, it would have destroyed Chapter 6. Told in full, or indeed in part, in retrospect it would be out of date and hold up the action (as it does in Chapter 9).

The solution, imperfect, was to cut down the whole episode (which in full would belong rather to a *Saga of Aragorn Arathorn's Son* than to my story) and tell the ending of it briefly during the inevitable pause after the Battle of the Pelennor.

I was in fact longest held up – by exterior circumstances as well as interior – at the point now represented by the last words of Book III (reached about 1942 or 1943). After that Chapter 1 of Book V remained very long as a mere opening (as far as the arrival in Gondor); Chapter 2 did not exist; and Chapter 3, Muster of Rohan, had got no further than the arrival at Harrowdale. Chapter 1 of Book IV had hardly got beyond Sam's opening words (Vol II, p. 209). Some parts of the adventures of Frodo and Sam on the confines of Mordor and in it had been written (but were eventually abandoned).

Anthony Trollope (1815-1882)

Trollope's reputation rests of course upon his work as a novelist but his autobiography has been called one of the few master-pieces of that particular art. It is a pleasure to read, bringing as it does before the reader an experience of life at its high moments and its drudgery and times of unhappiness.

One of the chapters carries the heading 'On Novels and the Art of Writing Them'. It has to be absorbed in its entirety but here are two passages, one concerned with his characters, the other with dialogue.

I have never troubled myself much about the construction of plots, and am not now insisting specially on thoroughness in a branch of work in which I myself have not been very thorough. I am not sure that the construction of a perfected plot has been at any period within my power. But the novelist has other aims than the elucidation of his plot. He desires to make his readers so intimately acquainted with his characters that the creatures of his brain should be to them speaking, moving, living, human creatures. This he can never do unless he know those fictitious personages himself, and he can never know them unless he can live with them in the full reality of established intimacy. They must be with him as he lies down to sleep, and as he wakes from his dreams. He must learn to hate them and to love them. He must argue with them, quarrel with them, forgive them, and even submit to them. He must know of them whether they be cold-blooded or passionate, whether true or false, and how far true, and how far false. The depth and the breadth, and the

narrowness and the shallowness of each should be clear to him. And, as here, in our outer world, we know that men and women change – become worse or better as temptation or conscience may guide them – so should these creations of his change, and every change should be noted by him. On the last day of each month recorded, every person in his novel should be a month older than on the first. If the would-be novelist have aptitudes that way, all this will come to him without much struggling; but if it do not come, I think he can only make novels of wood.

It is so that I have lived with my characters, and thence has come whatever success I have obtained. There is a gallery of them, and of all in that gallery I may say that I know the tone of the voice, and the colour of the hair, every flame of the eye, and the very clothes they wear. Of each man I could assert whether he would have said these or the other words; of every woman, whether she would then have smiled or so have frowned. When I shall feel that this intimacy ceases, then I shall know that the old horse should be turned out to grass.

And the dialogue, on which the modern novelist in consulting the taste of his probable readers must depend most, has to be constrained also by other rules. The writer may tell much of his story in conversations, but he may only do so by putting such words into the mouths of his personages as persons so situated would probably use. He is not allowed for the sake of his tale to make his characters give utterance to long speeches, such as are not customarily heard from men and women. The ordinary talk of ordinary people is carried on in short sharp expressive sentences, which very frequently are never completed – the language of which even among educated people is often incorrect. The novel-writer in constructing his dialogue must so steer between absolute accuracy of language – which would give to his conversation an air of pedantry, and the slovenly inaccuracy of ordinary talkers, which if closely followed would offend by an appearance of grimace – as to produce upon the ear of his readers a sense of reality. If he be quite real he will seem to attempt to be funny. If he be quite correct he will seem to be unreal. And

above all, let the speeches be short. No character should utter much above a dozen words at a breath – unless the writer can justify to himself a longer flood of speech by the speciality of the occasion.

Mark Twain (1835-1910)

Mark Twain's *Autobiography* is a curious work. It does not follow any standard rules and indeed, in an author's note he wrote:

Finally in Florence, in 1904, I hit upon the right way to do an autobiography: start it at no particular time of your life; wander at your free will all over your life; talk only about the thing which interests you for the moment; drop it the moment its interest threatens to pale, and turn your talk upon the new and more interesting thing that has intruded itself into your mind meantime.

Also, make the narrative a combined diary *and* autobiography. In this way you have the vivid thing of the present to make a contrast with memories of like things in the past, and these contrasts have a charm which is all their own. No talent is required to make a combined diary and autobiography interesting.

The important word in that extract is 'narrative'. He goes on to describe it.

Within the last eight or ten years I have made several attempts to do the autobiography in one way or another with a pen, but the result was not satisfactory; it was too literary. With the pen in one's hand, narrative is a difficult art; narrative should flow as flows the brook down through the hills and the leafy woodlands, its course changed by every boulder it comes across and by every grass-clad gravelly spur that projects into its path; its surface

broken, but its course not stayed by rocks and gravel on the bottom in the shoal places; a brook that never goes straight for a minute, but *goes*, and goes briskly, sometimes ungrammatically, and sometimes fetching a horseshoe 3/4 mile around, and at the end of the circuit flowing within a yard of the path it traversed an hour before; but always *going*, and always following at least one law, always loyal to that law, the law of *narrative*, which *has no law*. Nothing to do but make the trip; the how of it is not important, so that the trip is made.

With a pen in the hand the narrative stream is a canal; it moves slowly, smoothly, decorously, sleepily, it has no blemish except that it is all blemish. It is too literary, too prim, too nice; the gait and style and movement are not suited to narrative.

Later he offered a compelling example of the power of narrative. Several pages were devoted to an account of the Morris case, which we can read many years later with admiration for the author's prescience.

The reason I want to insert that account of the Morris case, which is making such a lively stir all over the United States, and possibly the entire world, in these days, is this. Some day, no doubt, these autobiographical notes will be published. It will be after my death. It may be five years from now, it may be ten, it may be fifty – but whenever the time shall come, even if it should be a century hence – I claim that the reader of that day will find the same strong interest in that narrative that the world has in it today, for the reason that the account speaks of the thing in the language we naturally use when we are talking about something that has just happened. That form of narrative is able to carry along with it for ages and ages the very same interest which we find in it today. Whereas if this had happened fifty years ago, or a hundred, and the historian had dug it up and was putting it in *his* language, and furnishing you a long-distance view of it, the reader's interest in it would be pale. You see, it would not be *news* to him, it would be history; merely history; and history can carry on no successful competition with *news*, in the matter of sharp interest. When an eye-witness sets

down in narrative form some extraordinary occurrence which he has witnessed, that is *news* – that is the news form, and its interest is absolutely indestructible; time can have no deteriorating effect upon that episode. I am placing that account there largely as an experiment. If any stray copy of this book shall, by any chance, escape the papermill for a century or so, and then be discovered and read, I am betting that that remote reader will find that it is still *news* and that it is just as interesting as any news he will find in the newspapers of his day and morning – if newspapers shall still be in existence then – though let us hope they won't.

And here is the item that Mark Twain included in his autobiography a century ago. We even have the headline.

MRS MORRIS'S ILLNESS TAKES A SERIOUS TURN
Cabinet Officers Urge President to Disavow
Violence to Her

A DISCUSSION IN THE CASE

Mr Sheppard Criticizes the President and Republican
Leaders Try to Stop Him.

(Special to The New York Times.)

WASHINGTON, Jan. 10. – Mrs Minor Morris, who on Thursday was dragged from the White House, is tonight in a critical condition.

She seemed to be on the road to recovery on Saturday, and her physicians held out hopes that she would be able to be out by Monday. At the beginning of this week her condition took an unfavourable turn, and she has been growing steadily worse. She had a congestive chill today and has continued to grow worse. It is evident tonight that her nervous system has suffered something approaching a collapse.

The bruises inflicted upon her by the policemen have not disappeared, a striking evidence of their severity. Her arms,

shoulders and neck still bear testimony to the nature of her treatment. Mentally and physically she is suffering severely.

It was learned today that two Cabinet officers, one of whom is Secretary Taft, have been labouring with the President for two days to get him to issue a statement disavowing the action of Assistant Secretary Barnes, who ordered Mrs Morris expelled, and expressing his regret for the way she was treated. They have also urged him to promise to take action which will make impossible the repetition of such an occurrence.

The President has held out stoutly against the advice of these two Cabinet officers. He authorized Mr Barnes to make the statement that he gave out, in which the treatment of Mrs Morris was justified, and it is not easy to take the other tack now. On high authority, however, it is learned that the two Cabinet officers have not ceased their labours. They both look on the matter not as 'a mere incident', but as a serious affair.

The Morris incident was brought up in the House today just before adjournment by Mr Sheppard of Texas. He was recognized for fifteen minutes, in the ordinary course of the debate on the Philippine Tariff bill, and began at once to discuss the resolution he introduced Monday calling for an investigation of the expulsion. He excused himself for speaking on the resolution at this time, saying that as it was not privileged he could not obtain its consideration without the consent of the Committee on Rules.

He went on to describe the incident at the White House. He had proceeded only a minute or two when he was interrupted by General Grosvenor, who rose to the point of order that the remarks were not germane to the Philippine Tariff bill.

'I will show the gentleman that it is germane,' cried Mr Sheppard. 'It is just as proper for this country to have a Chinese wall around the White House as it is to have such a wall around the United States.'

'Well, if he thinks it is proper to thus arraign the President and his household,' said Mr Grosvenor, 'let him go on.'

'If the President had heard the howl of a wolf or the growl of a bear from the adjacent offices,' retorted Mr Sheppard, 'the response would have been immediate, but the wail of an American woman fell upon unresponsive ears.'

There had been several cries of protest when General Grosvenor interrupted Mr Sheppard, many of whose Democratic friends gathered about him and urged him to proceed. They applauded his reply to Mr Grosvenor, and the Ohioan did not press his point.

'These unwarrantable and unnecessary brutalities,' continued Mr Sheppard, 'demand an investigation. Unless Congress takes some action we shall soon witness in a free republic a condition where citizens cannot approach the President they have created without fear of bodily harm from arbitrary subordinates.'

Mr Sheppard had nearly reached the close of his remarks when Mr Payne, the titular floor leader of the Republicans, renewed the Grosvenor point of order. Mr Olmstead of Pennsylvania, in the chair, however, ruled that with the House sitting in Committee of the Whole on the state of the Union, remarks need not be germane.

Mr Payne interrupted again, to ask a question.

'If a gentleman has the facts upon which to found his attack,' he said, 'does he not think the police court is the better place to air them?'

'The suggestion is a reflection upon the gentleman himself, although he is a friend of mine,' replied Sheppard.

When the speech was finished Grosvenor got the floor and said he had been aware of the rules when he did not press his point.

'But I made the point,' he continued, 'merely to call the attention of the young gentleman from Texas in a mild and fatherly manner to my protest against his remarks. I hoped he would refrain from further denunciation of the President. He has introduced a resolution which is now pending before the proper committee. That resolution asks for facts and I supposed that the gentleman would wait for the facts until that resolution is brought into the House.

'I know no difference in proper conduct between the President's office and household and the humblest home in this Nation, but I don't believe a condition has arisen such that the husband of this woman cannot take care of the situation.'

A high government official tonight added to the accounts of

the expulsion an incident, which he said was related to him by an eye-witness. While the policemen and their negro assistant were dragging Mrs Morris through the grounds the scene was witnessed by the women servants, some of whom called out, 'Shame!' One of the policemen pressed his hand down on Mrs Morris's mouth to stifle her cries for help, and at that sight a man servant, a negro, rushed forward and shouted:

'Take your hand off that white woman's face! Don't treat a white woman that way!'

The policeman paid no attention to the man, and continued his efforts to stifle Mrs Morris's cries.

Evelyn Waugh (1903-1966)

Evelyn Waugh's *Diaries* tell us a lot about the man, but over many years not a great deal about his methods of writing. However, there is one revealing reference on 2 June 1947. As it is brief the entry for the whole day is quoted so that we can all share the pleasures which sometimes follow the creative effort.

I have decided to try a new method of work. When I began writing I worked straight on into the void, curious to see what would happen to my characters, with no preconceived plan for them, and few technical corrections. Now I waste hours going back and over my work. I intend trying in *The Loved One* to push straight ahead with a rough draft, have it typed and then work over it once, with the conclusion firmly in my mind when I come to give definite form to the beginning.

Eve of Corpus Christi. I decided my new method of work left me with an itch to get things into shape. Accordingly I shall begin rewriting at once what I hastily jotted down.

Low-spirited, so took a long walk through sunny lanes, woods – Wick, Nibley, Stancombe, and over the golf course. Everything like Birket Foster. Sweated heavily. Returned to a bath and change, a glass of burgundy, fruit juice and soda and a story by Henry James. And a cigar – which was contrary to my resolution and very sweet.

Waugh's letters are a joy to browse through, although, like his *Diaries*, they do not contain much about his writing habits. But reproduced here are two letters to other writers which are rele-

vant to our interest. Alex Comfort later made a name for himself not only with his literary work but also with his highly praised scientific books, not least on sex. The letter to the *Spectator* about Angus Wilson's novel *Old Men at the Zoo* provides a fascinating insight into the reactions of one master craftsman on the work of another. Among the various comments come thought-provoking remarks such as 'A novelist has a difficult task in fixing his characters in historical time.'

To Alexander Comfort

Piers Court.
29 June [1938]

Dear Mr Comfort

I am returning to you under separate cover the manuscript of *Send Forth the Sickle* which you submitted to Chapman & Halls and which was sent on to me for a final opinion. I should like first to thank you for the great interest which its reading afforded me.

I gather from your letter, which was enclosed with it, that you have some doubts about the book yourself and feel that it needs revision. The advice I am going to give you must seem drastic: it is to put the book away for five years and not look at it until you have written a second book. You may then find in it much valuable material which, with your greater skill and experience, you may be able to put to a new use. At present I believe the book to have defects which will prove fatal to its success. Too hasty publication would be a discouragement to you now and an embarrassment in the future.

It has many good qualities of vigorous narrative and keen observation. It is clear from it that you have a gift for writing that, properly developed, should be of great use to you later. But the book must be judged on its merits as a single work. It seems to me to fail because it has the air of being a *tour de force*. You are dealing with a historical period of which you have no first-hand acquaintance and the general issues seem to me imperfectly understood. I have some acquaintance with the county about

which you are writing and, I must tell you, the atmosphere of your story seems very false to my own experience. In particular the incident of d'Arcy going poaching with a tramp appears wildly improbable. Very likely it is based on some actual occurrence; half the problem of a novelist is to make real life credible, and you have certainly failed in this case. The conversations of another class are always peculiarly difficult to report. I think it was audacious of you to try rural dialect; even when well done, it is sometimes tedious, and, frankly, I do not think yours very well done. The book as a whole, moreover, seems to lack a unifying theme. You call it 'the General Dissection of a Character', but it seems to me to fall far short of this and become, in many places, a mere succession of rather melodramatic incidents. I am afraid I found Ridgway a great bore – the pseudo-Bohemian of the film – *Beloved Vagabond* type, and I am sure, not drawn from the life.

My real criticism is that the book owes its origin to an impulse to write *a* book, not this particular book. Your imagination was not so obsessed by your subject that it had to find literary expression. And that is the only way – at least while you are learning the trade – that a good book can result.

I believe that any good writer has, in his early life, scrapped at least one book. It would not be a good sign if he started doing competent work at once, that way lies the mechanical prosperity of the higher journalists. Above all please do not think that a single minute of the long hours you have spent on this book has been wasted. The time has been as well spent as if the book were published. Let me also advise you, not as a publisher but as a fellow writer, not to send it to other publishers. It is possible you might get one to take it, but I am sure the results would be disappointing for you in the long run and perhaps harmful to your development as a writer.

<div align="center">

With best wishes,

Yours sincerely,

Evelyn Waugh

</div>

To the Editor of the Spectator

Combe Florey House.
13 October [1961]

OLD MEN AT THE ZOO

Sir

Can you find space for a second opinion on Mr Angus Wilson's latest novel, *Old Men at the Zoo*? I read the book with keen delight and admiration and have since been dismayed by the reviews I have seen, of which Mr John Mortimer's in your columns is typical. I have only the most shadowy personal acquaintance with Mr Wilson and none at all with his publishers. My only motive in writing to you is the fear that the public may be discouraged from reading what seems to me a very fine book.

Your readers have already been given some indication of the plot. Few critics, including your own, seem to have appreciated the technical achievement of its intricate structure. There are not so many master craftsmen among the post-war novelists that we can afford to neglect them. I have always admired Mr Wilson's skill, but hitherto with certain reservations of sympathy and suspensions of credulity. As Mr Mortimer remarks, he has described 'a small and creepy world'. It should be an occasion for rejoicing that he has now chosen a larger and (to me) more plausible milieu. All his new characters, major and minor alike, seem to me brilliantly observed and drawn. Nothing in the narrative is haphazard. Every incident has significance. The least successful scene is the one which some critics (not Mr Mortimer) have singled out for praise – the party after the young keeper's funeral – which is most like Mr Wilson's earlier work. Reviewers should welcome variety and development in a writer.

Mr Mortimer opens his review by deploring the tendency to regard writers as authorities on questions of morals, politics and philosophy. I think he confuses two issues. On one I agree with him. Some days ago there appeared in *The Times* a letter signed by a number of well-known writers (Mr Wilson among them) protesting against the arrest of an Angolan poet. Injustice, if injustice has been committed, is equally deplorable whether the

Evelyn Waugh (1903-1966)

victim is a poet or a peasant. I do not believe that all the signatories were familiar with this poet's work or had even heard his name before being invited to subscribe. I do not believe they all had *personal* knowledge of the circumstances of his arrest. This seems to me an example of 'pressure' being brought on them 'to pontificate'. But Mr Mortimer's condemnation is wider. 'Many writers,' he says, 'are not very good at anything except writing and the value of their work is often not to be judged by the quality of their thoughts.' But writing is the expression of thought. There is no abstract writing. All literature implies moral standards and criticisms – the less explicit the better.

Mr Mortimer's second confusion is in his use of 'symbolism'. In a novel the symbols are merely the furniture of the story. They are not to be taken allegorically as in *Pilgrim's Progress*. They are not devised consciously but arise spontaneously in the mood of composition.

Thirdly, and this is most important, Mr Mortimer and all the critics I have read have been trapped by the date – 1970. It was audacious of Mr Wilson to put his story into the near future and, as things turn out, injudicious, for *Old Men at the Zoo* is not a novel like *Brave New World* or *1984* in which a warning is offered of the dangers to posterity if existing social tendencies fructify. Mr Wilson postulates no new scientific devices. His characters live and speak in the present or in the recent past.

A novelist has a difficult task in fixing his characters in historical time. Many – I think if one counted them up one would find most – good novels are set in the past. Public events intrude on private lives. It is very difficult to write a novel about 1961 which can give any indication of the final destiny of the characters, and it is with their final destiny that their creator is primarily, if unobtrusively, concerned. Mr Wilson informs us that he does not think the public events of his book are likely to occur. If I read him right, he is concerned with what might have happened, rather than with what will happen. Consciously or unconsciously he has written a study of 1938-42. The causes of his war are deliberately made absurd. He required *a* war for his plot and the war he has given us is what many Englishmen feared at the time of Munich. They were given wildly exagger-

205

ated notions of the impending disaster. Gas, microbes and high explosive would devastate the kingdom. Communications would cease. Famine would ensue. We should capitulate and the victors would impose a Nazi regime. The young may find it hard to believe, but that was in fact the belief of many intelligent people. Mr Wilson has accepted all that body of – as it happened – quite false assumptions and has used it in the machinery of his story. What he is concerned with, and what he so brilliantly portrays, is the working of the machinery on the lives of his characters.

Evelyn Waugh

H.G. Wells (1866-1946)

It is doubtful whether many today read the *Experiment in Autobiography* which H.G. Wells wrote in the 1930s. But it is worthy of our attention, especially where it deals with his early years, when he was attempting to escape from the drudgery of an apprentice's life in a shop and obtain a higher education. Not surprisingly, Wells pays attention to the challenges and problems of writing. His remarks do not lend themselves readily to being quoted out of context, although a few paragraphs from an account of his relationship with Arnold Bennett can stand alone and are instructive with regard to any consideration of 'craftsmanship' and 'artistic expression'. But it is best to read or at least dip into the autobiography.

He wrote to me first, in September 1897, on the notepaper of a little periodical he edited, called *Woman*, to ask how I came to know about the Potteries, which I had mentioned in the *Time Machine* and in a short story, and after that we corresponded. In a second letter he says he is 'glad to find the Potteries made such an impression' on me, so I suppose I had enlarged upon their scenic interest, and adds, 'Only during the last few years have I begun to see its possibilities.' In a further letter he thanks me for telling him of Conrad. He had missed *Almayer's Folly* in a batch of other novels for his paper and I had discovered it. That was one up for me. Now under my injunction he is rejoicing over *The Nigger of the Narcissus*. 'Where did the man pick up that style and that synthetic way of gathering up a general impression and flinging it at you? ... He is so consciously an artist. Now Kipling

isn't an artist a bit. Kipling doesn't know what art is – I mean the art of words; *il ne se préoccupe que de la chose racontée.'* Follow praises of George Moore. That unnecessary scrap of French is very Bennett. He was already deliberately heading for France and culture, learning French, learning to play the piano, filling up the gaps of a commonplace middle-class education with these accomplishments – and all with the brightest efficiency. Presently he came to Sandgate to see us and his swimming and diving roused my envy.

Never have I known anyone else so cheerfully objective as Bennett. His world was as bright and hard-surfaced as crockery – his *persona* was, as it were, a hard, definite china figurine. What was not precise, factual and contemporary, could not enter into his consciousness. He was friendly and self-assured; he knew quite clearly that we were both on our way to social distinction and incomes of several thousands a year. I had not thought of it like that. I was still only getting something between £1,000 and £2,000 a year, and I did not feel at all secure about getting more. But Bennett knew we couldn't stop there. He had a through ticket and a timetable – and he proved to be right.

Our success was to be attained straightforwardly by writing sound, clear stories, lucidly reasonable articles and well-constructed plays. His pride was in craftsmanship rather than in artistic expression, mystically intensified and passionately pursued, after the manner of Conrad. Possibly his ancestors had had just the same feel about their work, when they spun the clay of pots and bowls finely and precisely. He was ready to turn his pen to anything, provided it could be done well. He wrote much of the little weekly paper, *Woman*, he was editing – including answers to correspondents – often upon the most delicate subjects – over the signature, if I remember rightly, of 'Aunt Ellen'. He did it as well as he knew how. He declared he did it as well as it could be done. His ancestors on the potbanks had made vessels for honour or for dishonour. Why should not he turn out whatever was required? Some years ago he and Shaw and I were all invited by an ingenious advertisement manager to write advertisements for Harrods' Stores, for large fees. We all fell into the trap and wrote him letters (which he used for his

purposes) for nothing. Shaw and I took the high attitude. We were priests and prophets; we could not be paid for our opinions. Bennett frankly lamented the thing could not be done because it 'wasn't *done*'. But he could see no reason why a writer should not write an advertisement as an architect builds a shop.

Patrick White (1912-1990)

The collection of Patrick White's letters runs to some 600 pages, in spite of his wish that his papers be destroyed and not published on his death. The disregard of such a wish always causes some sense of guilt as we read and profit from remarks.

The first two extracts are taken from letters written shortly before he was awarded the Nobel Prize for Literature in 1973. He was a reluctant laureate but his increasing fame is indicated in the other two letters. The response to the Association for the Study of Australian Literature (ASAL) raises some nice questions for debate.

To Maie Casey

It is now 06.30. I got up four hours ago, unable to sleep because of the caterwauling outside, and being so close to the end of my book, I worked till 05.30, when I finished the second version of *The Eye of the Storm*. Finishing at that hour pleased me very much because that is when the story closes (as it opens also, towards dawn). I already find myself wanting to go back to it, so I must put it in the bank tomorrow. Then I shan't look at it for two months, and perhaps it will read like something written by another person. (I can only really *see* what I have written if I pick it up years afterwards.)

To Cynthia Nolan

I am now typing the final version of *The Eye of the Storm*. I haven't got far enough to run into any *physical* difficulties (I've only done

between one-sixteenth and one-eighth) but I have already grown fat and flabby from having sat so much. I am quite enjoying it at the moment, which may or may not be a good sign. But how different everything looks when one transfers it from longhand to typescript. I'm afraid my main character, who has to be a great beauty, bitch, charismatic figure, destroyer and affirmer all in one, may turn out to be no more than an impossibly selfish devouring female to the reader. It is still too early to tell, and she will change into something different again when she goes from typescript to print.

To Dr George Chandler
Director-General, National Library of Australia

20 Martin Road, 9.iv.77

Dear Dr Chandler

Thank you for your P 23/3/978 of 25th March.

I can't let you have my 'papers' because I don't keep any. My MSS are destroyed as soon as the books are printed. I put very little into notebooks, don't keep my friends' letters as I urge them not to keep mine, and anything unfinished when I die is to be burnt. The final versions of my books are what I want people to see and if there is anything of importance in me, it will be in those.

Yours sincerely
Patrick White

To Mary Lord

20 Martin Road, 17.vi.79

Dear Mrs Lord

I can't accept the Honorary Life Membership you offer, because I feel that in many ways ASAL is misguided in its aims. Australia seems to be suffering from a sickness called seminar. To me the literary seminar is a time-wasting and superfluous event; it may encourage a few lonely hearts and dabblers, but I

don't believe anyone intended and determined to be a serious writer would get anything positive out of these occasions.

Surely what the writer needs is orthography, grammar and syntax, which he learns at school; after that he must read and write, read and write, and forgetting all about being a writer, live, to perfect his art.

In my childhood and youth I groped my way through what I was *supposed* to read, and came across what I needed. When I went up to Cambridge I received a certain amount of guidance, but I can honestly say there was only one academic who kindled my imagination. The others dispensed a course in desiccation, so I gave up lectures – and read, and read.

Since then I have been suspicious of the academic approach to literature and attempts to foster it through seminars. True writers emerge by their own impetus; to encourage those who haven't got much to contribute you are prolonging false hopes and helping destroy the forests of the world.

This must appear a churlish reply to your kind letter with its offer of an honour and literary conviviality. But it's what I believe, and much as I enjoy conviviality, I suspect that more literature plops from the solitary bottle than out of the convivial flagon.

<div align="center">

Yours sincerely,
Patrick White.

</div>

Oscar Wilde (1854-1900)

The letters of Oscar Wilde need reading. Whatever preconceptions one may have of the man, the letters written during his time in prison and after his release are remarkable in their expression of the horrors he endured. But there are also those written over many years which provide the means of assessing his personality and way of life and these include some about his approach to writing.

The letter which follows was sent to the Editor of the *Scots Observer* in 1890 and gives a brilliant account of the relationship between an artist and his subject matter.

To the Editor of the *Scots Observer*

<div align="right">

16 Tite Street, Chelsea
9 July 1890
</div>

Sir

You have published a review of my story, *The Picture of Dorian Gray*. As this review is grossly unjust to me as an artist, I ask you to allow me to exercise in your columns my right of reply.

Your reviewer, sir, while admitting that the story in question is 'plainly the work of a man of letters', the work of one who has 'brains, and art, and style', yet suggests, and apparently in all seriousness, that I have written it in order that it should be read by the most depraved members of the criminal and illiterate classes. Now, sir, I do not suppose that the criminal and illiterate classes ever read anything except newspapers. They are certainly not likely to be able to understand anything of mine. So let them

pass, and on the broad question of why a man of letters writes at all let me say this. The pleasure that one has in creating a work of art is a purely personal pleasure, and it is for the sake of this pleasure that one creates. The artist works with his eye on the object. Nothing else interests him. What people are likely to say does not even occur to him. He is fascinated by what he has in hand. He is indifferent to others. I write because it gives me the greatest possible artistic pleasure to write. If my work pleases the few, I am gratified. If it does not, it causes me no pain. As for the mob, I have no desire to be a popular novelist. It is far too easy.

Your critic then, sir, commits the absolutely unpardonable crime of trying to confuse the artist with his subject-matter. For this, sir, there is no excuse at all. Of one who is the greatest figure in the world's literature since Greek days Keats remarked that he had as much pleasure in conceiving the evil as he had in conceiving the good. Let your reviewer, sir, consider the bearings of Keats's fine criticism, for it is under these conditions that every artist works. One stands remote from one's subject-matter. One creates it, and one contemplates it. The further away the subject-matter is, the more freely can the artist work. Your reviewer suggests that I do not make it sufficiently clear whether I prefer virtue to wickedness or wickedness to virtue. An artist, sir, has no ethical sympathies at all. Virtue and wickedness are to him simply what the colours on his palette are to the painter. They are no more, and they are no less. He sees that by their means a certain artistic effect can be produced, and he produces it. Iago may be morally horrible and Imogen stainlessly pure. Shakespeare, as Keats said, had as much delight in creating the one as he had in creating the other.

It was necessary, sir, for the dramatic development of this story to surround Dorian Gray with an atmosphere of moral corruption. Otherwise the story would have had no meaning and the plot no issue. To keep this atmosphere vague and indeterminate and wonderful was the aim of the artist who wrote the story. I claim, sir, that he has succeeded. Each man sees his own sin in Dorian Gray. What Dorian Gray's sins are no one knows. He who finds them has brought them.

In conclusion, sir, let me say how really deeply I regret that

you should have permitted such a notice as the one I feel constrained to write on to have appeared in your paper. That the editor of the *St James's Gazette* should have employed Caliban as his art-critic was possibly natural. The editor of the *Scots Observer* should not have allowed Thersites to make mows in his review. It is unworthy of so distinguished a man of letters. I am, etc.

Oscar Wilde

Letters to aspiring authors are seldom without value and the same may be said of accounts of a writer's inability to make progress with his work. The full letter and the extract which are shown below are good examples.

To an Unidentified Correspondent

16 Tite Street

I have been laid up with a severe attack of asthma, and have been unable to answer your letter before this. I return you your manuscript, as you desire, and would advise you to prune it down a little and send it to either *Time* or *Longman's*. It is better than many magazine articles, though, if you will allow me to say so, it is rather belligerent in tone.

As regards your prospects in literature, believe me that it is impossible to live by literature. By journalism a man may make an income, but rarely by pure literary work.

I would strongly advise you to try and make some profession, such as that of a tutor, the basis and mainstay of your life, and to keep literature for your finest, rarest moments. The best work in literature is always done by those who do not depend upon it for their daily bread, and the highest form of literature, poetry, brings no wealth to the singer. For producing your best work also you will require some leisure and freedom from sordid care.

It is always a difficult thing to give advice, but as you are younger than I am, I venture to do so. Make some sacrifice for your art, and you will be repaid; but ask of Art to sacrifice herself for you, and a bitter disappointment may come to you. I hope it will not, but there is always a terrible chance.

With your education you should have no difficulty in getting some post which should enable you to live without anxiety, and to keep for literature your most felicitous moods. To attain this end, you should be ready to give up some of your natural pride; but loving literature as you do, I cannot think that you would not do so.

Finally, remember that London is full of young men working for literary success, and that you must carve your way to fame. Laurels don't come for the asking. Yours

Oscar Wilde

To George Alexander

I am not satisfied with myself or my work. I can't get a grip of the play yet: I can't get my people real. The fact is I worked at it when I was not in the mood for work, and must first forget it, and then go back quite fresh to it. I am very sorry, but artistic work can't be done unless one is in the mood; certainly my work can't. Sometimes I spend months over a thing, and don't do any good; at other times I write a thing in a fortnight.

Angus Wilson (1913-1991)

Angus Wilson gave some lectures in 1960 at the University of California, Los Angeles, as part of a series when writers discussed the 'process of creation'. The lectures were later incorporated into a book, *The Wild Garden*, or *Speaking of Writing*. In the extract offered here he discusses the ideas relating to geographical setting in his novels.

This unconscious location of a fictional climax in a real setting raises the whole question of the novelist's visual picture of the geographical setting of his work, and not only the geographical setting, but the time span, and the relationship of the characters. How far do these answer to any similar patterns in the 'real' world. How far is the fictional world merely a more or less considerable distortion of the real?

I am a person who easily visualizes life – my own life and other people's lives – in terms of maps, time charts and genealogies. I think this is the most marked effect upon me of my education. I failed to learn any mathematics, but the order and pattern that I might have achieved from them were built deep into my preferred subjects of geography and history. If I remember at some moment a particular object that I have seen, say the Blue Mosque in Istanbul, then the natural tendency of my mind, if unchecked (of course it is usually checked by other thoughts), is to place this building in relation to other famous Istanbul mosques that I have seen, and these in turn I see visually on what I remember from the whole map of Istanbul in my Blue Guide. If I am tired and idle the picture will begin automatically

to expand. Istanbul will appear on a map of Turkey beside the other Turkish towns I have visited, which will in their turn acquire visual details. This map will also be marked with the towns I failed to see, in feebler pictures of details that I have only read of – Trebizond from writings or remarks of Rose Macaulay, Lake Van from a French novel that was laid in that area, and so on. On the edges of my consciousness, waiting to slide into vision, if I am unoccupied or tired, is a whole world map, appearing something like those demographic charts in which densely populated areas are heavily studded with black dots, Antarctica largely a blank. My map, however, has black dots of real experience and grey dots of imagination and, in between, varying shades to mark literary associations, historic events, the home towns of people whom I have met when they were travelling abroad, and so on. Thus on my mental map the London area is a black splodge, Provence richly black, Antarctica (the scene of many of my ice fears) a heavy grey, Tehran lightly marked by my view of the airport in the early-morning hours, overshaded because it is the residence of an old friend, cross-shaded by the word Mussadiq and his pyjamaed form (which fades by association into the pyjamaed form of another captive 'evil' figure, Dr Mabuse). Above this world map with its overlays or shadings and collections of dramatis personae, time spirals upwards so that each place too has its historical chart either dating personal experiences or bringing into mind its historic past. I cannot have, as perhaps a scientist could, any spiral of the future. The sheer weight of my obsession with history, however, has given my imagination at times a furious hunger for some prophetic counterweight which science-fiction can only partly assuage.

Marseilles, which I knew well in adolescence and have later visited periodically for a few nights when motoring in France, has dates clearly marked above it on the map in my mind: 1931, 1935, 1937, 1938, 1946, 1948, 1952, 1956, 1959, 1962. It may well be that some of these years are inaccurate, but so they are fixed in my memory. Each year carries the names or the facial expressions or associative objects of different companions – to analyse the different shorthands by which people make their impact upon memory would prove, I suspect, embarrassingly

revealing of one's purely physical feelings for them. Over all hangs a general picture of the Cannebière looking up from the Vieux Port and the Vieux Port quarter as it was pre-war; somewhere on the edge lies Corbusier's apartment house on its stilts and the zoo with a polar bear with sores that I remember from my earliest visit. Around the hazy edge I can detect some pictures of Marseilles seen in a television documentary about Simone Weil, and more clearly Mr Meagles talking to Miss Wade at the opening of *Little Dorrit* (but not the more famous scene of Rigaud in prison which somehow has no geographical setting for me). Somewhere far off is Dumas's Château d'If covered with a peacock butterfly that settled on my hand there. The chains of association, geographical, historical, or purely associative, are no doubt much the same as most other people's. I suspect that the rigid map-time-chart shape of my memories is less general. It is the only automatic discipline that my historical education has given me and it can be conveniently called 'educated memory'.

This educated memory plays an essential part in all the conscious preparations I make when I am writing fiction. It is of obvious importance in controlling and maintaining a broad-canvassed narrative like *Anglo-Saxon Attitudes*. It also perhaps accounts for a too mechanical regularity in the parts of my books – for example, the balancing of each character's public behaviour by an analogous marital relationship pointed out by Mr Francis Hope in his review of *The Old Men at the Zoo*. As a result, the conscious artistry I am able to contribute to my novels is far more evident in their general composition – methods of narration, proportions of narration, all the preparatory labours, in fact – than it is in the actual writing, where a more primitive, less educated memory, which I shall discuss later, tends to take over.

P.G. Wodehouse (1881-1975)

One of P.G. Wodehouse's school friends, William Townend, himself a writer, in later life published a selection of the letters which he had received from Wodehouse over the years. Many of them contain advice on the problems of writing, as the extracts shown below illustrate. The professionalism in his work is clearly revealed. The first two are taken from letters written in the 1920s, the second pair in the 1930s and the last dates from 1947. The advice is always straightforward and unequivocal.

Just one more thing. I think you have made a mistake in starting interesting stuff and then dropping it. The principle I always go on in writing a long story is to think of the characters in terms of actors in a play. I say to myself, when I invent a good character for an early scene: 'If this were a musical comedy we should have to get somebody like Leslie Henson to play this part, and if he found that all he had was a short scene in act one, he would walk out. How, therefore, can I twist the story so as to give him more to do and keep him alive till the fall of the curtain?'

This generally works well and improves the story. A good instance of this was Baxter in *Leave it to Psmith*. It became plain to me as I constructed the story that Baxter was such an important character that he simply had to have a good scene somewhere in what would correspond to the latter part of act two, so I bunged in that flower-pot sequence.

What a sweat a novel is till you are sure of your characters. And

what a vital thing it is to have plenty of things for a major character to *do*. That is the test. If they aren't in situations, characters can't be major characters, not even if you have the rest of the troupe talk their heads off about them.

Hell's foundations quivering briskly just now. The *Saturday Evening Post* have rejected *The Luck of the Bodkins* – my first rejection in America in twenty-one years. I have reread the book as critically as if it were someone else's – all right someone's else, if you prefer it – and see now what's wrong. Gosh, isn't it awful the mistakes one can make and not see till too late? It's 25,000 words too long.

Do you know, I believe over-longness is the worst fault in writing. I had such a good farcical plot in this one that I got all hopped up and felt that it wasn't possible to give 'em too much of this superb stuff, so every scene I wrote was elaborated till it lost its grip. To give you some idea, I now reach on page 45 a situation which in the original I got to on page 100! That's 15,000 words out for a start. I expect to cut 30,000.

I agree with you absolutely about cut-backs. I hate the type of novel which starts off in childhood, so that you don't get to the interesting stuff till about page 234. There is something, too, about the cut-back in itself which is valuable. It gives the reader a sort of double-angle. I mean, he has become absorbed with the story of old Jones as a grown-up and then suddenly he gets a glimpse of him as a kid, and the fact that he has been absorbed with him as a grown-up makes the kid stuff twice as vivid as it would have been if simply dished up as kid stuff at the start of the book. Rottenly put, but you know what I mean. Denis Mackail works the thing in his new book, *Our Hero*, but there he does it in alternate chapters. He gives you a scene with his hero as of today, then the next chapter is back in the fellow's childhood. It's very effective.

Virginia Woolf (1882-1941)

It is ironic that Virginia Woolf offered a sensitive account of the demands of *writing* in an essay called 'How Should One Read a Book?'

It is simple enough to say that since books have classes – fiction, biography, poetry – we should separate them and take from each what it is right that each should give us. Yet few people ask from books what books can give us. Most commonly we come to books with blurred and divided minds, asking of fiction that it shall be true, of poetry that it shall be false, of biography that it shall be flattering, of history that it shall enforce our own prejudices. If we could banish all such preconceptions when we read, that would be an admirable beginning. Do not dictate to your author; try to become him. Be his fellow-worker and accomplice. If you hang back, and reserve and criticize at first, you are preventing yourself from getting the fullest possible value from what you read. But if you open your mind as widely as possible, then signs and hints of almost imperceptible fineness, from the twist and turn of the first sentences, will bring you into the presence of a human being unlike any other. Steep yourself in this, acquaint yourself with this, and soon you will find that your author is giving you, or attempting to give you, something far more definite. The thirty chapters of a novel – if we consider how to read a novel first – are an attempt to make something as formed and controlled as a building: but words are more impalpable than bricks; reading is a longer and more complicated process than seeing. Perhaps the quickest way to understand the

elements of what a novelist is doing is not to read, but to write;
to make your own experiment with the dangers and difficulties
of words. Recall, then, some event that has left a distinct impres-
sion on you – how at the corner of the street, perhaps, you
passed two people talking. A tree shook; an electric light
danced; the tone of the talk was comic, but also tragic; a whole
vision, an entire conception, seemed contained in that moment.

But when you attempt to reconstruct it in words, you will
find that it breaks into a thousand conflicting impressions. Some
must be subdued; others emphasized; in the process you will
lose, probably, all grasp upon the emotion itself. Then turn from
your blurred and littered pages to the opening pages of some
great novelist – Defoe, Jane Austen, Hardy. Now you will be
better able to appreciate their mastery. It is not merely that we
are in the presence of a different person – Defoe, Jane Austen, or
Thomas Hardy – but that we are living in a different world.
Here, in *Robinson Crusoe*, we are trudging a plain high road; one
thing happens after another; the fact and the order of the fact is
enough. But if the open air and adventure mean everything to
Defoe they mean nothing to Jane Austen. Hers is the drawing-
room, and people talking, and by the many mirrors of their talk
revealing their characters. And if, when we have accustomed
ourselves to the drawing-room and its reflections, we turn to
Hardy, we are once more spun round. The moors are round us
and the stars are above our heads. The other side of the mind is
now exposed – the dark side that comes uppermost in solitude,
not the light side that shows in company. Our relations are not
towards people, but towards Nature and destiny. Yet different as
these worlds are, each is consistent with itself. The maker of each
is careful to observe the laws of his own perspective, and
however great a strain they may put upon us they will never
confuse us, as lesser writers so frequently do, by introducing two
different kinds of reality into the same book. Thus to go from
one great novelist to another – from Jane Austen to Hardy, from
Peacock to Trollope, from Scott to Meredith – is to be wrenched
and uprooted; to be thrown this way and then that. To read a
novel is a difficult and complex art. You must be capable not
only of great fineness of perception, but of great boldness of

imagination if you are going to make use of all that the novelist
– the great artist – gives you.

A second but brief quotation, this time from her diary for 17
November 1934, expresses despair. Perhaps that should not
surprise the reader who knows what was to follow a few years
later. At least it could be said that she was trying to offer hope to
others.

A note: despair at the badness of the book: can't think how I
ever could write such stuff – and with such excitement: that's
yesterday: today I think it good again. A note, by way of advis-
ing other Virginias with other books that this is the way of the
thing: up down, up down – and Lord knows the truth.